BFI BRITISH SCREEN ST(

SERIES EDITORS: Mark Duguid and Patrick Russell, BFI

The British Screen Stories series provides a unique guide to key genres within the history of British film and television. Rooted in, and richly illustrated with, material from the BFI's unique archive, the books lead readers through this fascinating terrain, expanding our understanding of familiar genres and enabling the discovery of those less well-known..

Each book focuses on a key aspect of British film and television, written in an authoritative yet accessible style. Extensive use of stills and other archive materials that tell new stories about our film heritage complement the text. A distinctive aspect is the 'close-up' features interspersing each book. These features illustrate a particular topic through a case study, technique or aesthetic development using a concise, direct and strong visual narrative approach.

OTHER TITLES IN THIS SERIES

PUBLISHED

The Story of British Animation by Jez Stewart
The Story of Victorian Film by Bryony Dixon

FORTHCOMING

The Story of Video Activism by Ed Webb-Ingall
The Story of British Screen Advertising by Emily Caston
The Story of British Screen Sport by Paul Wells

BRITISH SCREEN STORIES

THE STORY OF
BRITISH
PROPAGANDA
FILM

Scott Anthony

BFI

THE BRITISH FILM INSTITUTE
Bloomsbury Publishing Plc
50 Bedford Square, London, WC1B 3DP, UK
1385 Broadway, New York, NY 10018, USA

BLOOMSBURY is a trademark of Bloomsbury Publishing Plc

First published in Great Britain 2024 by Bloomsbury on behalf of the
British Film Institute
21 Stephen Street, London W1T 1LN
www.bfi.org.uk

The BFI is a cultural charity, and the UK's lead organisation for film, television and
the moving image. Our mission is to ensure that film is central to our cultural life,
in particular by supporting and nurturing the next generation of film-makers and
audiences. We serve a public role which covers the cultural, creative and economic
aspects of film in the UK.

Cover design: Louise Dugdale
Front cover image: *Animal Farm* (John Halas & Joy Batchelor, 1954)

A catalogue record for this book is available from the British Library.

A catalog record for this book is available from the Library of Congress.

ISBN: PB: 978-1-8390–2139–8
HB: 978–1–8390–2135–0
ePDF: 978–1–9112–2137–4
ePUB: 978–1–9112–2136–7

Series: British Screen Stories

Designed, typeset and packaged by Tom Cabot/ketchup
Printed and bound in India

To find out more about our authors and books visit www.bloomsbury.com and sign up
for our newsletters.

CONTENTS

ACKNOWLEDGEMENTS

This book could not have been written without the guidance and encouragement of Mark Duguid and Patrick Russell, not only the driving force behind this series but knowledgeable and thoughtful editors to boot.

The Story of British Propaganda Film rests on enormous amounts of research and could not have been completed without a series of visiting fellowships – I want to thank Professor Susan Pedersen at Columbia University, Professor Peter Kuznick at American University Washington D.C. and Dr Andrew Blick at The Constitution Society for providing me with important institutional homes. I owe an enormous debt to Professor Peter Vale for awarding me a Research Fellowship at the Johannesburg Institute of Advanced Study, the most productive, stimulating and happy period of my scholarly life. The research in this book also built on my previous involvement with the ERC's 'Economics and the Public Sphere' project which I worked on for two years at the University of Cambridge: a belated thank you to my colleagues Dr Tiago Mata, Dr Andrea Salter and Dr Tomas Undurraga for the opportunity to work on such a timely and heterodox project. While researching this book I benefitted from conversations and interviews with an enormous range of people, I would like to particularly thank Lord Boateng, Dr Elizabeth Darling, Professor Lee Grieveson, Glenna Forster-Jones, John Hall, Tymn Lintell, John Lloyd, Dr Tapsi Mathur, Hannah Neale, Dr Tom Rice, Dr Martin Stollery and Dr Henry K. Miller for their help. Thank you also to my friend Paul Moses and my mother Sue Boswell for their willingness to visit archives and libraries in the UK to dig up or double check obscure and poorly remembered references.

Several commissioning editors have given me opportunities to try out, or expand on, my developing ideas in the commercial media. This has been intellectually, motivationally and materially important to me: particular thank yous to Ash Carter at *Air Mail*, Robert Haddow at *The South China Morning Post*, Owen Hatherley at *Tribune*, Anna Jones at the BBC, Tomas Jones at the *London Review of Books* blog, Paul Jump at *Times Higher*, Michael Mosbacher at *The Critic Magazine*, Audrey Quek at *The Straits Times* and Nigel Farrow at Lund Humphries.

Annabelle Khoo, Josiah Ho and Rebekah Lim assisted in the preliminary gathering of research materials for this book, while Alexander Koh, employed through the SG United Research Assistant scheme, provided first-rate editorial support. Thank you all.

This book was written in Athens, Jakarta, Johannesburg, London, New York and Singapore. While it is impossible to list everyone and everything that has influenced my thinking, I would particularly like to mention Tim Boon, Song-Chuan Chen, Tamares Goh, Albert Heta, Laavanya Kathiravelu, Yin Ker, Paul Khoo, Peter Mandler, Eko Prawato, Kevin Riordan, Els van Dongen, Farah Wardani and Faizah Binte Zakaria for their encouragement, wisdom and friendship.

This book is for Stefanos.

BRITISH SCREEN STORIES: EDITORS' INTRODUCTION

Acentury and a quarter since the first films flickered onto the screen, moving images dominate our lives. Our workplaces, schools and homes – even the journeys between them – are saturated with film. So how did we get here? What's the story? Or rather, the stories – because film contains multitudes. Moving images preceded the cinema, found a new home on television, and began to fill the online space as soon as capacities allowed. Today, most of us carry a cinema in our pocket. And film has always taken countless forms, performed many different functions and (intentionally or not) elicited numerous effects. From the start, films have entertained, informed and educated, but also provoked, disturbed, challenged, experimented, aroused, recorded, reported, promoted, sold, persuaded and deceived.

This dizzying variety is an enduring feature of film, linking its present to its past and its future. Digital technology has transformed the ways moving images are produced, distributed and consumed, and the volume of screen 'content' has skyrocketed. But while almost none has ever seen a strip of celluloid, today's 'films' – be they features or television programmes, adverts or pop videos, gallery installations or TikToks – share a common ancestor in the first moving images to dazzle 1890s audiences.

As studios and broadcasters mine their back catalogues and public archives – who have been conscientiously preserving film heritage for many decades – open up their vaults with mass digitisation initiatives, so much that was previously largely hidden from public view is now available on a device near you. Britain has been in the vanguard of this digitisation revolution. For

example, the BFI's own video-on-demand platform, BFI Player, now boasts some 15,000 films. The borders between past and present are collapsing, as are the boundaries between the mainstream and what were once assumed to be niche tastes. Silent newsreels and CGI blockbusters, 19th-century street scenes and 21st-century vlogs: all these and countless more now sit side-by-side on video streaming platforms.

This sudden superabundance demands a redrawing of the boundaries of what film in Britain is, while laying bare just how much remains unmapped. This series strives to explore this territory, telling fresh stories, retelling and revitalising familiar ones in the light of new discoveries and shining a light on overlooked or undervalued sectors, traditions and genres of British filmmaking.

The third book in this series, Scott Anthony's *The Story of British Propaganda Film* is the first to focus on film function. Propaganda is usually understood as one of the political 'dark arts', associated particularly with manipulating public opinion at home and abroad during times of war. But, crucially, this book redraws the boundaries of propaganda film, embracing both specialist content such as colonial films and international Expos, and blockbuster feature franchises from James Bond to Paddington.

The book shows how film has worked, directly and indirectly, as an instrument of British hard and, more often, 'soft power'. It illuminates the complex relationship between Britain's moving image industries and the State, as well as the nation's fluctuating sense of itself and its changing role in an increasingly complex world.

Scott Anthony has been an academic, a journalist and a civil servant, and has written widely on film, public relations and media communications. He is uniquely qualified to draw together the many strands of this compelling and topical story.

Mark Duguid & Patrick Russell

INTRODUCTION: THE THREE AGES OF THE PROPAGANDA FILM

All art is propaganda,' wrote George Orwell, 'but not all propaganda is art.'[1] Something similar can be said of film. Film has continually shaped new forms of propaganda, while evolving practices of propaganda have changed film.

Orwell's expansive notion of propaganda, a notion that animates this book, is at odds with how we generally think about the subject. We tend to think of propaganda in the abstract as something like bias, or as an attempt to deceive by providing misleading or incomplete information. Historically, the origins of the term lie in the Catholic Church's response to the advance of Protestantism, although the modern usage of propaganda is still mainly informed by the political and military calamities of the early 20th century.

The rise of the propaganda film was just one of the long-term consequences of the First World War. Fought between alliances of roughly equal power, the war necessitated the mobilisation of the entire populace. While Britain's military leadership had initially prevented filmmakers from working at the front, by the end of the war the *War Office Official Topical Budget* newsreel had become an established vehicle of government propaganda.[2] Over the course of the conflict, as the focus of state attention shifted from elite groups to popular audiences, propaganda became an important instrument of control and coordination. Public morale mattered; fighting could not be left only to soldiers.

Broadly, this explains why, when we imagine film 'propaganda', our attention tends to focus on a relatively brief period after the First World War. This is the period when the canonical landmarks of film propaganda took shape.

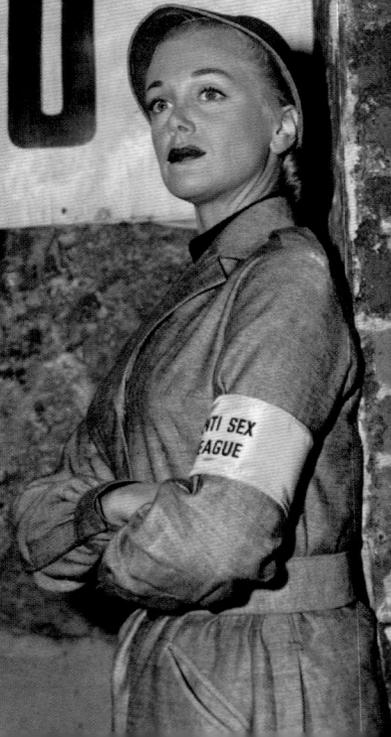

As formal and technological innovations in newsreels, documentary and fiction films laid the foundations for cinema's rise to global pre-eminence, Nazi Germany gave the world Leni Riefenstahl, while the Soviet Union offered Sergei Eisenstein, Vesvolod Pudovkin and Dziga Vertov. Less heralded but equally significant, at around the same time, Britain developed its own unique approach to film propaganda.

In response to a series of national crises in the 1930s and 40s, government, civil servants and filmmakers aimed a barrage of film propaganda at the populace. Residual belief in the 'propaganda of facts' encouraged government experiments in documentary film. For example, the work of state sponsored filmmakers at the GPO Film Unit (1933–39) balanced visions of startling technological progress with portraits of social harmony and growing prosperity. This 'heroic' phase of the propaganda film, which forms the first section of the book, reached its fullest expression during the Second World War, when figures from Alexander Korda and Michael Balcon to Humphrey Jennings and Powell & Pressburger were enlisted in the battle against totalitarianism. This was propaganda as vanguardism: artists, intellectuals and activists utilising media technology to create cross-class enthusiasm for an idea of Britain as a modern democratic state.

The book's second section deals with the heyday of what might be termed 'the cultural era' of the propaganda film. From the fashion of Mary Quant to the terraces of White Hart Lane football stadium via David Bowie and Monty Python, during the cultural Cold War British propagandists attempted to promote a distinctive brand of news, culture and mass entertainment to a global audience. In this period, from the end of World War II to the fall of Soviet Russia, propagandists were often less involved in the production of propaganda than its packaging; their focus was often on the publishing, distributing and political framing of pre-existing popular works. The writings of George Orwell provide us with the example *par excellence* of this phenomenon. Orwell was an anti-Stalinist socialist whose work has been appropriated by (among many others) British intelligence operatives, American McCarthyites and 21st-century populists.[3]

OPPOSITE: *1984* (Michael Anderson, 1956).

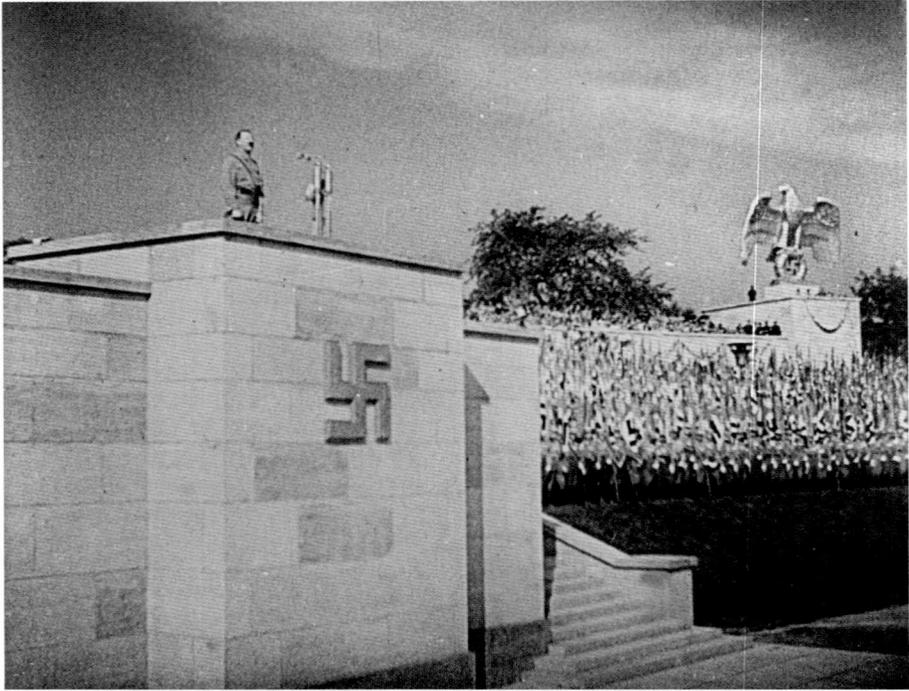

Triumph des Willens (*Triumph of the Will*, Leni Riefenstahl, Germany, 1935).

Whereas the 'heroic' phase of propaganda arose in response to the rise of mass politics, 'the cultural era' advanced with the development of a self-consciously inclusive, pluralistic managed democracy. Furthermore, the reconfiguration of the 'heroic' propaganda film into the 'cultural' piggy-backed the development of Britain's mass education system. This was an era defined by the revolutionary expansion of the national education system that followed the passing of the Butler Act in 1944. In its wake followed a number of propaganda films about education as schools, universities and publishing companies became foundational to promoting a new role for Britain in the postwar world.[4]

New approaches to learning were also encouraged by the imperatives of the Cold War. The transformation of British education underpinned wider cultural shifts that promoted the qualities of scepticism, openness

and self-realisation, partly because they served as useful shorthand for underlining the differences between the Communist bloc and 'the West'. At the same time, while directive political propaganda became imbued with negative connotations, the economic and cultural propaganda produced by Britain's blossoming advertising industries began to acquire a degree of respectability. Aesthetic and rhetorical norms from advertising consequently seeped into British cinema, as figures such as David Puttnam, Ridley Scott and Hugh Hudson moved from making film and television commercials to feature films.

If the first part of this book deals with forms of propaganda strongly influenced by the avant-garde and experimental film, as well as by competing political ideologies, in the second part the practice of propaganda is dominated by television, personal biographies and the belief that the ends of popular culture and new technologies of mass communication are inherently emancipatory. Propaganda film became less about propounding alternative political visions than embedding shared behavioural norms, values and

Броненосец «Потёмкин» (*Battleship Potemkin*, Sergei Eisenstein, USSR, 1925).

London Line Colour Series 1 Issue 1 (Central Office of Information, 1966).

practices. The British propaganda film was born out of a modernism that saw itself shaping a new kind of national democracy, but during the cultural Cold War it began to morph into a postmodernism that understood itself as a product of democracy.

Tracing the development of the propaganda film not only demands that we pay attention to the development of mass democracy, the rapid growth of the state and the reshaping of everyday life by new technologies. The British propaganda film also needs to be understood as the product of a changing political economy.

In Eric Hobsbawm's history of the 'short 20th century', the period between the end of the Second World War and the successive economic crises of the mid-1970s is described as 'a golden age.' [5] In Britain and much of Western Europe the notion that the decades that immediately followed the war were an extraordinary period of prosperity and freedom is now well established. However, this idea of 'a golden age' only really stands up if you

exclude the postwar experiences of China and much of East and South East Asia. That is to say, if you exclude the majority of the people on the planet. Hobsbawn's 'golden age' included Pol Pot, the Vietnam War and the Cultural Revolution alongside a range British military and diplomatic interventions (including propaganda operations) aimed at fighting off any challenges that appeared to endanger the balance of the Cold War. In short, we should be wary of simply assuming that the world of 'cultural' propaganda was relatively benign.

Even at the time, many Western intellectuals were sceptical about how far the postwar period marked the attainment of lasting democratic empowerment. In a series of mid-century books, Jacques Ellul, a French scholar of propaganda, argued that modern society had been captured by the logic of the machine (which he called 'technique'), setting in chain a kind of collectivist technological reordering of society that worked against individual human autonomy.[6] In the postwar period, according to Ellul, propaganda was no longer about advancing discreet goals. Instead of agitating for the workers of the world to unite (for example), propaganda's new role was to soothe the social, physiological and psychological stress and dislocation caused by the perpetual reordering of the human environment.[7] Perhaps most interestingly, whereas scholars of propaganda in its heroic phase focused on the manipulability of 'the masses', Ellul saw the growth of propaganda as a response to the emotional anxieties, needs and desires of an emerging postindustrial middle class. He saw the expanding reach and creeping normalisation of propaganda during the postwar period as a sinister and insidious development.

Officially the role of state 'propaganda' after 1945 was to provide a buffer between the party in government, the populace and the commercial media. Because this was a model of 'information' analogous to postwar understandings of economics, with limited government intervention understood as offering insurance against the resurgence of inter-war extremism, I have previously characterised state propaganda during this period as representing a type of 'cultural Keynesianism'.[8] The role of propaganda in this era was to ameliorate, defuse and explain away social conflict. Whether it was the emergence of a more ideological politics that followed the election of Margaret Thatcher in 1979, the collapse of the Soviet Union

roughly a decade later or the rise of audiovisual and then digital technologies, by the turn of the 21st century the era of cultural Keynesianism was over, and the assumptions, form and format of the propaganda film were transformed again.[9]

In Britain, the 7/7 bombings of 2005 eventually led to the creation of a new generation of propaganda organisations such as the Research, Information and Communications Unit (RICU), the Counter Disinformation Unit (CDU) at the Cabinet Office, and the army's 77th Brigade.[10] Alongside censorship, counter-radicalisation and surveillance programmes, these organisations have produced film and video content that has tried to both reconfigure a more assertive idea of Britishness and undermine the appeal of militant Islamist groups such as ISIS. What is striking about these operations is that they blur domestic and international audiences; geographical borders now mattered less to the British propaganda film than managing the extended religious, racial and cultural affiliations of the populace. In the 'heroic' era, there is an argument that propaganda created the media sacrament of modern national politics; the work of RICU is propaganda aimed at a post-secular and post-national world.[11]

The rise of this new era of propaganda film has also been informed by the emergence of concepts such as asymmetric warfare. According to this analysis of the contemporary world, since the collapse of the Soviet Union the threat to Britain and its Western allies no longer comes from direct engagement with large standing armies, but instead from the wider adoption of tactics previously associated with groups tightly bound together by religion, ideology or historical grievance. For groups like ISIS, Hezbollah or the Moro Islamic Liberation Front, propaganda film has become an extremely cost-effective weapon.[12] ISIS, for instance, have been able to create effective internet memes as well as social media films. By making use of platforms such as YouTube they have been able to communicate with a reach and apparent effectiveness out of all proportion to their fighting capabilities. Through their Al-Hayat Media Center ISIS has even distributed self-produced documentaries such as *The Flames of War* (2014).[13]

While these groups had no choice but to fight 'asymmetrically' through psychological, economic and technological sabotage, the global dominance of the American military means that rival state actors have now also begun

to adopt these methods. This is especially true of countries who resist or reject aspects of the current global order, such as Russia, Iran and China, which they understand as dominated by American imperatives. In the 21st century, according to British military strategists such as Emile Simpson, war has become politics and politics has become war.[14]

In 2012, the British government abolished the COI, which had been Britain's major postwar propaganda agency. It had produced widely respected, high-impact postwar works such as Academy Award-winning *Daybreak in Udi* (1949), *Atomic Achievement* (1956), and *Return to Life* (1960). It had also underwritten the expansion of the private advertising industry through partnerships with firms like Saatchi & Saatchi, and it had helped pioneer important experiments in audiovisual installations. While justified as a cost-saving modernisation, the scrapping of the COI led to an exponential increase in spending on government propaganda.

In a world awash with digital images, even films narrowly and self-consciously created as propaganda will for the most part be encountered indirectly, if not aggregated and discovered indirectly in informational contexts quite different from those which shaped their creation. This development presents a considerable challenge to propagandists. With the steady democratisation of filmmaking tools, the propaganda film has been increasingly able to float free from the intentions of its creators. Whereas propaganda used to be understood as an activity that advanced a particular set of interests, it has now become ferociously difficult to delineate, analyse and understand. Purpose now seems inadequate as an explanatory lens. We live in a world where films can easily become propaganda whether they were intended to be or not.

This explains why, since the COI was disbanded, impatient politicians, behavioural psychologists and media evangelists have instead embraced the idea of 'digital choice architecture' as the ethos of the propaganda film has moved away from public information and towards something closer to state direction. While the standalone propaganda film continues to exist, the majority of visual propaganda is now disseminated through short videos, clips and memes. The propaganda film has become part of a larger media toolbox focused on achieving specific behavioural changes, rather than a vehicle for articulating new understandings of the world.

Daybreak in Udi (Terry Bishop, Colonial Film Unit, 1949).

By 2020, although partly engendered by the response to COVID-19, the UK government had become the nation's largest advertiser. In retrospect, the abolition of the COI was notable primarily because it signified a profound change in the state's approach to the propaganda film. The constraints on centralised state power that existed during the Cold War were unapologetically being cast off.

This book is not a comprehensive, end-to-end history of the propaganda film – that would be impossible. The practices of film propaganda are both evasive and continually evolving.[15] The modern means of digital media production have impacted the structure of the economy, patterns of work and leisure, and cultural norms of behaviour to such an extent that emotions, attitudes and forms of paid employment have become blurred together. It is difficult to extricate a simple definition of propaganda that can encompass what has become an extremely diffuse set of practices.

By weaving together thematic and chronological stories of important and interesting propagandists, filmmakers and films, this book attempts to respect this complexity and to avoid abstractness, over-simplification or the temptation to collapse labyrinthine and multifaceted histories into comforting moral or political frames. If the first section of the book deals with propaganda films as standalone objects, and the second analyses the broader cultures of the propaganda film, the third section deals with the dissolution of the propaganda film within an all-encompassing digital media environment. It tells the story of how propaganda film has become less about minting new iconographies, ideas and explanatory narratives than reiterating messages, creating emotional reflexes and priming political judgements. In broad strokes, a pedagogical aesthetic has given way to a form of propaganda that prioritises emotional impacts.

Of course, in reality, the story of propaganda does not split neatly into three separate sections. The British government still commissions prestige films, and 'the Blitz spirit', so central to the heroic phase of the British propaganda film, continues to be heavily influential. Equally, the cultural strand that dominated postwar British propaganda has never entirely gone away. David Bowie, graffiti artists and the celebration of liberal attitudes to sexuality are still utilised (for example) by British propaganda films across the Arab world.[16] There are also constants in the story: the production of films about the monarchy, or to mark international expos or global sporting events, have remained staples of British propaganda throughout this period. The British Council still champions prestige film and television.

Nevertheless, the story this book outlines for the most part bears out Ellul's prediction that propaganda would become an endemic feature of a world organised around technological imperatives. Propaganda and propaganda films have become ubiquitous and, rather than committing to eliminating the phenomena, states everywhere now try and train their citizens to spot the misinformation, malinformation and disinformation created by 'bad' propaganda.[17] The only answer to the propaganda film has turned out to be the production of even more propaganda. We no longer live in an age defined by heroic or cultural propaganda; ours is an age of total propaganda.

1 PROPAGANDA FILM AND THE INTERWAR AVANT-GARDE

Everybody knows what propaganda is. Propaganda brought us the Nazis, the Soviet Union and the recruitment posters of the First World War. Google 'propaganda' and you'll also likely bring up images of Chairman Mao, Che Guevara or the (North) Korean People's Army. When we visualise propaganda, we visualise an unstable combination of brute force and political charisma.

Many of these ideas about propaganda have their roots in the First World War. When the conflict began, the British state had turned to authors for inspiration.[1] Initially, writers like Rudyard Kipling, Arthur Conan Doyle, J. M. Barrie, G. K. Chesterton and Thomas Hardy were enlisted to spread pro-British sentiments overseas, but over the course of the war their private networks were gradually replaced by the professional norms of filmmakers and ethnographers.[2]

This wasn't a straight swap – Kipling later advised the Empire Marketing Board on its early experiments with film propaganda – but it presaged what would become a dominant trend.[3] Filmmakers helped create an 'authentic' image of the war: they disseminated visual stereotypes of the conflict that anchored political, social and cultural understandings. Factual film footage provided by the armed services and munitions factories during the war proved enormously popular.[4] One consequence of this was that film became an important frame – perhaps the most important – for assessing reality. The 1916 propaganda film *The Battle of the Somme* (d. Geoffrey Malins and John McDowell) now sits on the UNESCO Memory of the World register.

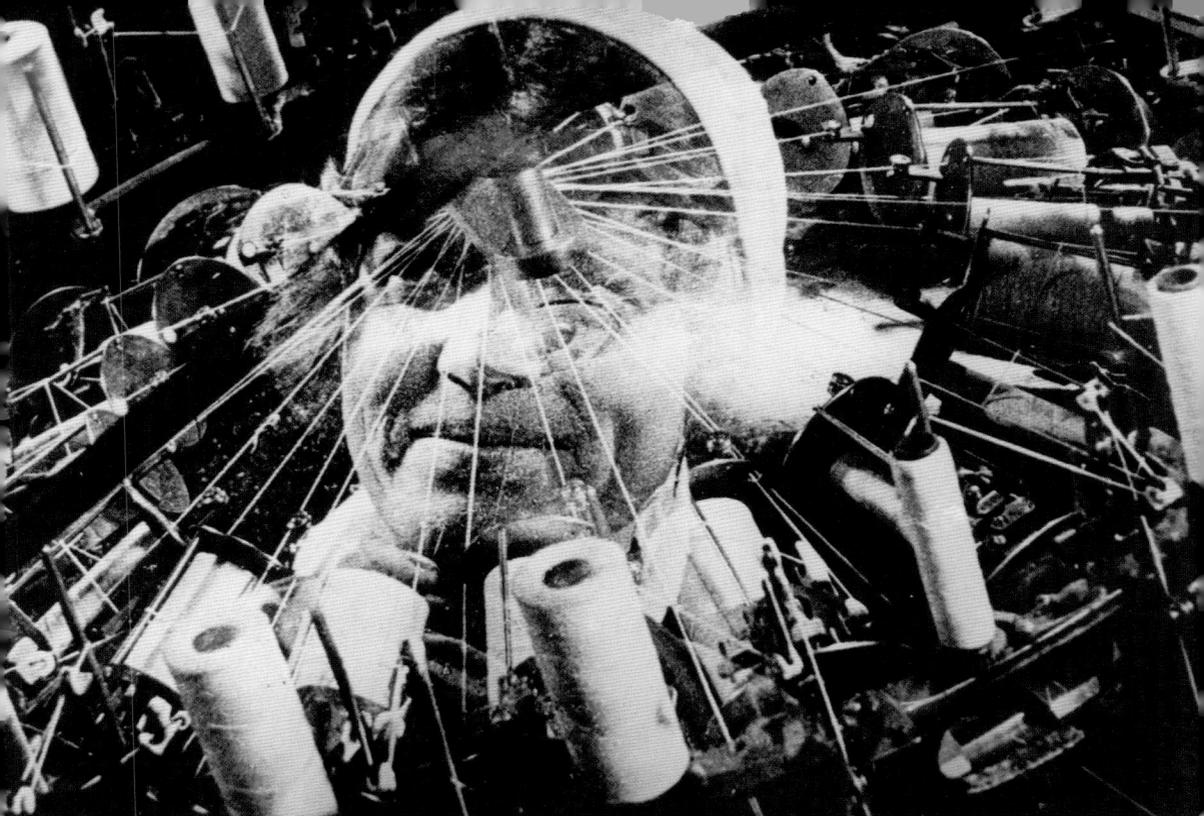

Человек с киноаппаратом (*Man with a Movie Camera*, Dziga Vertov, USSR, 1929).

During wartime it also proved relatively easy for researchers to identify foreign propaganda, isolate it, and then study its workings. Close readings of pamphlets, books and films enabled analysts to understand how audiences were being imagined, understood and targeted. The rhetorical appeals of enemy propaganda were broken down into typologies. Insights for addressing particular audiences were developed. For academics like Harold Lasswell, who pioneered its study, propaganda was a psychological weapon.[5] Propaganda was the name given to the systematic production and distribution of information designed to either weaken the morale of opponents or create new alliances. This was an uncontroversial definition, but also one that quickly began to dissipate during peacetime when there was no easily defined enemy. In practice, this lack of intellectual definition assisted rather than constrained further state experiments in propaganda during the

tumult of the interwar years. The emergence of the propaganda film also reflected important changes in the film industry. During the interwar years British film was struggling to cope with American competition. The First World War had disrupted European film production and Hollywood studios filled the gap. Sound and the invention of 'the talkies' then helped American film establish itself as the bedrock of global cinema.[6] It became a common complaint that Hollywood had turned every cinema in the world into an American embassy. Fearing that an important emerging industry could be destroyed and in an effort to protect a distinctive national cinema, British politicians began to experiment with a range of interventions.

The British government created its first state film unit in 1928. Like many actions with radical consequences, this was an intervention so poorly thought through that what developed could almost be deemed an accident. The film unit established at the Empire Marketing Board (EMB) was one of a series of policy measures that aimed to defend the 'free trade' system from the growing demand for protectionist economic measures. Instead of tariffs on imported goods, then prime minister Stanley Baldwin created the EMB to produce sales propaganda. Through exhibitions, posters, publicity stunts and films, the EMB was directed to encourage citizens across the British Empire to develop more patriotic buying habits. The EMB projected short films advertising Australian Wines onto the concourses of London's major railway stations, while the Arsenal football team, 'question-answering robots' and a Himalayan bear starred in their publicity stunts.[7] Baldwin's political opponents disparaged the Board's efforts as pathetic and absurd.

However, EMB Secretary Sir Stephen Tallents proved to be a far-sighted figure, making important innovations in the theory and practice of cultural propaganda during the Board's seven-year existence. Here he was assisted by the Scottish educator and film theorist John Grierson, who joined the EMB after studying in the US under the political scientist Walter Lippmann in America.[8] Grierson was an evangelist of Soviet cinema who organised screenings of films by Sergei Eisenstein, Alexander Dovzhenko and Vsevolod Pudovkin for civil servants in an effort to illustrate how bold aesthetic experiments could be wedded to national purpose.[9]

Encouraged by Grierson, Tallents embedded artists, filmmakers and writers into scientific research programmes. The nutritionist John Boyd Orr,

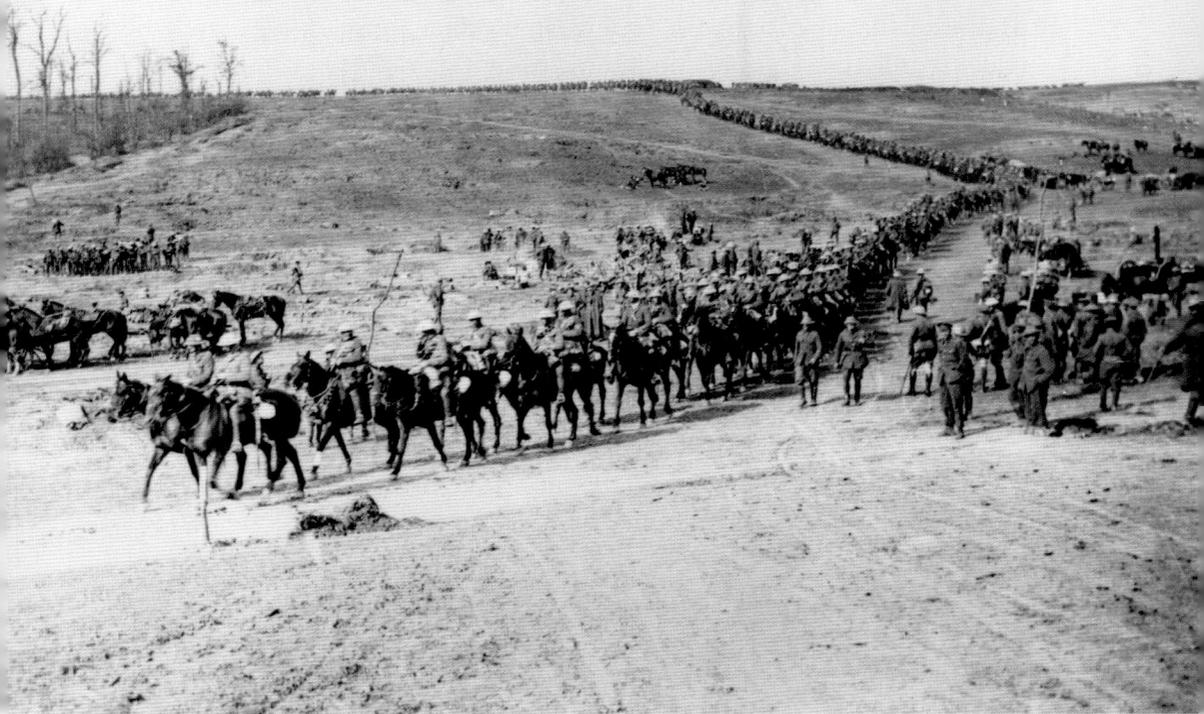

The Battle of the Somme (Geoffrey H. Malins / J. B. McDowell, 1916).

environmentalist George Stapledon and the polymath Julian Huxley were among the important figures whose work was promoted by the EMB's media campaigns. Indeed, the EMB proved a networking organisation par excellence – if nothing else, propaganda reveals the human infrastructure underlaying elite politics – incubating a strand of technocratic, scientific and media activism that would help shape postwar organisations such as the International Monetary Fund, the World Bank and the United Nations Food and Agriculture Organisation. After the war, Grierson became the first Director of Mass Communications and Public Information at UNESCO.[10]

Propaganda was in vogue. During the inter-war years, it became an object of imaginative fascination for artists, because it seemed to crys-

tallise the contradictions of the human condition in a media-dominated age.[11] By exemplifying some of the core preoccupations of modernism, such as the relationship between feelings, individual consciousness and the wider world, the works of the interwar avant-garde often complimented rather than transcended the practices of propaganda. From Dziga Vertov's *Man with a Movie Camera* (Soviet Union, 1929) to Picasso's *Guernica* and the social designs of London Transport under Frank Pick, propaganda gave practical shape to modernist experimentation. Avant-garde documentaries were commissioned as propaganda by the British state because, as Grierson put it, film could 'give a pattern of thought and feeling' to an otherwise senseless world.[12]

Here it is also worth stressing the intellectual influence of Paul Rotha, one of the trainee filmmakers at the EMB. At the age of 23, Rotha published *The Film Till Now* (1930), the first English-language history of cinema.[13] According to Rotha, film was a nationally distinct art form, like fine art or literature. He saw state patronage as necessary for the development of a

The Voice of Britain (GPO Film Unit, 1935).

Night Mail (Harry Watt / Basil Wright, GPO Film Unit, 1936).

distinctive British 'art cinema'. His book laid the intellectual grounding for the propaganda film to become one of Britain's outstanding contributions to global cinema.[14]

In 1933 the Empire Marketing Board was disbanded and its film unit transferred to the General Post Office (GPO). Cinematic techniques that had been addressed to the problems of scientific and economic cooperation across the Empire and Commonwealth were now put to work in the service of more tangible national ends. The GPO Film Unit would become the training hub of a new generation of directors, technicians and writers that would come of age during the Second World War and shape the direction of British film (not just the propaganda film) for years to come.

Swinging the Lambeth Walk (Len Lye / TIDA Film Unit, 1939).

In the same year, Tallents published *The Projection of England*, a pamphlet setting out the social necessity of creating new icons of British modernity able to create imaginative links between the personal, the institutional and the national.[15] In a period otherwise dominated by political authoritarianism, one of the hallmarks of Tallents' approach to propaganda was that it worked through trade unions, women's institutes and professional societies – a strategy reflecting Tallents' belief that media activism could only be effective if it collated and amplified existing strands of civic activism.

We can see this impulse in many of the canonical films produced by the GPO Film Unit, including *BBC – The Voice of Britain* (1935), *Night Mail* (1936) and *North Sea* (1938). It is no accident that these films were launched alongside popular innovations such as Sir Giles Gilbert Scott's telephone kiosk, the talking clock and the '999' service. Nor that so many icons of British modernity, from Harry Beck's tube map to the Routemaster bus, were created at the same time.[16] The wider goal of the GPO Film Unit was to build the media landmarks of a new democratic age. GPO films such as *Night Mail* became

cornerstones of Britain's contributions to international events such as the New York World Fair of 1939, while Tallents' ethos has remained visibly influential (for example) on events like the 2012 Cultural Olympiad.

This was not just a nativist project. The GPO Film Unit was an internationalist enterprise. It was indebted to the expertise of filmmakers like the Brazilian Alberto Cavalcanti, as well as an interesting array of artists, intellectuals and filmmakers such as Lazlo Maholy-Nagy, Len Lye and Lotte Reiniger, fleeing Europe or in transit to the USA. Tallents understood that the successful projection of Britain depended on international collaborations.

Ultimately, the interwar development of the British state's propaganda machinery was both a symptom and a consequence of profound changes in the national political economy. The rise of the British propaganda film is intertwined with the emergence of an interventionalist state. At the same time that liberals such as John Maynard Keynes, William Beveridge and Stephen Tallents began to forge the bureaucratic machinery necessary to operationalise limited 'liberal' state interventions in economics, society and culture, conservatives like Harold Macmillan began to accept the need for a degree of centralised planning and state intervention in order to stave off the threat of totalitarianism.[17] One of the key postwar missions of British propaganda would be to film this new political consensus into existence.

Close-up: So This is Britain

Over the past ten years the pursuit of 'screen tourism' – instrumentalising film production to attract large numbers of overseas visitors – has become fashionable among policy makers. The popularity of the *Harry Potter* films, so the argument goes, increased the number of visitors to Alnwick Castle (Hogwarts). But while the jargon is new, the idea is an old one.

From the early 1930s, the Travel and Industrial Development Association (TIDA) began to commission, produce and distribute films to encourage tourism. While high profile figures such as Winston Churchill, Lord Waldorf Astor and Gordon Selfridge were noisy advocates of the cause, and TIDA opened offices in in Buenos Aires, Paris, and New York, the venture was mainly funded by local authorities hoping to attract business during the Great Depression.

Bold claims were made for TIDA films like *So This is London* (1933), *So This is Lancashire* (1935) and *Key to Scotland* (1935). According to TIDA, *So This is London* was seen by more than 400,000 people in Sweden alone. While the network of international distribution appears to have been impressive, it's extremely difficult to work out how these films were perceived by overseas audiences and what their effect was.

Stylistically, TIDAs films were of a piece with those of the EMB. This was no coincidence. The TIDA film unit was run by Marion Grierson, sister of the EMB's John. TIDA outsourced much of its production to the Strand Film Company, an important employer of Paul Rotha that also happened to be run by Marion's husband, Donald Taylor. Typical TIDA titles like *The English Potter* and *Glassmakers of England* (both 1932) foregrounded the kinds of values and aesthetic sensibilities praised by Stephen Tallents. TIDA was supposed to be playing to the preconceptions of foreign visitors, but its propaganda also reflected the values of a particular section of the British establishment.

With the growth of the British Council in the 1930s, TIDA's function began to pivot away from tourism and investment and towards the wider practice of cultural diplomacy. Alongside the GPO Film Unit and the British Film Institute, TIDA and the British Council would be responsible for programming major overseas events such as the New York World's Fair of 1939.

So This is London (TIDA Film Unit, 1933).

War saw the TIDA Film Unit swallowed up by the British Council, although its name lived on in America 'to avoid the British Council being accused of distrib-uting films of a political or belligerent nature.' Its role was taken up after the war by the Travel Association, which used newsreels and other films to market events such as the London Olympics of 1948, the Festival of Britain and the Coronation of Queen Elizabeth II to US audiences.

While TIDA's early films continued to have an important afterlife as a staple of the British Council's English language classes, the Travel Association was ultimately replaced by the British Tourist Authority (now VisitBritain). TIDA's approach to propaganda would be supplemented and eventually dominated by a more direc-tive approach to advertising. Tourism was no longer supporting industry; it had become an industry in its own right.

2. PROPAGANDA FILM AND THE SECOND WORLD WAR

On 19 March 1940 Britain's military leaders sat down to a private screening of *Film as a Weapon*. It was a film show that reflected the growing frustration of Britain's propagandists. 'The Nazis have four fighting services – Land, sea, air and PROPAGANDA', its titles ran, 'Propaganda has paved the way for many German victories.'[1]

Trailed by opinion pieces placed in *The Daily Express* and *The Evening Standard*, the screening of *Film as a Weapon* was part of a sustained lobbying effort by Sidney Bernstein and Jack Beddington, both prominent figures in energising British film propaganda during the war. Bernstein was a cinephile who had built up the Granada chain of cinemas in the 1930s, while Beddington made his name as a far-sighted patron of art and film while publicity manager at Shell.[2] When the Ministry of Information (MoI) was created in 1939, the pair had been seconded into the Civil Service to help promote the utility of film propaganda to a sceptical Whitehall. 'By press, radio and film the legend of dictatorship was established,' they argued, 'press, radio and film can help our armed forces to kill that legend and reassert the lesson of democracy.'

The MoI had made *Film as a Weapon* by clipping together propaganda footage from fascist countries. It was designed to illustrate why international newsreels had come to rely so heavily on film provided by Nazi Germany. By using multiple cameras, German cameramen generated (from a news editor's perspective) irresistibly dramatic footage of dogfights. The film also showed how embedding cameras at political events, such as a cere-

Desert Victory (Roy Boulting, Army Film Unit, 1943).

mony of friendship between Nazi Germany and Vichy France, allowed them to be staged for maximum visual effect.[3]

Film as a Weapon was an attempt to challenge the general suspicion of film among the armed forces. Bernstein and Beddington wanted to challenge the conventional wisdom that without tangible victories on the battlefield, worthwhile propaganda was impossible. They argued that film propaganda was not just about driving home victories; it also played an important role in generating a sense of momentum. If newsreels continued to rely on Nazi footage, the propagandists' argument went, then Britain's adversaries would continue to frame the response of global audiences to the war.

British intelligence added their own, shriller assessments, warning that screenings of *Feuertaufe* (*Baptism of Fire*, 1939), a German film that showed Nazi forces brutally laying waste to Poland, had helped build

support for neutrality among diplomats, businessmen and politicians in Spain and Sweden.[4]

Whether or not Bernstein and Beddington were successful in altering the military's attitude to film propaganda, a lack of capacity would ensure that propaganda campaigns remained primarily a bureaucratic rather than military initiative. On the outbreak of war, Britain's military, unlike France's or Germany's, did not employ a single cameraman.

When the military finally began to recruit filmmakers, they tended to be drawn from civilian life rather than the film industry. Since the Sudan campaign of 1899, there had been profitable films about war. Indeed, the British state began endorsing 'official' films after the outbreak of the First World War because military leaders believed that during the Boer War public attitudes had been overly shaped by 'fake' films. Well into the mid-century, Britain's military leaders considered the film industry disreputable, dishonest and obsessed only with money.[5]

Instead, from 1940, inexperienced young recruits (mostly under 30) began to be funnelled into the newly established Army and RAF Film Production Units. Their training consisted of the basics of film grammar (long shot – medium shot – close-up) as well as camouflage skills: concealment was a key skill because in battle cameramen were actively targeted. One aesthetic consequence of this was that the long, low-angle shot from below became a staple of the military film units' work.[6]

Ultimately, as Britain's fortunes improved, the status of the Army and RAF Film Production Units rose with them. To an extent Britain's military leaders had been proven correct: success on the battlefield begat the triumph of the British propaganda film. *Desert Victory* (1943), which documented Field Marshal Bernard Montgomery's struggle against General Erwin Rommel in North Africa, became an instant classic.[7] Churchill sent copies of the film to Roosevelt, Stalin and the prime ministers of Australia, New Zealand, and South Africa.[8]

During the push for victory, British and American military film units collaborated on *The True Glory* (1945), a monumental record of the Allied offensive in Western Europe. The joint propaganda project was meant to reflect a joint military effort, but the film's production was dogged by bad-tempered arguments over the relative size and importance of America

The True Glory (Carol Reed / Garson Kanin, UK/US, 1945).

and Britain's contributions to the war.[9] While the internal politics killed off the Joint Anglo-American Film Planning Committee's hope for future collaboration, *The True Glory* bolstered the reputation of British director Carol Reed and won the Academy Award for best documentary in 1946.

The long-term impact of the military film units' work on the memory of the war is incalculable. Although the Army Film Unit was poorly equipped in comparison to their American and German peers – producing only black and white footage – its work has proved of continued utility.[10] From extraordinary scenes of the Blitz shot from the roof of St Paul's Cathedral to the liberation of Belsen concentration camp, footage captured by AFU cameramen has become a staple of newsreel, documentary and feature films.

More immediately, the Army and RAF Film Production Units also provided a pathway into the postwar commercial film industry. Among its most successful alumni were the Boulting brothers, who, having developed their careers through the war with films such as *Desert Victory* (Roy Boulting, 1943), went on to produce notable films such as *Brighton Rock* (1947), *Lucky Jim* (1957) and *I'm Alright Jack* (1959).[11] The Second World War became an audio-visual media phenomenon. In addition to developing the military's capacity to produce film, the British state would scale up its own film production unit and collaborate with independent producers, established commercial inter-ests and international film moguls.[12] The collective scale of these initiatives reflected the enormous amounts of imaginative labour required to nurse the country through the conflict.

The experience of the Second World War remains foundational to the national self-image. Historians have argued both that Britain was democ-ratised and modernised by the experience of the war, and also that Britain was bankrupted and ultimately broken by it.[13] One of the reasons it can be so difficult to thoughtfully weigh these radically competing sentiments is because of the ubiquity of the propaganda film. Winning the war entailed creating a series of extremely powerful myths about Britain's role in the world that continue to reverberate around the Anglosphere today.

Unlike his generals, Winston Churchill loved film. Indeed, with the possible exception of Harold Wilson, Churchill was the only British Prime Minister of the 20th century with a deep affection for the cinema. While contempo-raries often wrote him off as a patrician relic of Britain's past, unlike many of his peers he grasped the necessity of propaganda. While he could be moved to suppress and censor unflattering 'news', he also understood the power of cinema to create imaginary alternative worlds, and so placed political confidants such as Duff Cooper and Brendan Bracken at the head of the newly-formed Ministry of Information.[14]

Hitler had his bunker; Churchill had a private cinema. Early in the conflict, two projectionists were seconded to Churchill's residence at Ditchley Park. Summoned to organise screenings at any time of day or night, they soon began to complain about their working hours.[15] While monitoring the progress of the war, Churchill spent hours cheering, shouting and sobbing in front of the silver screen. Patriotic melodrama was his preferred mode;

he responded to intensity and apparently disliked any sort of self-reflective, cinematic interiority. He never managed to sit through *Citizen Kane* (US, 1941). This love of cinema enabled Churchill to create an emotional connection with people around the world that entirely evaded many of his more 'modern' colleagues. With a startling emotional openness, he identified himself with mythologised figures of Britain's past, writing his own political life against theirs.[16]

His friendship with the Hungarian film producer Alexander Korda is key to understanding his relationship with film.[17] During the interwar years Korda had become famous for producing – and sometimes directing – popular films that celebrated episodes from the history of Britain and its Empire. Films such as his own *The Private Life of Henry VIII* (1933), *Fire Over England* (d. William K. Howard, 1937) and *The Four Feathers* (d. Zoltan Korda, 1939) portrayed the British as an embattled but honourable and ultimately triumphant people, a cinematic stereotype that would be consciously built upon by propagandists during the war.[18] Churchill's admiration of Korda was cemented when the film impresario paid him large sums of money to produce two unfilmed screenplays: it was a transaction that mixed clientelism, imaginative sympathy and political activism.

Intriguingly, Churchill and Korda's propaganda operation had preceded the start of the Second World War. Opposition to Nazism had drawn both into a network of anti-appeasement activists centred around the diplomat Robert Vansittart.[19] Korda's connections throughout the European film industry were used to place freelance intelligence officers throughout the continent and feed information about Nazi Germany back to the UK. When in 1933 Charles Laughton's Henry VIII bemoaned, 'this little island is no match for all of Europe' and counselled that all a king can do is 'build ships, ships and more ships', he was echoing the call for national rearmament of the so-called 'Vansittart Detective Agency'.

While these early films were addressed to 'the free world', the fall of France in 1940 led to Britain refocus its film propaganda on the USA.[20] Korda was dispatched to America, and British stars such as David Niven and Laurence Olivier, as well as Alfred Hitchcock, were encouraged to stay in Hollywood and cautiously advance the British cause.[21] Apparently with his own money, and at Churchill's personal request, Korda set up offices in New York and

Los Angeles which also doubled as clearing houses for British intelligence. Winning over the American public had become an issue of national survival.

Lady Hamilton, aka *That Hamilton Woman* (1941), a melodrama based on the life of Nelson's mistress, provides a powerful example of Churchill and Korda's friendship in action. To circumnavigate censors, the film made strategic use of historical parallels, albeit far from subtle ones. When Nelson warned his admirals, 'believe me, gentlemen, he wants to be master of the world. You cannot make peace with dictators. You have to destroy them,' he is clearly describing Hitler at least as much as Napoleon. Churchill watched the film at least nine times, according to records at the Imperial War Museum.[22] He burst into tears while watching the film with President Roosevelt aboard the HMS Prince of Wales. This level of emotional engagement perhaps supports the claim that Churchill himself may have written Nelson's dialogue.[23]

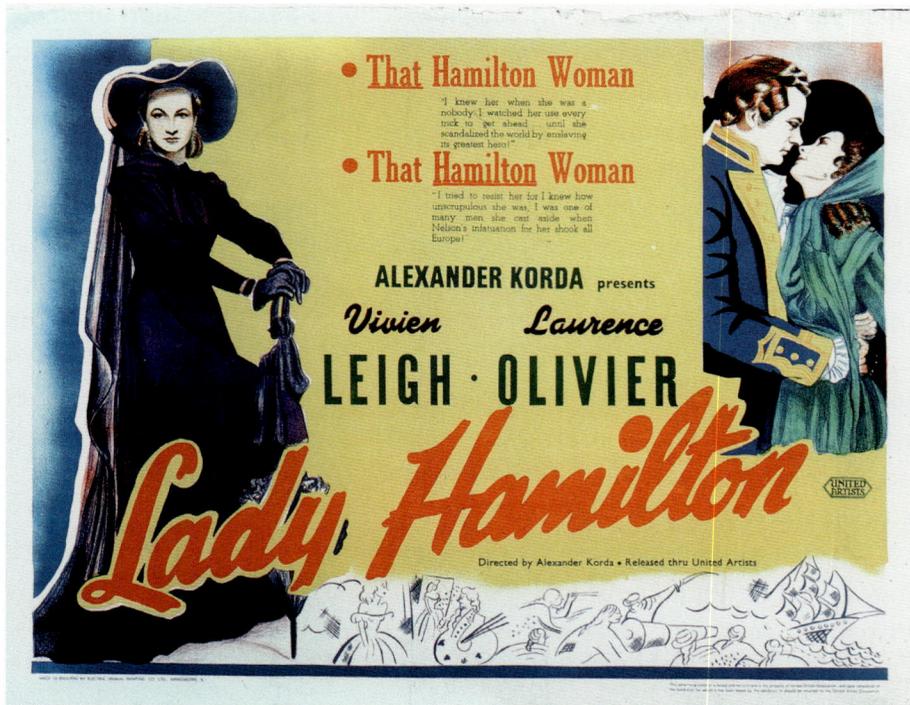

Lady Hamilton, aka *That Hamilton Woman* (Alexander Korda, 1941).

British influence in the US film industry, along with the individual initiative of left-wing Hollywood screenwriters, saw the production of a range of popular films with anti-Nazi messages. Cumulatively, films such as Chaplin's *The Great Dictator* (1940), *The Mortal Storm* (Frank Borzage, 1941; co-produced by Britain's Victor Saville) and the melodrama *Mrs Miniver* (William Wyler, 1942) helped build a sense of inevitability to America's entry into the war. Indeed, isolationist American politicians saw these films as evidence that Hollywood had been infiltrated by foreign agents, and Korda was saved from deportation only by the Japanese attack on Pearl Harbour. '*Mrs Miniver*,' proclaimed Churchill, 'did more for the Allied cause than a flotilla of battleships.'[24] The film won the Oscar for best picture in 1942. Beyond Korda, private propaganda initiatives shaped commercial British cinema in a variety of ways. While lacking Korda's political connections, Michael Balcon's Ealing Studios made important contributions to the national propaganda effort. Disappointed with the early wartime performance of the MoI, Ealing worked directly with individual government departments to produce a series of propaganda shorts, satires and stories for audiences at home and overseas.

While Ealing's early efforts were poorly received – criticised for their poor dialogue, cheap jokes and facetiousness – the studio began to develop a house style that would prove foundational to its postwar success. Substantial filmmakers like Charles Crichton, Charles Frend and Robert Hamer developed their skills on Ealing's propaganda shorts, guided by former GPO Film Unit stalwart Alberto Cavalcanti, and carried their influence into the studio's wartime features.[25] Notable works included *San Demetrio, London* (Frend, 1943) and *For Those in Peril* (Crichton, 1944), which married from-the-headlines stories with a stress on collective courage that aligned Ealing with 'people's war' sentiments. The low-key naturalism that informs Ealing's successful postwar films such as *It Always Rains on Sunday* (Hamer, 1947) and *The Blue Lamp* (Basil Dearden, 1950) is a legacy of this work. Successful propaganda takes what already exists and crystalises and amplifies it: not only did wartime propaganda turn Churchill into 'Churchill', it played an important role in establishing Ealing Studios as 'Ealing'.

There is a stark contrast between the impatience of Churchill and Korda's personal initiatives and the Ministry of Information's response to the challenge of the propaganda film.[26] The first director of the films division, Sir

Joseph Ball, focused his attention on newsreels and commercial advertisers. Reflecting his background in intelligence, Ball's focus was on the control of information and the suppression of dissent. By the time Bernstein and Beddington had reversed this policy orientation, there was a great deal of ground to be made up.

To lift public morale, politicians and military officials who had previously been sceptical of state involvement in film production swiftly swung behind extraordinary government statements such as 'success consists in being seen by a minimum of something nearer two hundred million people.'[27] In line with the industrial logics demanded by total war, and in imitation of Hollywood studios, the British state facilitated a massive increase in film production.

Yet the British state's involvement in the production of films for the general purpose of 'propaganda' was kept as unobtrusive as possible. Although the government funded and distributed films made in the private sector, the Ministry of Information's support was rarely acknowledged. The long-running ambition (seemingly never realised) was to produce propaganda in Hollywood. By distributing British propaganda through an 'independent' company in America, officials hoped to secure the attention of large global audiences.[28]

The British propaganda film also tended to work in quiet collusion with the commercial film industry. By the end of the war parts of the British propaganda film were already organised along something approaching post-Fordist lines, pointing the way towards approaches that would become more influential as the 20th century progressed and direct state control fell further out of favour.

Ironically, propaganda produced by authoritarian nations was considerably more open in its intentions and amenable to rationale critique than the all-pervasive modes of background propaganda subsidised by the British state. While totalitarian systems boasted about the effectiveness and efficiency of their propaganda films, the British system was scaled up in near silence. Propaganda film in totalitarian countries worked through clear hierarchies, while the British model combined elements of the American studio system with a number of 'contracted out' partnerships.

However, by signing up to the notion that the more blatant propaganda was the less effective it would be, cynical film producers continued

to produce 'genuine entertainment' while benefiting from government subsidy. Perhaps intentionally, this blurring together of political, commercial and cultural imperatives also made it difficult to delineate, let alone assess, the effectiveness or efficiency of the British propaganda film. 'We generally finish up with an old-fashioned thriller incorporating old irrelevant lines of dialogue about freedom, persecution, fascism,' complained one critic, 'or one of the characters will hold up the action while he makes a wordy and self-conscious speech about democracy.'[29]

Yet officials often found managing such cliches preferable to dealing with the unorthodox ambiguities of genuinely patriotic filmmakers. Michael Powell and Emeric Pressburger's *The Life and Death of Colonel Blimp* (1943), based on a popular cartoon strip by David Low, satirised the failures of Britain's political and military leaders.[30] The film's portrayal of a complacent high command clinging to archaic 'gentleman's rules' of warfare made

Mrs. Miniver (William Wyler, US, 1942).

British officials deeply uneasy, and there were calls in the printed news media (supported by Churchill) for it to be banned. Nevertheless, it became a popular commercial success.[31] Over the longer term, and partly thanks to the tireless advocacy of Martin Scorsese, *The Life and Death of Colonel Blimp* has come to be understood as a subtle meditation on the national character and one of the greatest of British films.[32]

For a brief moment during the Second World War, the British state itself also became a major producer of films. Initially, this work had a domestic focus. In 1940, the GPO Film Unit was reconfigured into the Crown Film Unit which immediately began producing a range of 90-second 'poster films' – as well as longer shorts and some feature-length films – recording the impact on the war on everyday life.

Fundamental to this early work was the experience of the 'Blitz', the 1940–41 German bombing campaign of Britain. The capacity of ordinary people to endure aerial bombardment provided both dramatic footage and a compelling story of courage and cross-class unity. The US reporter Quentin Reynolds was invited to contribute commentaries to two emotive Blitz accounts, *London Can Take It!* (1940) and *Christmas Under Fire* (1941) to help solidify the sympathy of American audiences for the suffering of British civilians.

The most famous example of this genre was Humphrey Jennings' *Fires Were Started* (1943), a devastatingly sober portrayal of the human sacrifices made by the fire service. The backdrop of total war ennobled everyday exchanges in the film with a pathos that could be incredibly moving. In Jennings's hands the stressful and particular experiences of war were transformed into something like a parable of the human condition. According to David Thomson, the fires Jennings filmed 'were, like [William] Blake's, a condition of the soul.'[33]

The impact of footage from the Blitz helped ensure that themes of survival and resilience became central to Crown's propaganda. This was partly also because audiences apparently leapt on any sign of nationalistic feeling. 'Such films may cause hot-blooded Italians to leap to their feet crying, "let us sweat and die for our country!",' complained one correspondent to *The Picturegoer and Film Weekly*, 'we don't want to have patriotic heroics blared at us from the screen.'[34] It was bad enough having to live through the reality of the war; there was no pleasure to be had in sitting through lies about it.

The Life and Death of Colonel Blimp (Michael Powell / Emeric Pressburger, 1943).

By resisting military bombast, the Crown Film Unit set a template for future propaganda films that was to prove deeply influential. While the majority of Crown filmmakers saw themselves engaged primarily in recording the reality of Britain at war, over time their work began to shape perceptions of that reality. Propaganda films became an unescapable feature of the war. Like the EMB before it, Crown distributed its films through non-theatrical networks. They were watched communally in army bases, canteens, mobile cinemas and hospitals throughout the Americas, Africa, Asia and Europe. By 1951, Crown claimed that every year its films reached some 100 million people around the world.[35]

The success of *Target for Tonight* (1941), directed by Harry Watt, represented an important staging post in this development.[36] While the first wave

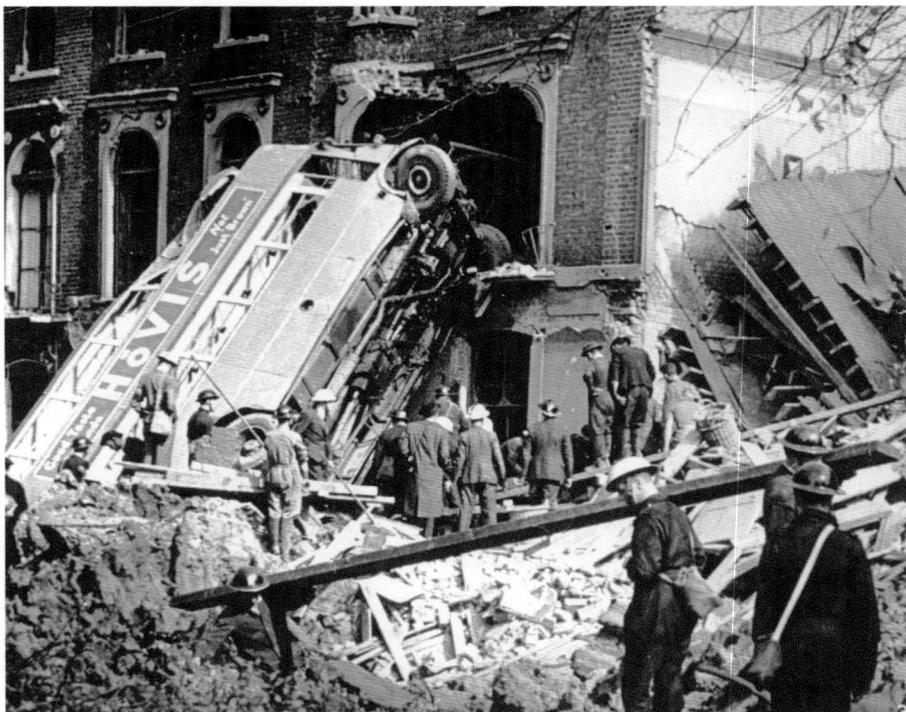

London Can Take It! (Humphrey Jennings, GPO Film Unit, 1940).

of British propaganda had focused on the heroics of everyday resistance, *Target for Tonight* was made at a point in the war when the Allies had begun a sustained counterattack. British civilians had suffered terribly during the German bombing of Britain, and Watt wrote that his film was meant to offer 'a glimmer of hope' – in 'a very British, casual, brave way' – that there would be redress.[37] *Target for Tonight* marked the beginnings of a more aggressive phase of the war, but it remained suffused with the somewhat pessimistic and defensive spirit that characterised the earlier propaganda films. Watt's film is a drama-documentary that follows a single crew from Bomber Command on a night raid to Germany. Although the crew are successful in knocking out an oil refinery, the plane is damaged by anti-aircraft fire and the plane and its injured crew struggle back to Britain in poor weather. Rather than celebrate the destruction of German targets, the film encour-

ages its viewers to will the survival of the flight crew. 'Churchill smoked furiously and was as tense as any film fan when things looked bad for the RAF bomber planes over Germany,' wrote one observer, 'he smiled when the bombs hit their Nazi targets, and he drew a deep breath of relief when the planes returned safely home.'[38]

When the film was released, Lord Beaverbrook, proprietor of *The Daily Express*, was Minister of Aircraft Production. Because it advanced the 'right' picture of Britain's war effort, Beaverbrook used his considerable influence to ensure that *Target for Tonight* was promoted heavily overseas. 'Those responsible for interpreting the British war effort to America and Russia have now another strong card in their hands,' was the matter-of-fact verdict of *The Times*.[39] Understood like this, the documentary aspects of the film, such as the awkward editing and camera placements, could easily be understood as an example of how a realist aesthetic was pulled directly into the service of propaganda.

Christmas Under Fire (Harry Watt, Crown Film Unit, 1941).

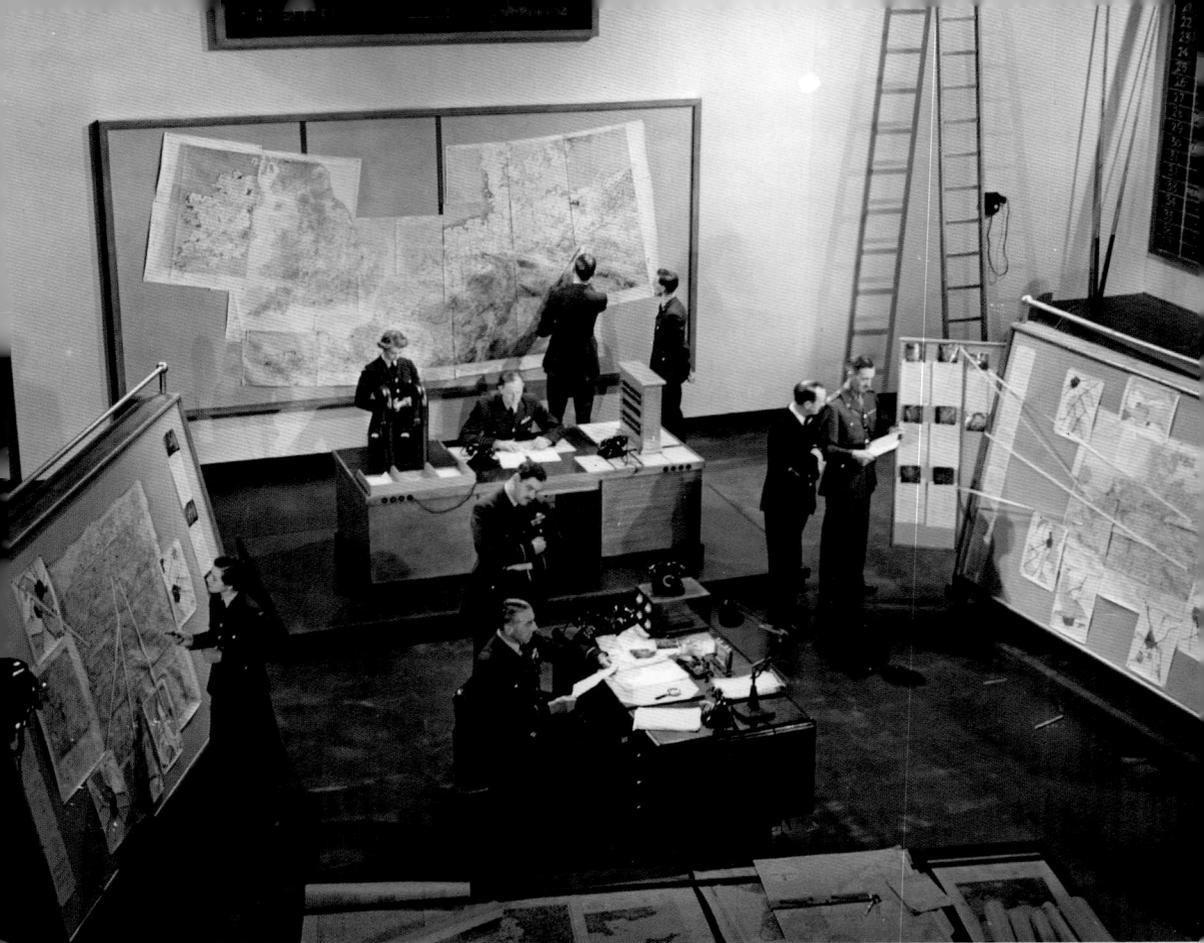

Target for Tonight (Harry Watt, Crown Film Unit, 1941).

For its supporters in the film industry, like Paul Rotha, the success of *Target for Tonight* appeared to herald the maturing of a tradition. While America had built Hollywood, Britain had developed its own brand of documentary cinema that claimed to be more attentive to reality. Yet while Hollywood prospered commercially, British documentary had connections with the avant-garde, a form whose survival depended on its utility as public or corporate propaganda. The commercial success of *Target for Tonight* opened up a pathway to mass paying audiences. Documentary filmmakers like Harry Watt envisaged a future where they could maintain their social commitments while operating in the commercial mainstream.

During the development of the film, Watt had become something akin to 'filmmaker in residence' at Bomber Command, and his film popularised an approach that would be copied by the Air Transport Auxiliary, Coastal Command and the Fire Service among many others. In Watt's eyes he was helping to build a cinema of tribute, where the real heroes of the British war effort would be accorded the respect and fame that their undemonstrative heroism deserved. 'From *Drifters* to *Daybreak in Udi* through *Night Mail*, *North Sea*, *Target for Tonight*, *Fires Were Started*, *Western Approaches* and many others,' wrote Paul Rotha, 'there stemmed a tradition of official filmmaking in the public service that made an incalculable contribution to Britain's prestige overseas.'[40]

With films like *Target for Tonight*, Crown perfected a successful hybrid of realist drama and documentary, creating popular archetypes of character, presentation and story that swiftly transferred into popular postwar commercial filmmaking. Whether made by British companies, or simply utilising British actors, writers and technicians (many of whom would have worked in some way for the Ministry of Information), the war film became one of British cinemas most exported genres. Even as the war itself faded into memory, *The Wooden Horse* (Jack Lee, 1950), *The Cruel Sea* (Charles Frend, 1953), *The Dam Busters* (Michael Anderson, 1955), *The Battle of the River Plate* (Michael Powell and Emeric Pressburger, 1956) and *The Bridge over the River Kwai* (David Lean, 1957) presented an image of Britain and the British character that retains an imaginative hold to this day. The boasts made about the 'authenticity' of the dogfights in Christopher Nolan's *Dunkirk* (2017) are just one element of this much larger cinematic heritage.[41] Arguably it's an idiom that has also proven foundational to the aesthetics of popular first-person shooter videogames such as the long-running *Medal of Honor* (1999–) series.

However, without doubting Watt's sincerity there are other ways to understand *Target for Tonight* and its legacy. Viewers around the world would not have known that the RAF's first 'area bombings' took place before the Blitz had begun, while the British government had been intentionally targeting German civilians since 1940. Churchill justified the 'terror bombing' of German cities on the grounds that it might be a catalyst for regime change.[42] The long-term impact is that barely anyone in Britain understands

the brutality of British bombing campaigns, while folk memories of the Blitz remain firmly embedded in the national consciousness.

Dubbed with American accents and re-edited by Alfred Hitchcock, the film also became a box-office hit in the US after the Japanese attack on Pearl Harbour in December 1941.[43] The US Office of War Information made 100 prints and sold 130 more to meet the public demand for 'hitting back' at the enemy. In *Target for Tonight*, Watt had tried to civilise the elation of being able to 'take it to the enemy' by building a narrative around the desperation for survival. It is a moot point whether Hitchcock's edit shared the same sentiment.

With its films extolling the virtues of an expanding state, and a staff of left-leaning intellectuals, Crown's films are often used to help explain the election of Clement Attlee and the rise of the postwar state. This is reasonable enough as far as it goes. If William Beveridge's nose for publicity was instrumental in the political realisation of the welfare state, we can understand Crown as part of a larger operation of political conscious-raising.[44]

Over the course of the war, the cinematic image of British workers can also be seen to have become increasingly Sovietised. *Workers' Weekend* (1943) celebrated the Stakhanovite commitment of factory workers by following a group voluntarily donating their days off in order to build a Wellington Bomber at record speed (and then donating their overtime to Red Cross Aid for Russia). But by the end of the war Crown's output had been remodelled as it began to produce documentaries about denazification programmes, and the role of the British in the establishment of a new German police force. Increasingly, Crown's films were no longer chronicles of war; rather prompts to further government intervention. Rather than empathising with the relief and emotional fatigue of surviving the war, the films attempted to cajole populaces in Britain and across the Commonwealth to support government initiatives that increased the range and reach of the state. From titles such as the *Patients Are In* (1945), which attempted to reassure Americans that wounded soldiers had access to good medical care in the UK, Crown began to produce films about modernising factory layouts, tackling youth crime and preventing venereal disease. Audiences became increasingly weary.

The reputation of Humphrey Jennings, whose work suffered a rapid collapse in status, is one obvious cinematic barometer of this wider

Cumberland Story (Humphrey Jennings, Crown Film Unit, 1947).

cultural shift. Addressed to a new-born child, Jennings' *A Diary for Timothy* (1945) called for renewed efforts to tackle ill-health, unemployment and the threat of more war. From the perspective of today the film is an incredibly moving portrait of an exhausted population. It offers a glimpse into a world where the prospect of 'victory' has become a source of anxiety. It's a film shot through with the jolting realisation that the losses suffered in wartime may never be meaningfully addressed. While it's generally well-regarded by critics now, the popularity of David Lean's *Brief Encounter* (1945) provided a telling comparison. The two films premiered on the same day, and although there is a degree of emotional sympathy between them, the point of identification is tellingly different. Celia Johnston's confessional reflections on the end of a brief extramarital affair pointed to a very different national mood.

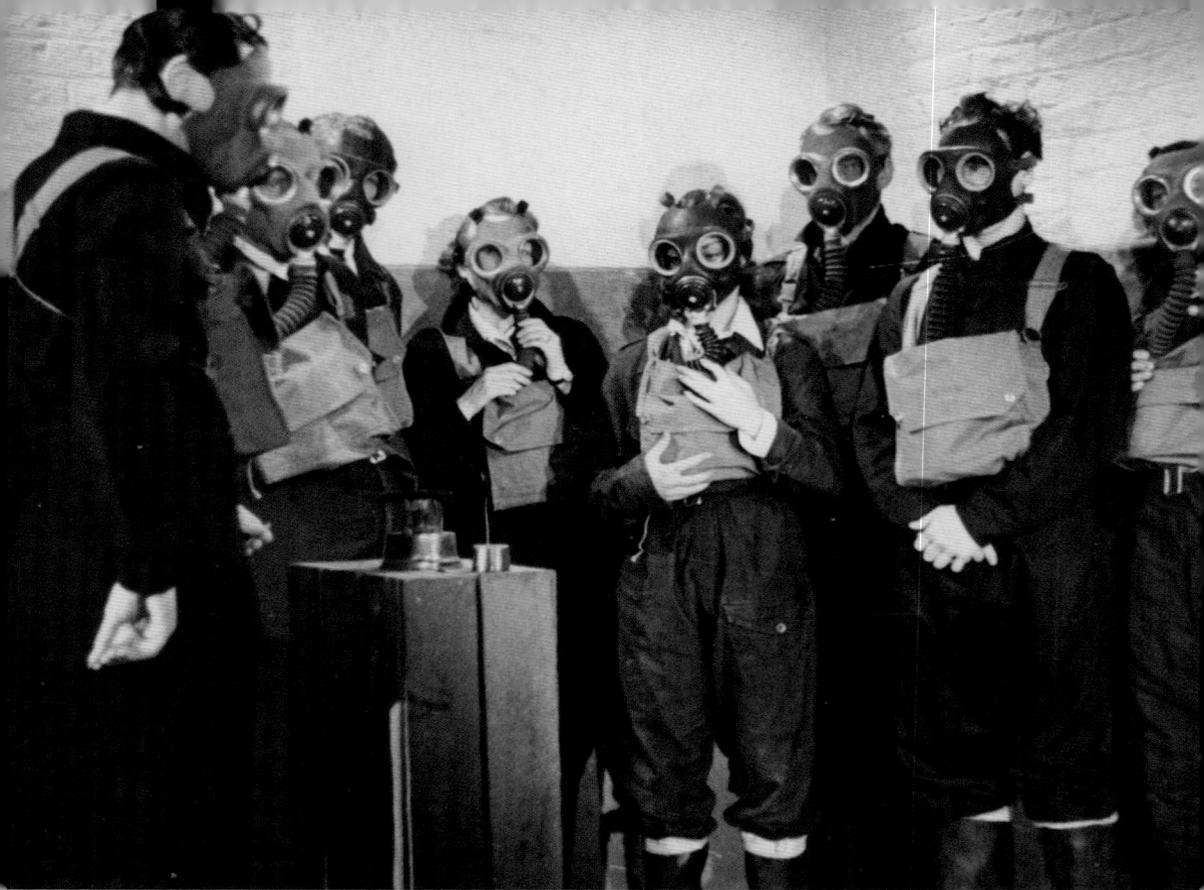

Waking Point (Crown Film Unit, 1951).

Jennings' *Cumberland Story* (1947), which celebrated the nationalisation of the coal industry, was even more poorly received. Without a widely shared bedrock of experience, the impact of Jennings' films began to dissipate.[45] The film's declaration that 'now the battle of the miners is over, and the mines belong to all of us,' was reportedly mocked and jeered by audiences.[46] The sensitive neo-romanticism of Jennings' wartime work appeared to suffer a reverse alchemy, where the mundane and parochial slid from the sublime back to their base metal.

The Crown Film Unit's energy and cultural relevance depended on a context of humanitarian crisis and political emergency. Quite different artistic visions, cultural values and political commitments had been kept

together by the totalising experience of war. Freed from the spectre of military defeat, Crown's idealists struggled to continue producing emotionally engaging propaganda films.

However, the legacy of Crown was far more tied into Britain's military objectives than many film histories allow. Its output continued to expand in the run up to war in Korea. It produced films like *Men of the World* (1950), which examined the role of British soldiers serving in Africa and South East Asia, as well as films about Indian soldiers and tributes to the Gurkas.

Before it was disbanded in 1952, the Crown Film Unit had begun to psychologically prepare citizens for the prospect of a nuclear conflict. In *Waking Point* (1951) a civil defence worker dreams of a nuclear bomb being dropped on North Yorkshire, a film that illustrated the British state's expectation that further conflicts lay ahead. Elements of Crown's work were later recycled in films such as *Atomic Attack* (1957) and *The Hole in the Ground* (1962), made with similar objectives.[47]

If one of *Target for Tonight*'s legacies was the celebration of working-class solidarity, another was the production of misleading (if not false) representations of British military intervention. Having produced propaganda which concealed the impact of Britain's bombing campaigns – in terms of immediate casualties, Britain's bombing of Dresden can be understood as analogous to Nagasaki – British propagandists after the war were forced to produce films designed to temper growing public terror of nuclear annihilation.[48] Historians have frequently understood the extension of universal state welfare provisions across Western Europe that followed the end of the Second World War as a type of war dividend. But by the time of Crown's closure, its films were offering surprisingly little of the dividend and promising plenty more war. The extent to which Britain's film propaganda promoted the welfare state has to be understood in relation to the expanding requirements of Britain's warfare state.[49]

3. PROPAGANDA FILM AND COLONIAL DEVELOPMENT

In 1926, a young sanitary inspector named William Sellers left Manchester for Lagos. Nigeria was in the grip of Bubonic plague, and on the day of his arrival Sellers claimed to have vaccinated more than 600 people. Drained by the experience of fighting a public health crisis, Sellers began experimenting with the production of posters, exhibits and eventually films to help improve hygiene and prevent the spread of future diseases.

Building on work by the Carnegie Corporation, Sellers created a Health Propaganda Unit and petitioned London for funding to expand his experiments throughout the colonies, on the grounds that educational film could not only help prevent disease but encourage the adoption of hygienic practices. In 1939, Sellers' Health Propaganda Unit became the Colonial Film Unit (CFU), and an important initiative in British propaganda began. Tom Rice has claimed that British cinema is colonial cinema.[1] It seems much less contentious to say that British propaganda film is colonial film.

Mr. English at Home (1940) provided the CFU with its first major success. The film was an attempt to illustrate the typical daily routine of a British family, in which the father goes to work as a carpenter on a building site, the son goes to school and the mother looks after the younger children before preparing an evening meal. Family life is supported by friendly shopkeepers, postmen and policemen, as well as punctual and well-ordered public transport.

While the primary motivation behind the film was to encourage colonial audiences to compare themselves with 'Mr English', and by doing so highlight the importance of values such as self-discipline, the CFU also

Springtime in an English Village (Colonial Film Unit, 1944).

hoped the film would combat misconceptions about life in Britain. 'Our way of life in this country is judged by the very artificial lives we officials and others live in the colonies,' as Sellers explained it.[2] The CFU reported with some glee audience disbelief that there was so little difference between a British family and an African one. *Mr. English at Home* was useful to officials because it portrayed a Britain where ordinary people had no servants and worked hard. While the EMB raided the iconography of the Soviet revolution to produce films promoting the heroism of labour, Sellers developed a genre that emphasised mundanity.

More importantly, *Mr. English at Home* became the template for the CFU's 'specialised technique' for addressing colonial audiences. While the EMB's propaganda films borrowed from the interwar avant-garde, Sellers' argued that a new form of cinema was needed (at least temporarily) to meet the

Mr. English at Home (Gordon Hales, Colonial Film Unit, 1944).

needs of largely illiterate peoples. CFU films were accordingly composed in long takes that eschewed rapid cutting and any type of montage. Sellers believed that slow tempo films were an essential ingredient of successful propaganda. The CFU claimed that *Mr. English at Home* was not only the most popular film ever screened in the Gold Coast, Kenya and Nigeria, but a worldwide success. In Bangkok, university students 'voted it the best film which they had seen as giving them a clear idea of life in a foreign country.'[3]

Where *Mr. English at Home* led, a remarkable number of 'day-in-the-life' CFU films followed. Often the day-in-the-life element would be overlaid with a 'Mr Wise and Mr Foolish' comparative element. By interweaving the stories of 'good' and 'bad' examples, the films sought to demonstrate best practice in areas such as co-operative agriculture, education and the prevention of disease. What had begun as a four-man team rapidly expanded, as the success

of *Mr. English at Home* prompted the creation of umbrella film units such as the Jamaica Film Unit, the Nigerian Film Unit, and the Malayan Film Unit.

On the face it, it might appear strange that such a narrow approach to film-making could stimulate so many imitations, but the simplicity of the CFU's template is exactly what made it so effective. While Sellers' enthusiasm for slow tempo film was mocked by the film industry, and his superiors disparaged his provincial origins, for a brief moment around the middle of the century his unusual commitment to film propaganda became useful to the British state. Accusations that the Second World War was an imperialist war were to be countered by the cinematic portrayal of colonial development programmes.

One striking example of this is *Springtime in an English Village* (1944), which tells the story of a six-year-old Black girl, Stephanie Antia, being crowned Queen of the May in a Northamptonshire village.[4] 'We didn't know what propaganda was,' her friend Joy Baker remembered, 'but they told us the film was made to be shown in African countries to show that we British were not a dreadful race of people.'[5]

As the war progressed the CFU made greater efforts to show the integration of African visitors or guests into British life, with the CFU's 'day-in-the-life' formats increasingly centred on an African visiting Britain. In *An African in England: An English Village* (1945), 'Kofi' is shown around an Essex village complete with bakery, church, school and workers in skilled trades. Although 'Kofi' was actually an art student at St Martin's College, officials praised him for posing exactly the kind of questions the people of a Gold Coast village would want answered.[6]

CFU films were also deployed to help manage colonial troops and to create a sense of pan-imperial unity. Postwar films such as *Education in England: A Village School* (1945), *African Conference in London* (1948) and *Nigerian Footballers in England* (1949) continued this tradition.

It's been argued that the Colonial Film Unit foregrounded the British provinces, and the English village in particular, because it encouraged viewers in the colonies to identify with provincial Britain as equals while also implicitly underpinning the pre-eminence of the colonial centre.[7] Yet there are more charitable interpretations of the imaginative equivalences drawn by the CFU. Elizabeth Lebas argues that the development of the British documentary film is tied up with the emergence of activist munic-

Nigerian Footballers in England (Colonial Film Unit, 1949).

ipal government.[8] In Britain, social democratic demands for political and social reform were often realised through the extension of local government responsibilities for housing, health and education. Localism, self-help and vocation were key planks of British reformist politics for much of the 20th century; these weren't qualities invented by the Colonial Film Unit for nefarious imperialist ends. Famously, *Housing Problems* (1936), which pioneered the use of working-class testimony, tapped into the municipal socialism of London County Council. CFU titles such as *Local Government* (1943) similarly reflected the fact that African civil servants were often seconded to the provinces of the UK.

In this context it doesn't seem wholly accurate to accuse the CFU's films of consciously trying to underpin the pre-eminence of the metropole; the films operate in pre-existing traditions of both reformist politics and colonial cinema. To acknowledge this is not to say that the colonial context

doesn't or shouldn't alter our understandings of that tradition. But it might mean that the 'colonial' context shouldn't overwhelm our interpretation, especially since (for example) the Crown Film Unit produced similar films on the reform of local and municipal government, aimed at West Germany. Suspicion of state centralisation, which was associated with totalitarianism, provided the dominant political frame.

The Colonial Film Unit had begun as an individual initiative born out of localised medical, social and cultural conditions, but during the War the films it made, and the controversies it excited, reached London as a series of abstract but urgent questions about Britain's place in the world.

In *The Projection of England*, Stephen Tallents had argued that the success of a propaganda campaign depended as much on context as on content. Sellers similarly emphasised the importance of screening films in places where new relationships could form. By doing this, Sellers was following in some well-established practices. In village halls and workplaces across the UK it was commonplace for local personalities to introduce film screenings. The CFU subsequently also liked to invite local African leaders to screenings and employed 'interpreters' to introduce and expand on the content of the films by weaving stories and jokes between screenings. Descriptions of instructional CFU film shows bring to mind something like a TED talk. 'I don't think I'd ever seen hunger for knowledge on quite such a big scale as in that bush cinema,' commented the novelist Montagu Slater of his experience at a CFU show, 'they want a cinema to tell them how – how a motor car works, how diseases are cured, how things come to be as they are.'[9] The CFU's propaganda screenings became part of a social infrastructure bringing geographically isolated people together.

However, Sellers' straightforward approach to audience development was far from uncontroversial. In Bengal, Cyprus and Kenya, public gatherings organised by the CFU were taken over by nationalist groups. Officials also complained about the CFU screening films about industrial safety in the context of (for example) a province badly affected by mining accidents.[10]

The British Council instead wanted films that would impress new elites, while colonial officials demanded a more hard-headed approach to film propaganda. The criticism here was that rather than focusing on the necessity of rapid economic and political modernisation, the Colonial Film Unit

was more akin to a cosy charitable enterprise. 'Insipid pictures depicting dully shot scenery, natives driving cattle about and women crushing maize have been done to screaming point', one British official complained, 'the one thing I loathe is the soggy attitude which produced empty Women's Institute films about the African that can do no wrong.'[11] Instead of a humanitarian mission, the Colonial Office were encouraged to understand colonial development as primarily an economic and industrial imperative.

This impatience was shared by the first generation of postcolonial leaders. The umbrella film units of the CFU that survived the transition to independence quickly developed away from the templates laid out by Sellers. The Gold Coast Film Unit was led by Sean Graham (born Hans Friedrich Hermann Isay), a Jewish émigré from Germany who had joined the CFU with the intention of producing an African *Grapes of Wrath*.[12] This wasn't an ambition that endeared him to Sellers, but it did chime with the ambition of Kwame Nkrumah, first prime minister of independent Ghana, to raise the global status of African culture. The international acclaim that greeted the Gold Coast Film Unit's *The Boy Kumasenu* (1952), encouraged Nkrumah to place film at the heart of the new Ghanaian state's propaganda apparatus. Nkrumah aimed to accelerate the pace of social and economic development in Ghana: 'nation building' through investment in state propaganda was an important part of this process.[13]

While the work of the Gold Coast Film Unit made an instant political and cultural impact, raising Nkrumah's status as its films garnered international accolades, its output was hardly typical of the CFU approach. Sellers had wanted the Colonial Film Unit to nurture 'films for Africans, with Africans and by Africans', but these would be 'African' films that shied away from the immediately personal and political.[14] By contrast, Nkrumah valued new media technologies such as film because of their promise of transformative vanguardism. To revolutionary temperaments, the Christian campfire ethos of the CFU smacked of an infantilising paternalism. During the war, African leaders had pressed the CFU for more aggressive films showing African soldiers at the forefront of the fight against fascism. Postwar, they demanded rapid technological transformation.

Ultimately, Sellers was unable to communicate a convincing long-term vision to any of the CFU's major constituencies. As a result, over the course of its existence, the CFU films were condemned as both anti-colonial and

The Boy Kumasenu (Sean Graham, Gold Coast Film Unit, Ghana, 1952).

imperialist: simultaneously too undemanding for their audiences and too advanced for them. The range of these criticisms is revealing, bearing in mind the stability, if not uniformity, of the films produced by the CFU. The accusations that its propaganda was too 'political', while also completely irrelevant, reflected the ways in which extremely standardised films were screened in increasingly unstable social and political situations. Ironically, the CFU's uncomplicated and open confidence in social development could not survive the rush to decolonisation.

The CFU's immediate tangible impact on the future development of the British propaganda film was heavily bound up with the influence of George Pearson, once dubbed 'Britain's D. W. Griffith', who taught at the CFU into his eighties. Pearson grounded the CFU's multinational graduates with a distinct understanding of the cinematic form that reflected his own apprenticeship at the turn of the 20th century. Arguably, one of the reasons the CFU favoured the 'slow tempo film', constructed out of set pieces, was that it

reflected a conception of cinema that owed more to the 1910s than the 1940s, let alone the 1950s. The CFU s debt to early cinema was especially visible in its use of comedy. By far the most popular icon of British culture in Africa was Charlie Chaplin, whose screen persona was given African epithets like 'Kaumuntu' (an odd childish clown) and 'SiDakawa' ('Little Drunken Man').[15] To increase the popularity of their shows, the CFU clipped and edited scenes from Chaplin's films into their events. CFU shorts like *Deck Chair* (1946), built around a man's repeated attempts to put up a deck chair, also imitated the slapstick of early film comedies. It's been argued that the tension between anarchy and bureaucracy lies at the heart of British comedy from *The Goon Show* to *Mr Bean* via *Monty Python*.[16] One lasting influence of the approach to propaganda adopted by the CFU – itself an organisation split between anarchy and bureaucracy – was the decision to place 'British humour' at its centre.

Pearson's graduates, schooled as they were in the long history of film form, proved remarkably successful. The era of effects-driven 'event cinema' ushered in by the likes of George Lucas and Steven Spielberg threw up opportunities for CFU graduates, as filmmakers returned to the grammar of earlier cinema. Robert Paynter, who joined the CFU as a 15-year-old trainee, was subsequently in demand as a cinematographer on Richard Lester's *Superman II* and Superman III (US, 1980 & 1983), the music video *Michael Jackson's Thriller!* (1983) and *Little Shop of Horrors* (Frank Oz, US, 1986). CFU film schools also incubated important networks, techniques and iconographies. One further consequence of the CFU's ambition to develop films 'not always on the outside looking in' was support for interesting figures in postcolonial cinema at early stages in their careers, such as Mohammed Zain Hussain in Malaysia, Gadalla Gubara in Sudan, and Franklyn St Juste in Jamaica.

Intellectually, though, the CFU contributed little to the development of the propaganda film. Sellers was not an artist, an intellectual or an ideologue; his interest in propaganda had been ignited by the struggles of managing successive health crises. For the most part, his thinking didn't move beyond the passive transmission of contemporary ideologies of public health. Nevertheless, through the CFU's journal *Colonial Cinema* (1942–54), the wider utility of the unit's 'specialised technique' of film propaganda was discussed, debated and defended through the sharing of anecdotal experiences. While

Colonial Cinema

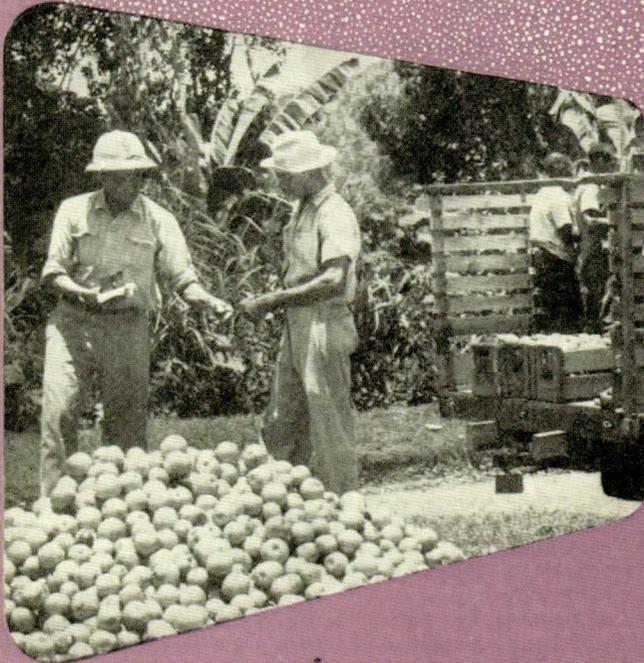

DECEMBER 1951 VOL. IX NO. 4

PUBLISHED QUARTERLY BY THE COLONIAL FILM UNIT

The CFU's *Colonial Cinema* journal.

contributors to *Colonial Cinema* overwhelmingly addressed themselves to the immediate practicalities of colonial film, Sellers was not above making a stab at abstracting rules of thumb from their shared experiences. More importantly, the journal circulated more widely among intellectuals, educators and policymakers. The film theorist André Bazin would later weave material from *Colonial Cinema* into his own writings, using the story of the CFU's struggle to develop a universal cinematic intelligibility in Africa to support his intellectual and aesthetic championing of a cinema of long shots and deep-focus *mise-en-scène*.[17] Paradoxically, while the CFU had been attempting to perfect an unobtrusively didactic cinema, Bazin glimpsed through its work the possibility of a form which empowered the spectator.

The influential British filmmaker Mary Field also drew inspiration from *Colonial Cinema*. As head of Rank's Children's Entertainment Films, Field argued (like Bazin) for the production of slow-tempo films constructed out of long takes that would encourage children's curiosity and reward patient looking. Under her direction, Rank produced films such as *Basuto Boy* (1947), about cattle thieves in Africa, which both aped CFU methods and sought to encourage British children to identify and empathise with African children. Field hoped such films would encourage the development of a Commonwealth identity able to resist American, Soviet, and Chinese influences. While Sellers and Pearson were horrified by the comparisons drawn by Field, UNESCO were impressed and codified these 'lessons' into case studies about the potential uses of film in children's education.[18]

Speculatively, one could even draw a link between the CFU's imaginaries of life in Britain, such as *These are London Firemen* (1942), *Education in England: A Village School* (1945) or *Journey by a London Bus* (1950), and the model worlds of internationally popular British children's television programmes like *Camberwick Green* (1966), *Postman Pat* (1981–2002) and *The Teletubbies* (1997–2001). Gerry Anderson, creator of the *Thunderbirds* TV series (1965–66), began his career at the Colonial Film Unit. In an alternate universe, Trey Parker's *Team America: World Police* (US, 2004) has a British colonial equivalent.

You could be forgiven for thinking that writing the history of the Colonial Film Unit entailed writing the story of an imposing and powerful intervention in propaganda film. But while the CFU proved extremely influential over the long term, for much of its existence it operated out of the contempo-

Journey by a London Bus (Central Office of Information, 1950).

rary mainstream of filmmakers, policymakers and politicians. The unit had expended enormous energy trying to seal off its missionary work from what it saw as the meddling of artists, speculators, racists and pro-independence activists. An isolated, cranky and embattled figure, it's perhaps not surprising that Sellers' methods were to prove more resilient than his messages.

When the CFU was formally wound down in 1955 it was superseded by the Overseas Film and Television Centre (OFTC), which would produce or facilitate more than 3,000 films focused on postcolonial development before it was itself disbanded in the 1990s. The OFTC also became a major commercial provider of film and media training overseas and a substantial source of British soft power.

In 1991, CFU graduate Sir Sydney Samuelson (son of producer G.B. Samuelson) became the British government's first Commissioner of Film, after a long and varied career that included making the official films of the FIFA World Cup.

Close-up: British Council Films

Created in 1934, the British Council was founded as an experiment in cultural diplomacy. While it arguably hit its stride during the War, when it was tasked with promoting a positive image of the nation overseas, the British Council had been an energetic commissioner of films through the 1930s. Preceding the Second World War, the topography of British Council films – whether commissioned, re-edited or just distributed – seldom wandered far from comfortable cliché: there's Stonehenge, St Paul's and Senate House, alongside the University of Cambridge, Lloyds of London and Magna Carta. These peaks of civilisation achievement were buttressed by the more generic treatment given to 'Industrial Cities', 'Coastal Towns' and 'Lowland Villages', as well as 'lower' forms of social activity such as crafts, trades and hobbies.

But war helped changed the meaning of the films. The emotional ballast of the slightly-out-of-date grew larger. War imbued the clichés with a self-awareness; the traditions are placeholders standing in for a vision of a better life yet to find its form.

Later films focused on the quiet resilience of the miners, teachers and nurses who carry on in the face of injury, exhaustion and ongoing hardship. Heroism is expressed in the struggle for normality. The familiar was something to be cherished and celebrated rather than dismissed, scorned or taken for granted.

From 1944, Lord Drogheda, who served in various senior advisory roles to the Council, drew together a revealing mix of collaborators drawn from organisations such as Shell, The Economist and the Empire Marketing Board. The result was an approach to film which insisted on the Council's work remaining 'strictly non-political', but which also anticipated considerable commercial and political benefits over the long-term.

CLOCKWISE FROM TOP LEFT: Stonehenge, Palace of Westminster, Senate House: all from *Architects of England* (1941); *The Story of English Inns* (1944); *Triumph Over Deafness* (1946): *Good Value* (1942); *They Live Again* (1944); *The People's Land* (1941): **CENTRE:** Western Isles (1942)

4. PROPAGANDA FILM AND POSTWAR PROPAGANDA

'The late Dr Goebbels' most effective propaganda did not consist in spreading frigid and calculated lies,' argued then-backbench MP Brendan Bracken in 1949, 'he arranged his facts to suit his argument.'[1] Having helped build a successful Ministry of Information during the war, Bracken, like most Conservatives, demanded its peacetime abolition. It was undemocratic, he declared, for the Ministry's existence to stretch into peacetime, no matter how politically 'neutral' its work was declared to be.

But having been elected on a platform that demanded continuing (if not expanding) state intervention in national life, the Labour government was reluctant to acquiesce. Instead, it argued that the task of national reconstruction necessitated the continued production of government publicity. To this end, during its six years in office the Labour government funded 30 national advertising campaigns, 170 exhibitions and more than 500 films.[2]

Created in 1946, the Central Office of Information (COI) established by Attlee's government would become the main conduit of the postwar British propaganda film. In a move that resurrected the political partnerships of the inter-war years, Herbert Morrison, Leader of the House of Commons, appointed Robert Fraser, a journalist from *The Daily Herald*, as the COI's first Director General. The pair had worked together at the London County Council, in the era of propaganda films like Arthur Elton and Edgar Anstey's *Housing Problems* (1935) and John Taylor's *The Londoners* (1939).[3] They would now work together promoting major postwar initiatives such as the Festival of Britain.

What a Life! (Michael Law, Public Relationship Films / Central Office of Information, 1948).

In a sop towards its political critics, the COI was, unlike its wartime predecessor, constituted as a non-ministerial department. In theory, this prevented the emergence of a Minister for Propaganda. The British propaganda film owed its existence to bureaucrats like Stephen Tallents, and over the long term it's certainly possible to argue that the COI primarily reflected the views of the Civil Service. Yet because the COI was created at the inception of the modern welfare state, it still periodically found itself accused of pro-Labour bias. This accusation wasn't entirely without foundation, and as a result Conservative MPs would turn the smallest of the COI's missteps into noisy and confected political spats.

One early controversy erupted around a short film commissioned from Richard Massingham's Public Relationship films company to help dispel postwar pessimism. Massingham had become a cult figure during the war, the innocence and comic expressiveness of his on-screen persona sweet-

ening the pill of short propaganda films like *Coughs and Sneezes* (1945), designed to encourage better hygiene. In *What a Life!* (1948), built around the story of an attempt at suicide that goes absurdly wrong, Massingham's black humour went a step further than usual. 'Two men so depressed by the conditions of life in England today that they try to drown themselves', summarised the Conservative MP Edward Keeling, '[is this] the sort of film on which £9,000 of the taxpayers' money should be spent without any possibility of a return?'[4]

Despite this façade of political hostility to the work of the COI, prestige propaganda films remained an important component of its output well into the mid-century. One early COI success was *Daybreak in Udi* (1949), a dramatised documentary charting the construction of a maternity hospital in Nigeria which won an Academy Award in 1950. Although it has not aged at all well, stylistically the film remains interesting for the way its otherwise familiar realist conventions are disrupted by a nightmarish sequence where a Nigerian nurse is intimidated by hostile villagers.[5] Later, *Seawards the Great Ships* (1961; co-sponsored by Films of Scotland), a tribute to Clydeside shipbuilding based on a treatment by John Grierson, became the first Scottish film to win an Oscar.

Relatively big-budget COI films were often used to stitch together larger diplomatic campaigns. Produced by Rayant Pictures, *Atomic Achievement* (1956), which championed the ill-fated 'ZETA' research into nuclear fusion, won several international awards. Media claims that Britain had unlocked 'H-power everlasting' in 'a triumph as great as the Russian Sputnik' encouraged more than ten million people around the world to see it.[6] While the COI's domestic propaganda programme could be contentious, the COI was able to build a political consensus around the need to promote British breakthroughs in agriculture, industry and science to overseas audiences. Keeping up with the Cold War Joneses remained a shared prerogative of consensus parliamentary politics.

Nevertheless, the election of Winston Churchill's Conservative government in 1951 resulted in sweeping cuts to the COI's budget. Alongside these cuts – the COI budget shrunk from over £4 million in 1946 to £1.6 million in 1955 – the Crown Film Unit was disbanded in 1952.[7] This decision not only

Atomic Achievement (John Reeve, Rayant Pictures / Central Office of Information, 1956).

turned the COI from a body which produced as well as commissioned propaganda films to one which only commissioned them; it also had the effect of hastening the departure of salaried creatives, like John Grierson, who were deemed politically undesirable or troublesome. Working at the COI became, in the judgement of David Thomson, 'about as an unrewarding experience as it is possible to imagine.'[8]

Instead, until 1964 the COI's film programme would be controlled by Colonel Charles Beauclerk. While serving in postwar Vienna, Beauclerk had written himself into the footnotes of British film history by tipping off Graham Greene about the city's 'sewer police', a detail which memorably made its way into Greene's screenplay for *The Third Man* (Carol Reed, 1949).[9] But more significantly for his role at the COI, Beauclerk had previously

worked in psychological warfare, disseminating what would now be called misinformation across Italy and North Africa during the Second World War. His prominence reminds us that while the story of the COI is often wrapped into the story of the welfare state, throughout its history more than half of the COI's budget was spent on campaigns for the British military.[10] Indeed, while the COI had struggled to gain acceptance for its attempts to update domestic initiatives, the British state continued to develop sophisticated propaganda campaigns aimed at overseas audiences. Notoriously, organisations such as the Information Research Department (IRD) proved able to usher the dubious practices of wartime into the postwar world without exciting great political controversy.

Garrett Ponsonby Moore (1910–1989), better known as the Earl of Drogheda, became central to the evolution of the 'cultural' propaganda film in the postwar period. Described in obituaries as a consummate networker, who reinvigorated the Royal Opera House and made the arts pages of *The Financial Times* 'the best in the world', Drogheda was an impresario whose private successes depended on creating social contexts where financiers could mingle comfortably with artistic talents such as the conductor Georg Solti, as well as intellectuals like Lord Annan and Sir Isaiah Berlin. Drogheda was also the protégé of Brendan Bracken.[11] The lessons he drew from his mentor became essential not just to furthering the success of his twin professional passions – opera and *The FT* – but to the operation of the mid-century British propaganda film.

In 1952, Drogheda had been commissioned by the Conservative government to assess the actual and potential value of British overseas information work. To examine the work of the Foreign Office, the Commonwealth Relations Office, the Colonial Office, the Board of Trade and the Central Office of Information, as well as the External Services of the BBC and the work of the British Council, Drogheda gathered together an eclectic mixture of representatives from the arts, the corporate world and the trade union movement. He also made room for the journalist and spy Donald McLachlan.[12] Although this committee was likely established on the assumption that it would identify areas where expenditure could be cut, Drogheda's final report argued that that the propaganda functions of the British state had been recklessly starved of funding since the Second World War.

Interestingly, the final report used the language of hard power to lobby for a more imaginative approach to soft power. 'Increases to the Foreign Office Information Service budget amounted to one day's subsidy to the Egg Marketing Board,' it argued, 'and as far as the total bill for the Information Services as a whole was concerned, to rather less than the cost of two bombers.'[13] In Drogheda's view, the pace of decolonisation and the threat of communism demanded greater investment in propaganda.

While the findings of the Drogheda Report were at first resisted, the fallout from the Suez Crisis of 1956 led to belated recognition of its wisdom. The unsuccessful attempt by Britain, France and Israel to recover control of the Suez Canal from Egypt using military force, prompted condemnation from the UN and hostility from the US and USSR, and threatened to split the Commonwealth. Ultimately the crisis led to the resignation of Prime Minister Anthony Eden and the realisation among governing elites that Britain was no longer a top-tier world power.

With its long-term aim of forging new educational and cultural networks across the developing world, the Drogheda Report had proved prescient. While its recommendations were only slowly realised – if at all – it helped established the idea that cultural relations had an important role to play in managing international opinion and prompted a surge in spending on overseas propaganda. Between Suez and 1962, the budget of the COI's film and TV division increased from £170,000 to over £1.5 million.[14] Newly-created or expanded COI 'telemagazines' such as *Transatlantic Teleview* (1954–58) and *Commonwealth Teleview* (1957–58) built on the practices of wartime radio to create new modes of screen propaganda.

In *Transatlantic Teleview*, Canadian journalist Robert McKenzie – who later became famous as the inventor of the BBC election night 'swing-o-meter' – interviewed British political figures in their own homes. Building on the idea of broadcast 'fireside' talks, the COI aimed to offer viewers 'a personal contact' with significant figures in British national life. The Prime Minister, Harold Macmillan, appeared on one programme, along with politicians such as Anthony Nutting and the trade unionist Victor Feather (both of whom had worked on the Drogheda Report). Indeed, it's striking that the 'informal' film propaganda that began to emerge mapped tightly onto Drogheda's friendships, cultural interests and political affiliations.

Close-up: The Information Research Department

Historians tend to assert that the Information Research Department (IRD) was created by the Labour MP Christopher Mayhew to combat Communist propaganda. 'The UN was being used by the Russians simply as a sounding board for Cold War propaganda', remembered Mayhew, 'I came to the conclusion that we needed to discourage these attacks by counter-attacking.'[15] The IRD was a secret organisation operating at the nexus between foreign diplomacy and secret intelligence, creating fake radio stations and distributing 'independent' news, pamphlets, and printed material. It also played an important role in the reorientation of the British propaganda film.

George Orwell's writings, especially his novels *Animal Farm* and *1984*, became particularly important to the IRD. On top of their memorable slogans – 'Big Brother is watching', 'the thought police', 'some animals are more equal than others' – Orwell's works appealed to propagandists because they operated at the level of parable. The potency of the rhetoric was enhanced by its vagueness. By avoiding the clichés of crude anti-Communism, Orwell's work made for powerful propaganda. The IRD translated Orwell's work into Italian, French, Swedish, Dutch, Danish, German, Spanish, Norwegian, Polish, Ukrainian, Portuguese, Persian, Telegu, Japanese, Korean, Hebrew, Bengali and Gujarati. The 1954 film of *Animal Farm*, produced by the British animators Halas and Batchelor, was apparently part-funded by the CIA as part of a joint propaganda operation.[16] Previously, Halas and Batchelor had produced a series of popular cartoon shorts for the COI promoting Labour's vision of the welfare state.[17]

In addition to popularising the works of British artists and intellectuals, operating on the principle that 'only an Easterner can convince an Easterner', the IRD also played a role in developing new film initiatives. After a trip across South East Asia, COI Films head Charles Beauclerk recommended establishing a number of newsreel and magazine series embedding 'British stories' in local contexts. *Roundabout*, which ran from 1962 to 1974, interwove news from Britain with deferential stories about the Thai royal family, UN Secretary General U Thant and modern Asian architecture.

Animal Farm (John Halas/Joy Batchelor, 1954).

Official film units overseas were also often drawn into the work of the IRD. Positive visions of the future, including promises to improve public services and work with 'sensible' trade unions, were commissioned in Ceylon, Hong Kong and Malaya.[18] Even more influential was the creation and support of film libraries (often working through the British Council), which distributed carefully curated selections of films to schools and universities.

Mayhew later argued that he created the IRD to 'give a lead in the spiritual, moral and political sphere to all democratic elements in Western Europe', but evidence suggests that an anti-communist propaganda organisation very much like IRD had existed in various governmental forms since the Russian Revolution.[19] Indeed, it has been argued that IRD employees saw their primary purpose as ensuring Attlee's Labour government increased military spending.[20] Suspicious of the right-wing character of its work, Labour Foreign Secretary David Owen closed the IRD down in 1977.

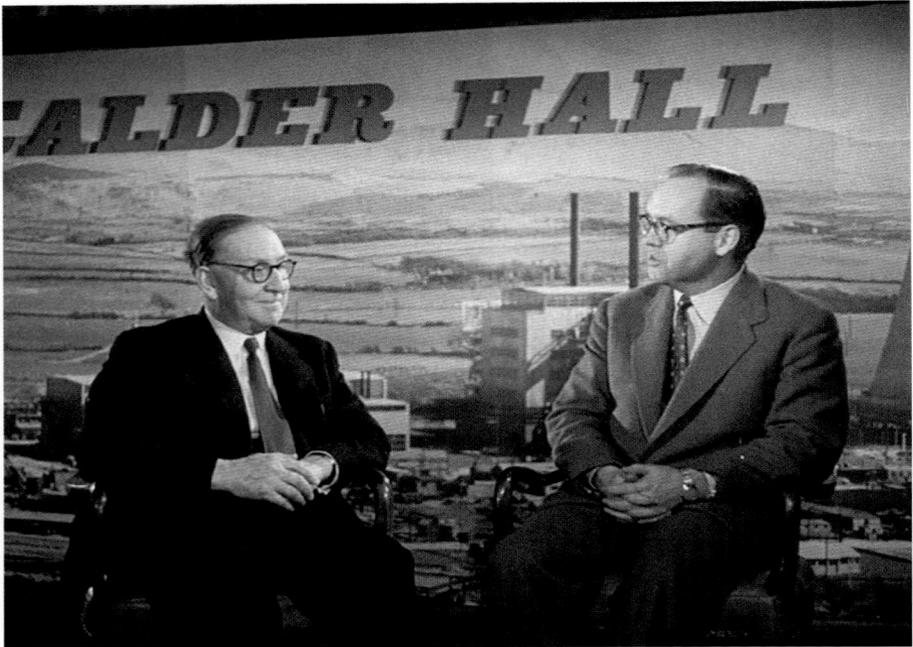

Commonwealth Teleview (Central Office of Information, 1957–58).

John Hall, who worked in Overseas Production before later becoming Director of the COI's Films Division, remembers the disdain of a British ambassador to the USA at the very idea of talking to 'the little people'. But over time the COI managed to persuade the Foreign Office that winning over public opinion had become a prerequisite for securing a sympathetic hearing with political elites.[21] As the Drogheda Report put it, 'the government must concern itself with public opinion abroad and be properly equipped to deal with it.'[22]

As the 1950s progressed, the image of the British establishment offered by programmes such as *Transatlantic Teleview* gradually broadened out to encompass a wider spectrum of British society. In the heroic era, propaganda films depended on aesthetic or political virtuosity. In the cultural era, success depended on human interest or approachable celebrities. Rather than 'the usual type of documentary film on subjects of lasting

interest,' the COI wanted 'inexpensive films with a short life on subjects of topical interest.'

The soprano Rita Hunter, who became one of the stars of the COI's popular *This Week in Britain* series of telemagazines that ran between 1959 and 1980, provides a good example of the kind of figure promoted by the British state. For a period in the 1960s, Hunter was regarded as one of the world's leading sopranos, cementing an international reputation with her performance as Brünnhilde in an acclaimed staging of Wagner's *The Ring* in 1973. Hunter's body of work was celebrated as both a significant achievement in itself and as evidence of greater social mobility. Born on the Wirral in 1933, Hunter was the daughter of a gas fitter who had begun her career in pantomime and trained in music hall. The COI celebrated Hunter as a talent who had risen 'from Merseyside to the New York Metropolitan Opera'.

By the mid-century the COI was producing a wide range of similar biography-led cinemagazines, including *British Sporting Personalities* (1959–62), *Moslems in Britain* (1961–64), *Commonwealth Review* (1964–65), *The Enthusiasts* (1967) and *The Pacemakers* (1969–71). Screened across the globe, from Cuba to New Zealand via Iran, Kenya and Indonesia, many of these COI telemagazines proved extraordinarily popular. Although in theory their content was localised, much of the material was heavily recycled. 'The versions for Nigeria feature a Nigerian artist', the COI explained, 'similarly, an Indian artist is seen in the Indian version, but the bulk of the shooting is in common to all versions.'[23]

Yet the triumphant vision of postwar democratisation represented by Hunter was surprisingly shortlived, and swiftly pushed aside by COI telemagazines that instead focused on individuals glamorising 'everyday' popular culture. Indeed, by the end of the 1960s, instead of stories about 'ordinary people' like Hunter storming the scientific, cultural or sporting citadels of excellence, the COI was promoting a new type of middle-class professional 'who challenged the status quo'.

Indeed, through the changing focus of the COI's telemagazines we can see the formation of what historian Dominic Sandbrook has described as the 'Great British Dream Factory', a national canon of popular culture that emerged from the mid-century and is now celebrated almost entirely uncritically in documentaries, retrospectives and major museum exhibitions.

British Sporting Personalities: Peter May (Associated British Pathé / Central Office of Information, 1962).

Figures such as Mary Quant, as well as outlets like Biba, were heavily promoted across the British information services. The rapidity of their success, and the ways in which their work connected high society, media celebrities and the ordinary high street shopper, supported visual stories about both Britain's 'modernity' and its entrepreneurial savvy.

By the 70s, COI series like *Pacemakers* included endless stories on Monty Python's Flying Circus, Pink Floyd and fashion designer Zandra Rhodes, as well as more combative establishment figures like politician Tony Benn and actress Glenda Jackson. The developments celebrated by the COI had swiftly evolved to focus on dynamic individuals 'helping to solve some of the pressing political and social problems of our time.' While the artistic legacy of these films is questionable, they have left a fascinating record of the speed at which social values changed.

Montage: Biographies of a New Britain

The cinematic equivalent of a colour supplement, cinemagazines blended travelogue, fashion and comedy, and were particularly popular from the 1950s to the 1970s. The format was refashioned by the COI into a

form of overseas propaganda for the TV age, with an increasing focus on the dynamic individuals 'helping to solve some of the pressing political and social problems of our time.

Clockwise from top left: agony aunt Marje Proops (*This Week in Britain*, 1974); fashion designer Bárbara Hulanicki (*The Pacemakers: Biba*, 1970); architecture critic Ian Nairn (*The Pacemakers*, 1970); politician Anthony Wedgwood Benn (*The Pacemakers*, 1967); fashion designer Zandra Rhodes (*Insight*, 1981); actress Glenda Jackson (*The Pacemakers*, 1971).

This new generation of COI films adopted a much more assertive and critical stance towards the aspirations of the postwar compact. Drogheda's circle of friends had been pushed aside by computer scientists, socially committed activists and cultural entrepreneurs. Twenty years after the Drogheda Report, the COI's propaganda films enable us to trace the outline of a new kind of postwar elite.

Conversely, by the time of her death in 2001, Rita Hunter had been all-but forgotten. 'It might be the Queen Elizabeth Hall,' as an extraordinarily snooty obituary in *The Guardian* had it, 'but she would treat the event as if it were taking place in a working-men's club which just happened to have been taken over by a load of screaming opera queens.'[24]

While the content and tone of the British propaganda film changed rapidly in the two decades after the Drogheda report, the principles and infrastructure it mapped out remained of lasting influence. The MP Charles Hill, who was appointed as coordinator of government information services in 1957, was crucial in in purging 'politics' from the British propaganda film and embedding the vision of the Drogheda report into the machinery of the state. Working in tandem with Harold Evans, a PR manager Macmillan had recruited from the Colonial Office, Hill attempted to steer the overseas services away from potential sources of difficulty by gently freezing out topics liable to cause embarrassment or political controversy. Once the parameters of acceptability had been safely established, Hill was able to free the practitioners of British cultural propaganda from strict administrative oversight.

By making a clear distinction between government interest and national interest, Hill strengthened the position of the technicians, artists and teachers who would play a key role in the long-term maintenance of Britain's international reputation. Where high diplomacy had failed, lines of cultural communication could still operate through the distribution of subsidised textbooks, the organisation of cultural tours and the awarding of scholarships. As much as politics, the 'cultural' propaganda film of the mid-century sold the mores of the professional middle-class. 'Cultural work was bringing British life and thinking to many parts of the world,' Hill wrote, 'for a philistine who would rather go to the Crazy Gang than to [*Waiting for*] *Godot* this is saying a great deal.'[25]

Arguably, the more significant lasting impact of Hill's stewardship was that the COI began to subsidise, build capacity in and even actively co-ordinate a growing commercial media sector. Whether buying advertising space, commissioning films or acquiring the rights to distribute commercial media products overseas, the COI helped to stitch the fortunes of private enterprise into a filmic consensus that nurtured a national industry to international significance.[26] Indeed, one of the functions of the British Overseas Information Services was to act as a broker between British private expertise and developing countries looking to establish their own overseas information services.

To give an example, one of the numerous postwar production companies doing a combination of public sector and commercial work was Rayant Pictures, which began life in 1947 as a producer of short 'true crime' films centring on Scotland Yard. During the 1950s the company grew as it began to make longer works for the COI, the British Travel Association and the General Post Office. In addition to filmic records of the Royal Family's overseas visits, Rayant also picked up bigger commissions from corporations such as BP, Shell and Unilever. Between 1947 and 1979, during the heyday of 'sponsored film', Rayant produced some 300 films.[27] Its range of domestic and international clients illustrated the social and institutional functions of the British propaganda film: a broad coalition of artistic, political and economic interests had been loosely arranged into a national brand of cinema.

One of the ironies of Hill's success was that, unlike the propaganda innovations developed by figures such as John Grierson or Christopher Mayhew (see 'Close-up: The Information Research Department', pp. 72–3), his interventions apparently lacked any programmatic social, theoretical or methodological conviction. Hill was originally a physician who had been bought into the public eye by his wartime broadcasts, and although he remained involved in organisations like the Central Council for Health Education, other than a commitment to ensuring 'professionalism' he apparently held no fixed ideas about the proper relationship between the British state and the mass media. He maintained that the significance of overseas information work only became apparent when its presence has been reduced or removed entirely. Cultural propaganda was to be valued as an end in itself.

Close-Up: *London Line*

'*London Line* reflected the optimism and confidence which had invaded almost every aspect of British life', remembered Hannah Neale, one of the COI telemagazine's African presenters, 'youth power had taken over; innovation, creativity, dynamism in fashion, music, art and culture all had new and exciting forms of expression. The skirts of the female presenters got shorter, and the men had brighter shirts.'[28]

Distributed for free to national and local television stations across North America, the Arabic world, Africa and Australasia between 1964 and 1978, *London Line* was one of the COI's most popular programmes aimed at overseas television audiences.

It was a magazine show that relied heavily on foreign journalists, intellectuals and writers to 'interpret' Britain back to their home countries. For example, over the course of its existence, the African version of *London Line* featured actress Jumoke Debayo, as well as journalist Israel Wamala and actor and filmmaker Lionel Ngakane. Lord Paul Boateng, Britain's first Black cabinet minister (and first High Commissioner), also worked on the show as a presenter in the 1970s.[29]

The content of the programme was eclectic, and could jump wildly from development economics to sport, poetry or medicine. By spinning a diverse web of connections, *London Line* attempted both to reflect and to engineer friendship between a rising cosmopolitan elite. For instance, Neale starred alongside Debayo and Ngakane in Wole Soyinka's 'The Lion and the Jewel' when it opened to great acclaim at the Royal Court Theatre in 1966.

Alongside worthy items extolling the virtues of new methods of agriculture and the expansion of higher education came items celebrating prefabricated buildings, affordable fashions and new media trends. Although the programmes are infused with a sense of propriety – overseas viewers often expressed the need for the presenters to speak English 'properly' – they also played on a widespread desire to 'get' the new forces shaping the world. Social and cultural interactions, not high politics, were the programmes' focus.

London Line promoted an appealing but particular image of Britain, rather than an incontestable representation of it. This was an approach that reflected a change of policy by the British Information Services. Before the Second World War, over-

London Line presenters (l.–r.) Jumoke Debayo, Lionel Ngakane, Hannah Neale.

seas programming kept at least one eye on expatriates, merchants and military families.[30] But from the later 1950s British propaganda began to move away from this 'extended family' model and towards a format that more aggressively sold Britain as both an 'open' tourist destination and a popular culture.

Growing political impatience, along with cuts to state expenditure and a new political strategy focused on European integration, eventually led to the programme's demise. But *London Line* in its various editions left a rich and varied legacy, which is not only interesting and important, but barely known about by anyone in Britain today.

5. PROPAGANDA FILM AT THE WORLD EXHIBITIONS

'In the hands of a lesser director, *Family Portrait* might have been little more than a smug, shallow cross between a tourist board travelogue and a corporate promotional short,' as one of Humphrey Jennings' biographers put it, 'indeed, until quite recently, the film was often dismissed in just those terms.'[1]

Jennings' *Family Portrait* (1950) was the official film of the Festival of Britain. Held 100 years after the Great Exhibition of 1851, the Festival was conceived as a celebration of 'common human heritage', promising to celebrate 'Britain's contribution to civilisation, past, present and future.' It was also intended to promote Britain to overseas visitors. By selling the 'British way of life' the Festival was selling British goods, and by selling British goods it was selling 'the British way of life'.[2]

Following in the rhetorical footsteps of earlier EMB films like *One Family* (1930), *Family Portrait* is built around the conceit of the audience flicking through a family album. This personal story expands outwards as the film progresses to eventually encompass Celts, Jutes and Vikings, as well as the Commonwealth. *Family Portrait* claims that the diversity of its peoples – 'a very mixed family' – was the source of Britain's strength. Distributed across Europe and the USA, the film would help entice 16.5 million visitors to visit London's South Bank in 1951.

Yet *Family Portrait* refrains from any sense of triumphalism. Having argued for 'the need for reconciliation' to close the social rifts exacerbated by the Industrial Revolution, it closes with an appeal for a future shaped by

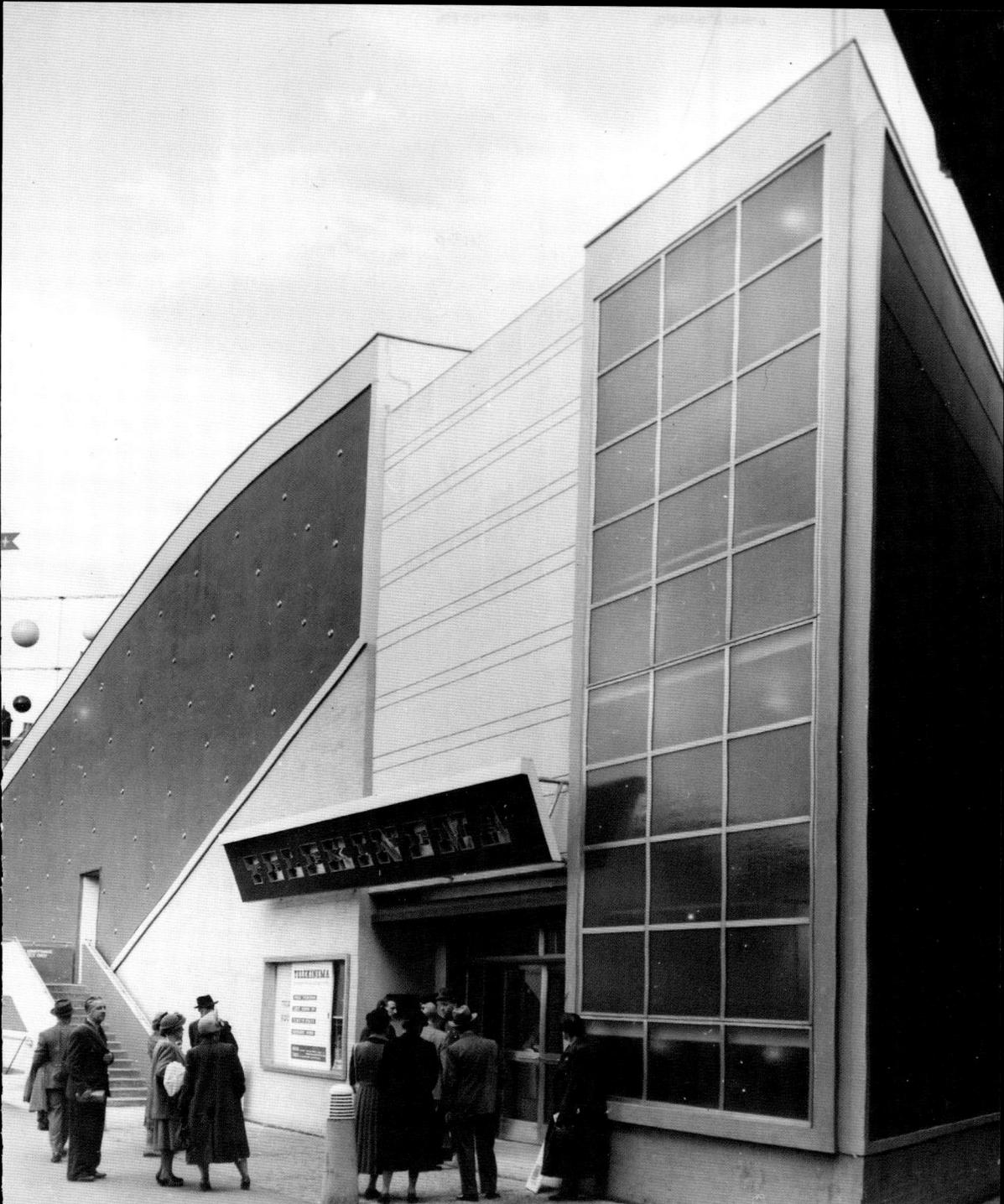

The BFI Telekinema *c*. 1950s.

imaginative compromises. 'The planners make plans, but the farmer has to *live* farming', the commentary tells us, 'here clearly is a magnificent field in which to apply our old genius for compromise and tolerance.' The film warily recognises that in a postwar world where an expanding state shapes the pathways of scientific and technological development, new bureaucracies have gained enormous power to reshape the pattern of peoples' lives.

For Jennings, hope ultimately springs from the ability of British people to stitch together binaries: eccentricity and objectivity, innovation and tradition, organisation and freedom. In *Family Portrait* shots of the Neolithic settlements at Avebury are followed by shots of space exploration. 'We like sitting quietly in the garden at home' runs the film, 'and we like pageantry.'

When released the film received praise for its delicately fashioned polish. Critics described it as 'a connoisseur's piece for the art house and better-informed patrons, [which] is also eminently suitable for general showing.'[3] It was a response that signalled that Jennings' approach to the propaganda film had become the preferred mode of the establishment. Indeed, one of the reasons that Jennings was commissioned by the Festival was because his wartime films – subtle collages of voices, observations and emotions such as *Listen to Britain* (1942) – evoked a world of social solidarity that had already begun to vanish. *Family Portrait* marked the decline of a model of propaganda film that had matured during the interwar period.

We can identify specific reasons why *Family Portrait* was unable to capture the public imagination. Jennings' working practices had arguably been harmed by postwar demands for a more 'professional' approach to film propaganda. In his best work, the script was built around the footage. But in order to secure the Festival commission, Jennings was forced to develop a series of substantial treatments for *Family Portrait* before he began shooting. The result was a type of cinematic propaganda that owed more to the 'filmed radio script' approach of his less talented peers than to his own trademark visual lyricism.

The Festival also represented the swansong of a cultural elite that had come to prominence in the 1930s. In the future, there would be much more ambivalence about the Festival. Its displays of upmarket ceramics and glassware illustrated just how parochial British modernism had been. It was this broader strand of critical opinion that Lindsay Anderson tapped into when he later dismissed *Family Portrait* (and pretty much all of Jennings' postwar

Family Portrait (Humphrey Jennings, Wessex Film Productions, 1950).

work) as complacent, insular and sentimental.[4] The necessity of tolerant imaginative compromises barely limped into the 1960s.

The high political context, too, was turning against Jennings. An unstated goal of the Festival was to encourage the idea that the Labour government's efforts to rebuild Britain were beginning to bearing fruit. Architectural novelties like Ralph Tubbs' Dome of Discovery were created to reassure weary citizens that the hardships of postwar austerity had begun to ease.[5] As a result much of the Festival of Britain didn't survive the election of the Conservative government, which erased its architectural memory with a partisan zeal and instead promoted its own house-building programme. While *Family Portrait* found favour with critics and well-heeled tourists, ordinary visitors flocked instead to the BFI's Telekinema, where a new form of cinematic expression was beginning to emerge.

The British Film Institute was one of the Festival's major beneficiaries. Although the BFI had been founded as an educational charity in 1933, the

Now is the Time (To Put on Your Glasses) (Norman McLaren, National Film Board of Canada / British Film Institute, 1951).

regeneration of the South Bank bequeathed it an iconic venue on the banks of the Thames and a larger slice of government funding. To support the Festival a BFI panel, which included Anthony Asquith, John Grierson and Harry Watt, was given the task of both commissioning new films and organising new film programmes. 'One of the most effective means of dramatizing the achievements of our people is through the medium of film', as a BFI pamphlet had it, 'encouragement should be given to manufacturers in the area to submit their own films for showing at the cinema so that visitors from abroad and other parts of the country can have a glimpse of the products and activities of the district.'[6]

Pride of place went to the BFI's Telekinema, a state-of-the-art facility built to enable the screening of stereoscopic 3D films. (Raymond Spottiswoode, the technical director of the Telekinema, appears to have invented the term '3D'.)[7] The Telekinema represented the most advanced media facility in the world, and to demonstrate its potential the BFI commissioned a series of short experimental films. The success of these perhaps reflected what Dylan Thomas described as the whimsical spirit that was essential to the Festival's success.[8] 'The main programme [of the Telekinema] consisted of specially made 3D films for which you had to put on polarizing glasses, with one lens red and the other green', remembered critic Peter Wollen, 'there were two animation films in the programme, made by Norman McLaren, and a demonstration film of the London Zoo.' It was, said Wollen, 'my first introduction to experimental film.'[9]

McLaren's two films with Canadian animator Evelyn Lambart, *Now is the Time (To Put on Your Glasses)* (1951) and *Around Is Around* (1951) were abstract shorts made up of oscillating patterns of shapes and sounds. While André Bazin hailed *Around Is Around* as a 'new and decisive step towards total

Around is Around (Norman McLaren, National Film Board of Canada / British Film Institute, 1951).

cinema,' McLaren's films also drew inspiration from Len Lye's films of the 1930s. McLaren had worked with Lye at the GPO Unit, where under Lye's influence he had first begun painting animations directly on to film. Like *Family Portrait*, McLaren's films stitched together a vision of the future with references to the past, but unlike *Family Portrait*, the films in the Telekinema became a popular sensation. McLaren's audiovisual experimentation also had the advantage of existing beyond the easy control of the cultural bureaucracy.

While the Telekinema was demolished in 1957, McLaren's 3D films struck a heavy blow against the sober pedagogical conventions of realist propaganda film. By throwing audiences into immersive worlds, the experimental film cultures of the mid-century anticipated a mode of propaganda in which networked media images coalesce into an unending, and constantly unfolding, all-pervasive audiovisual universe. This was to be the central pathway from the world of cultural propaganda into the world of total propaganda. The immediate impact of the Telekinema was to prompt Hollywood to invest in 3D, while the popularity of McLaren's films prompted the BFI to launch its Experimental Film Fund in 1952, the first of a wave of initiatives that supported a genuinely impressive range of new filmmaking, including work by distinctive talents such as Lindsay Anderson, Tony Richardson, Derek Jarman, Terence Davies, Sally Potter and Isaac Julien, as well as a film co-directed by Peter Wollen with film theorist Laura Mulvey.[10] By the late 1980s it was possible to draw a line from the Festival of Britain to a brand of British countercultural film that had indeed became part of the 'common human heritage' of international cinema.

In 1964, the Canadian scholar Marshall McLuhan published the book that would make him a global celebrity. Among other things, *Understanding Media: The Extensions of Man*, argued that the modern mass media should be understood as an environment.[11] Instead of focusing on discrete cultural objects in the media sphere, McLuhan emphasised the importance of understanding the media in its totality. With a nod to Jacques Ellul, McLuhan understood propaganda as 'macroscopic gesticulation, the total culture in action'.[12]

McLuhan argued that whereas the age of printed media had underpinned individual privacy, linear narratives and industrial lines of production, the immediacy and sensory overload of the new media age would 'retribalize' the world by destroying the fixed perspectives of time and space. McLaren saw

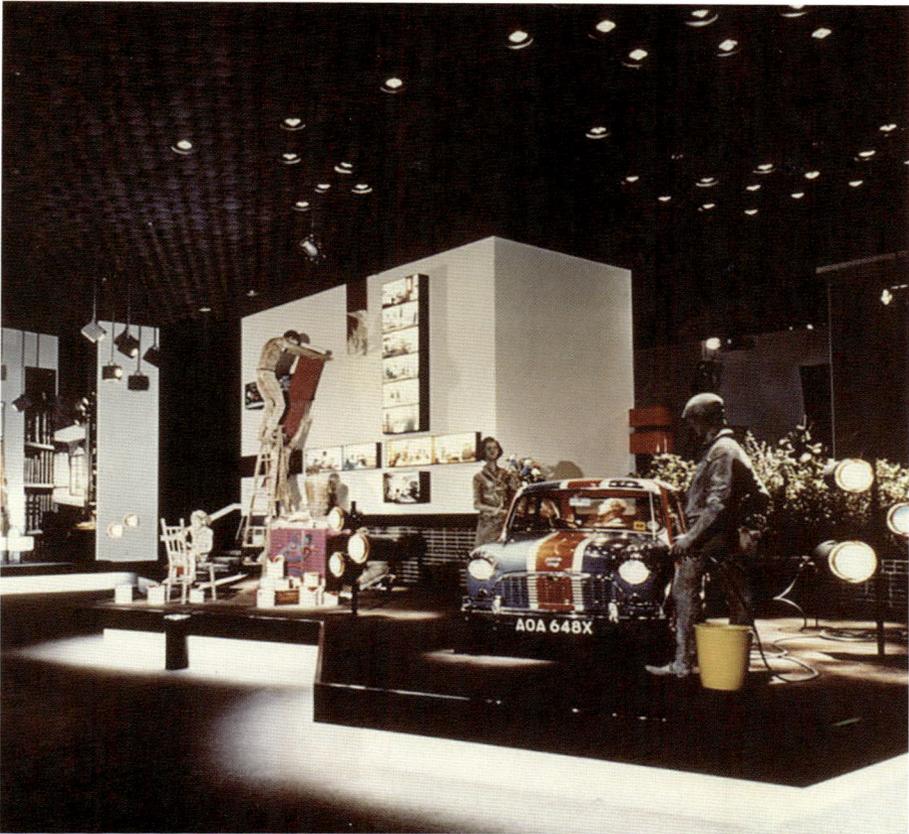

Expo 67 in Montreal (1967).

new media technology as returning human culture back to the world of cave painting. According to McLuhan, the media was a series of technologies best conceived as something like psychological scaffolding; closer in operation to roads or canals than works of art. Visual media wasn't meant to be broken down and studied in small pieces, but rather to be understood as an emotional and social landscape. If the wheel was an extension of the foot, he argued, the modern media might be considered an extension of the nervous system.[13]

Where the professor theorised, filmmakers at Expo 67 in Montreal followed. Sixteen years after his work for the Telekinema, Norman McLaren found himself working at 'McLuhan's fair' for the Canadian National Film

Board (NFB). In *Labyrinth*, the NFB's premier interactive film experience, visitors walked through a multiscreen environment constructed to 'guide them' towards the realisation that there was a shared global consciousness. Journalists described *Labyrinth*, which culminated in a series of shorts detailing cultural rituals – from a baptism in Greece to a crocodile hunt in Ethiopia – as a 45-minute 'acid trip'.[14]

To an extent, the COI was well-equipped to meet the challenge of the multimedia age. In the 1930s, Stephen Tallents had argued that successful national projection necessitated the creation of 'guilds' made up of specialised craftsmen. By making use of graphic artists like Reginald Mount and Eileen Evans, and theatre set designers such as Sean Kenny and Theo Crosby, by the time of Montreal the COI had realised Tallents' dream. The propaganda film of the future would become a component of fashion shoots, product launches and shopping centre video walls. However, while the COI proved able to build multidisciplinary teams of commercial designers, the scrapping of the Crown Film Unit in 1952 had broken its organisational link with the film industry, and it proved increasingly difficult to reintegrate filmmakers into the COI's multimedia teams.

The pavilion was supposed to demonstrate the diverse ways in which British know-how was shaping the modern world, but it proved extremely difficult for the COI to find a filmmaker able to realise this vision. Instead of displays of 'regimental bands, London buses and City of London antiquities' the COI wanted 'clothes designed by Miss Mary Quant, pop groups like The Beatles or the equivalent.'[15] Eventually, Don Levy was commissioned to produce *Opus* (1967), the COI's film for Montreal. Born in Australia, Levy had moved into filmmaking after completing a PhD in theoretical physics at the University of Cambridge. Before taking the COI's commission, he had been funded by the Nuffield Foundation to produce aesthetically challenging films that aimed at 'the advancement of education'. We can see Levy as a child of the Telekinema in the sense that his work combined avant-garde artistic practices with an interest in scientific research. Much as McLaren's animations had been shown alongside films about London Zoo, Levy matured in a culture where it was not unusual for the BFI to screen experimental works by Gregory Markopoulos alongside films from the biology labs at the University of Oxford.

Opus (Don Levy, James Archibald & Associates / Central Office of Information, 1967).

Commissioned to illustrate how Britain was responding to 'the challenge of change', *Opus* shows us footage of Eduard Paolozzi, Peter Brook, Alan Davie and the Royal Ballet hard at work. We're also introduced to the writings of Harold Pinter, the clothes of Mary Quant and the architecture of Colin St John Wilson. There is no spoken commentary, instead snippets from Benjamin Britten, Michael Tippet and The Beatles are inserted into a score from electronic music pioneer Tristram Cary.

Broadsheet newspapers praised *Opus* as excitingly modern. With the backing of Sir Thomas Fife Clark, Director General of the COI, *Opus* became Britain's entry to the Cannes Film Festival in 1967. Yet while film critics praised the film for catching the mood of the Expo, the designers of the British pavilion were less impressed.[16] In terms of ethos, *Opus* was made

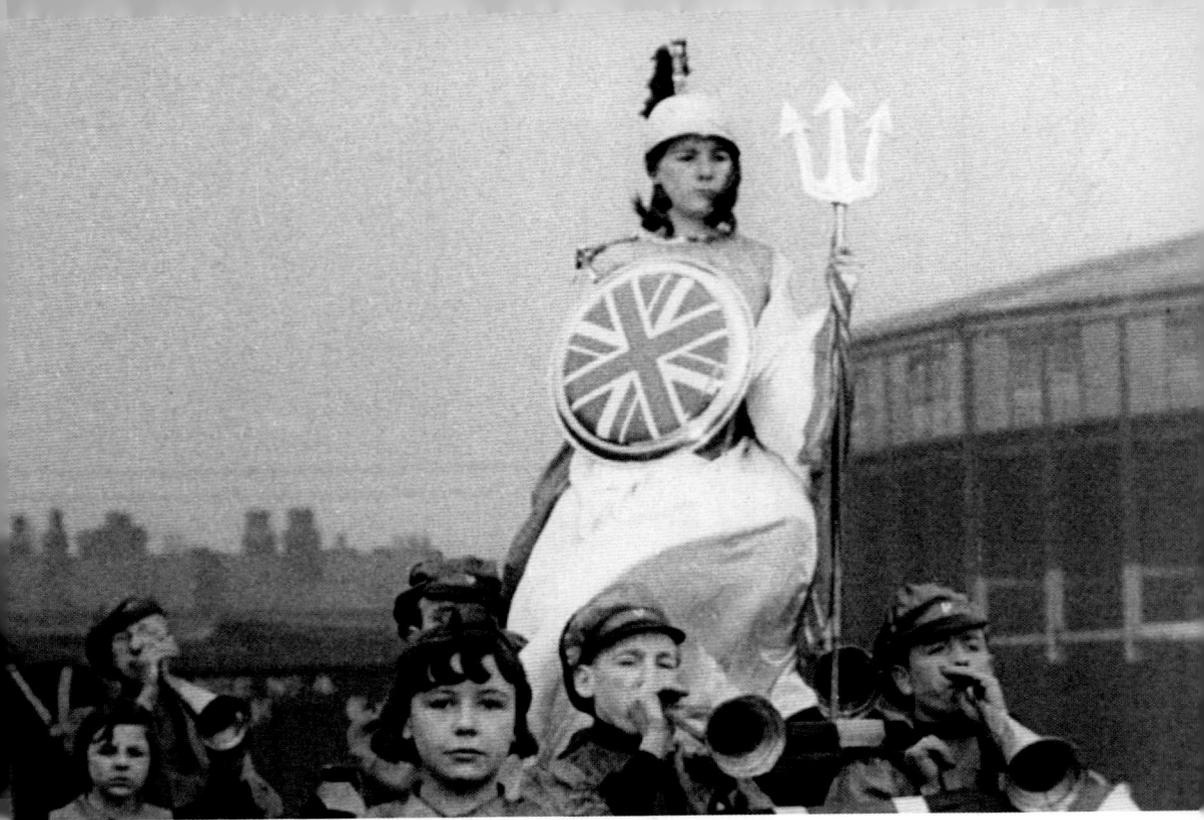

Spare Time (Humphrey Jennings, GPO Film Unit, 1939).

with indifference if not hostility to the principles of integrated design. Levy ignored his collaborators and much of their brief. By contrast, Edgar Anstey and Richard Guyatt, the much older figures overseeing the Royal College of Art's (RCA) cinematic contributions to the Expo, demanded their film-makers 'infused their love of art into the practical levels of our lives' by tailoring their films to the demands of the British Pavilion.[17] Reflecting on his experience at Montreal in *The Times*, Levy criticised 'the lack of individuality' in the British film industry, stating his ambition to produce work amplifying the 'psychedelic distortions' produced by the mediatisation of contemporary life.[18]

One of the ironies of this situation was that the COI had been producing kaleidoscopic visions of British culture – such as *London Line* – for more than a decade. *Opus* also seemed to follow in the footsteps of films like Humphrey

Jennings' *Spare Time*, which had been a centrepiece of the British Pavilion at the New York World Fair in 1939. In Jennings' film, with very little in the way of commentary, footage of kazoo bands, ballroom dancing and amateur Shakespeareans are edited together to paint an affectionate portrait of British working-class culture. By way of generational contrast, Levy's film assertively ignored the wellsprings of associational or democratic culture to draw exclusively on an emerging cultural vanguard. 'I think the cinema must ultimately and inevitably divide into serious and pop,' Levy argued, 'just has music has done.'[19]

Despite Levy's lofty ambitions, *Opus* made little impact on British film culture, for reasons that McLuhan's work had predicted. Because new media technologies excited audience demand for total absorption, McLuhan was dubious about both the possibility and relevance of artistic detachment. Instead, he highlighted ventures like *Our World* (tx. 25/6/1967), in which the BBC beamed The Beatles performing 'All You Need is Love' to 700 million people across the world by satellite. By provoking participation, identification and emotional immediacy, McLuhan saw The Beatles, rather than 'serious' film, as more suited to the new media environment.

More broadly, for McLuhan the particular significance of the 3,000 films exhibited at Expo 67 was less about the content of the films than the explosion of screens.[20] Propaganda films began to proliferate through projections, slide shows and display screens. In the burgeoning field of industrial theatre, existing technologies for synchronising lighting and sound were improved, enabling the control and coordination of complex patterns of images. As media technology became embedded into the modern urban landscape, film propaganda became the work of choreographers, set designers and special effect technicians. The conventions of representational iconography were being replaced by attempts to orchestrate a hypnotic synaesthesia.

Expo 67 offered a glimpse into the world of 'expanded media'. It anticipated a world awash with 24-hour news channels, computational propaganda, and psychologically manipulative social media platforms.

In the COI's promotional films for Expo 67, Sir Basil Spence was celebrated as the guiding influence, if not 'the author', of the British pavilion. Spence was the patron saint of British postwar reconstruction. He moved from designing

new embassies to new universities, via commissions in Athens, Baghdad and Delhi. Spence's work – including the JFK Memorial in Dallas – aimed 'to lift morale.' His fame rested on the rebuilding of Coventry Cathedral.

Before the opening of the Expo, the COI had spent several years extensively promoting the pavilion's development through models, photographs and newsreels. To take one example, in the 18 months before Expo 67, *Roundabout* distributed scores of stories directly or indirectly about the British pavilion. It carried items on South Asian and Malaysian engineers and architects inspecting its construction, on the artisanal British factories and workshops building its exhibits and furnishings, and on the planning and logistics required to realise Spence's vision. This focus on the pavilion coming into being was rhetorically significant. Not only was it an editorial device that naturally generated empathy and interest, but it was also helpful from a propaganda point of view. The story of the pavilion became the story of a multiplicity of personal struggles. Viewers weren't being encouraged to celebrate the British Pavilion, but to identify with the individual artisans struggling to pull it together. In propaganda films, Spence proudly compared himself to a tailor: his role was 'to make you feel comfortable and also elegant.'

Yet Spence's work was not universally admired. J.M. Richards unfavourably compared the British pavilion with the geodesic domes of Buckminster Fuller and the tensile structures of West Germany's Frei Otto. Next to Moshe Safdie's Habitation '67, a model community constructed out of prefabbed concrete, Spence's windowless pavilion (adorned with an unfinished tower, 'because the British story was still unfolding') was judged to be underwhelming.[21] Interestingly, while the *Daily Mail* and other mainstream conservative newspapers were for the most part happy to ignore these criticisms, a younger generation of self-described left-wing journalists viewed the Expo more sceptically. These journalists tended to view the pavilion through the prism of national decline. 'Observe the German image: industrious, prolific, functional, tough', complained Peter Preston, 'observe the dourly competent Swedes or the thrusting Americans. What have we to compete with?'[22] Spence, it was implied, had been unfairly favoured by Labour's Minister of Arts Jennie Lee. He needed to be knocked from his perch.

Preston's coverage was a harbinger of things to come. The cultural propaganda film depended on a collective sense of pride in Britain's postwar recovery, but by Expo '67 this self-confidence had begun to fray. 'On the one hand, a thousand years of history, the pomp of our royals, the memories of empire, the hallmarks of quality,' wrote Preston, 'on the other hand, junk.'

The acerbic response to the British pavilion can be understood as an early example of what McLuhan described as 'the global village', a fractious and hypercritical new social environment bought into being by the expansion of media technologies. These technologies ushered in a world where it became impossible to project a vision of Britain abroad without considering the domestic implications.

In retrospect, we can see Expo 67 as an important milestone in the architectonic development of the propaganda film, but the significance of this was much less evident at the time. British journalists were not especially interested in the consciousness-raising potential of synesthetic media images or alive to the potential of new media technologies to create a new kind of cognitive infrastructure. Their role was altogether more straightforward. They were in Montreal to extrapolate the comparative failures of the British state from what they perceived as the failings of the British Pavilion. Films of the French President Charles De Gaulle, waving to packed crowds as he sailed down the St Lawrence River to mark 425 years of French influence, were compared with Queen Elizabeth II's decision to completely avoid Montreal when she arrived in Canada to celebrate the Confederation of 1867. Britain's stature in the world appeared to be visibly collapsing.

Close up: Propaganda for the Audiovisual World

Developments at Expo 67 illustrate how the story of the propaganda film began to morph into the story of the audiovisual experience. The London theatre world, with its choreographers, set designers and prop managers, proved the perfect incubator for these developments. Freelance artisans from the worlds of music, fashion and theatre cross-subsidised their 'serious' work with commissions from advertising, nightclub design and corporate product launches. The priorities of the COI and the Foreign Office played an important role in coordinating these pockets of individual expertise in staging, lighting and sound design into an entirely new industry. The propaganda film moved steadily closer to the advertising promo – instead of content determining form, form began to determine content. The rise of the computer and optical storage made it possible to pre-programme and synthesise film and music into repeatable patterns that produced hypnotic 'emotional swells'.

By the time of Expo '88, the centrepiece of the British pavilion was 'The Crystal', an enormous inverted pyramid sculpted out of 120 television monitors (all fed by 96 minutes of imagery from a dozen synchronous video disc players). Pulsating images of Oxford laboratories, military jets and the cricketer Ian Botham were synchronised to music, while visitors passed through on a rotating floor. Overseas, similar cultural currents had led to the rise of artists such as Nam June Paik; in London it led to the establishment of new forms of advertising, propaganda and event promotion.[23] Described as 'visual confetti', 'The Crystal' illustrated the impact computers were beginning to have on the utilisation of the moving image. Innovations borrowed from Disney theme parks, George Lucas's Industrial Light & Magic studio and medical photography opened a new world of special effects. This was a propaganda of orchestration: images did little more than gesture towards – if not directly borrow from – existing cultural iconographies. 'The Crystal' was supposedly created 'in the style of [photographer] Martin Parr.'[24]

'The Crystal' also marked the career mid-point of a generation that grew up in the shadow of the Festival of Britain and would reach retirement age with the Millennium Dome.[25] Tymn Lintell, the commercial artist responsible for 'The Crystal',

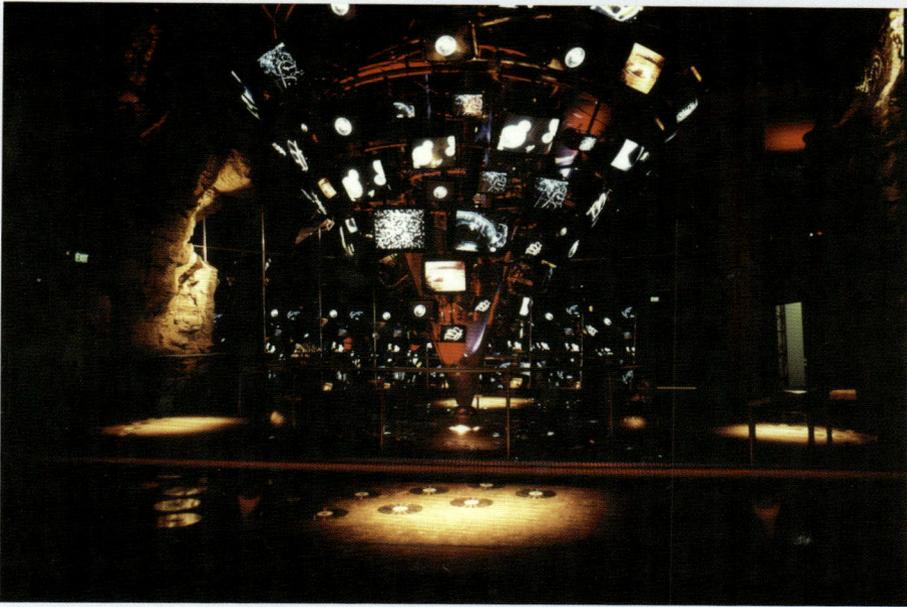

Tymn Lintell's 'The Crystal', created for Expo '88 in Brisbane, Australia

made installations for the 1972 United Nations Conference on the Environment in Stockholm, and subsequently worked on British government commissions for European trade missions and Expo '92.

The flood of National Lottery money into the British cultural sector, and the coming of the internet, further turbocharged these developments through the end of the century. 'Interactivity' became a buzzword, as portable miniature cameras, originally developed for endoscopy, were repurposed to create absorbing, immersive visual environments (rather than linear visual narratives). For cultural commissioners, these new 'interactive' technologies appealed because they promised a frictionless way to deliver 'inclusivity'. Having rhetorically wrapped together investment in media technologies with progressive social transformation, they channelled large amounts of public funding into screen-based audiovisual products, touch-screen exhibitions and computerised educational techniques.

'Instead of worrying about program content,' McLuhan had argued, 'the job is to program the total sensorium.' This is exactly what the audiovisual revolution had begun to do. The world of total propaganda was coming into being.[26]

6. PROPAGANDA FILM AND THE MONARCHY

'*A Queen is Crowned* has no equal in Hollywood or anywhere else', gushed the *New York Herald Tribune*, '[it makes] beribboned Royalty look like a Cecil B De Mille dream world. There are more soldiers than *Birth of a Nation*, more celebrities than in a month of newsreels.'[1]

The Coronation of Queen Elizabeth II was a global media sensation, and *A Queen is Crowned*, the official film of the ceremony, was the highest grossing film of 1953. It was a lavish production. 700 Technicolor prints of the film were made (a record at the time), and it was subsequently released in nine languages and 54 countries. For the first and only time, the most popular film of the year at the UK box office was a documentary.

This wasn't a success that came out of nowhere. The advent of film was coterminous with the peak of British hard power: film cameras captured both Victoria's Diamond Jubilee in 1897 and her Funeral Procession in 1901, the 1902 Coronation and 1910 Funeral of Edward VII, and the 1911 Coronation of King George V. The Coronation of King George VI in 1937 was watched by more than 100 million people around the world thanks to the huge reach of the newsreels. At its crudest level, the cinematic import of these events – and of spectacles like the Delhi durbars – can simply be understood as a reflection of state power. On the other hand, with or without the cooperation of the monarchy, a new kind of symbolic and psychological order was being created by the rapidly growing media industry.[2]

Due to a ban on filming in Westminster Abbey, the producer Charles Urban employed George Méliès to help him fake footage of Edward VII's Coronation,

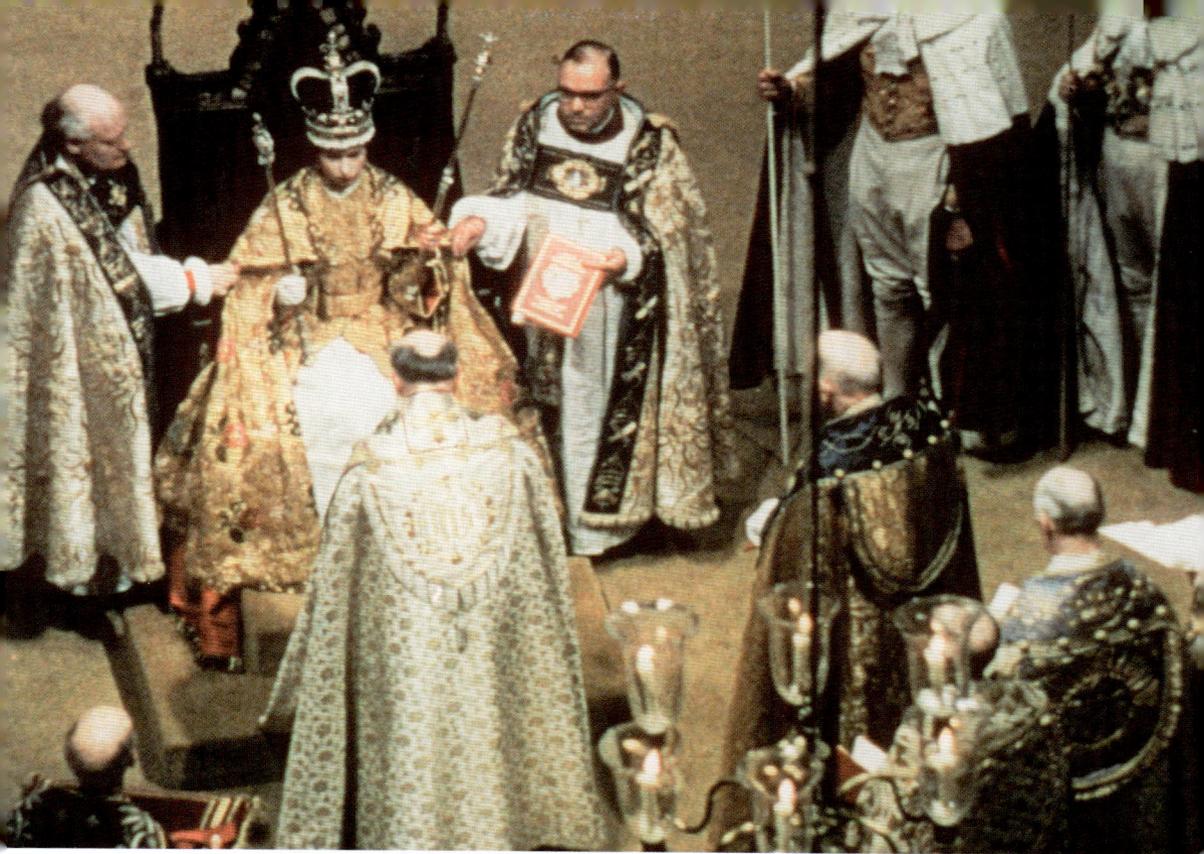

A Queen is Crowned (Michael Waldman, 1953).

while the death of King George V in 1937 opened the floodgates to a series of blockbuster films about Queen Victoria – depictions of the King's mother had been banned during his lifetime – such as *Victoria the Great* (1937) and *Sixty Glorious Years* (1938), both directed by Herbert Wilcox and starring Anna Neagle. By 1953, Hollywood film studios were pegging new commercial releases to the Coronation. MGM's *Young Bess* (US, 1953), about the early life of Queen Elizabeth I, was one of ten films about the British royal family released that year. From a propaganda perspective, having been outflanked by the commercial media industry, the Coronation marked an important attempt to self-consciously manage the global image of the royal family.[3] British film-makers, broadcasters and news media pledged to help build 'a new kind of legitimacy' for the royal family in exchange for greater access.[4]

To mark the Coronation, processions, youth festivals and civic receptions, had been staged in celebration across the Commonwealth. A diarist recounted: 'I thought I was immune, but I awoke this morning with the feeling that this day was different, like Christmas or one's birthday.'[5] Famously, 30 million British people would watch the Coronation on television, marking a watershed moment in the popularity of a still new medium. Prisoners were permitted to communally watch the television coverage. 'In experiencing television we have experienced a new extension of our senses,' *The Observer* reflected, 'and a major new factor in our public life'.[6] A new kind of community was coming into being, a community which depended on the sense of participation being generated by the shared consumption of visual media. These diverse experiences were themselves filmed and reported on, creating a powerful feedback loop. Indeed, one of the interesting things about *A Queen is Crowned* was the extent to which people flocked to the cinema to rewatch something they had already seen on television (albeit on a small black and white screen).[7] The filming of the Coronation exemplified a phenomenon noted by commentators at the time and subsequently theorised by Stuart Hall: the media does not just represent; it (re)produces.[8]

In the follow-up documentary, *Flight of the White Heron* (1954), dances, race meetings and war memorials become the set pieces knitting together the Queen's tour of the Commonwealth. In the US, where the film was renamed *Royal Tour*, the Queen was described as 'the first lady of the screen', whose performance flanked by 70,000 dancers in Melbourne 'beats anything I have yet seen in the way of giant Hollywood dance routines.'[9] While in America the monarchy tended to be described in the language of Hollywood spectaculars, it's important to note that Hollywood also borrowed from the aesthetic of these British films. For example, Christopher Fry, the Christian modernist who wrote the commentary for *A Queen is Crowned*, would subsequently work on epics such as *Ben Hur* (1959)[10].

Of course, the crowning of a monarch had always been both a highly-staged and symbolically-charged event, but the new compact between sovereign, state and the media forged around the Coronation of Elizabeth II would have profound implications for the future of the British propaganda film.

In the immediate postwar period, British politicians were keen to actively utilise the propaganda potential of the royal family. Speaking in the context of

the Partition of India, Clement Attlee praised the royal family's ability to appeal across national boundaries, and hoped that the monarchy could unify the Commonwealth like 'the holy family in the Christian world'.[11] While it's impossible to believe the Nehru government understood the British monarchy in the same way, this wasn't just delusion on Attlee's part. Historians have since argued that loyalty to the monarch was foundationally important to Indian soldiers in the First World War. Attlee seems to have assumed that this generational sentiment would stretch endlessly into the future.

Perhaps surprisingly, interest in, tolerance of and even support for the British monarchy could at times co-exist with the growth of independence movements. In Kenya, the Colonial Office reported that the *Royal Tour* films, released in both Swahili and English, were the most popular titles of 1957. Affection for the Queen could be (and sometimes was) decoupled from subservience to the demands of the British state. Films like *Self-Government for Western Nigeria* (1958) positioned local leaders like Chief Awolowo next to Queen Elizabeth II.

Gender was important here. 'Every British lad sees the Queen in his girl and his girl in the Queen,' as *The Express* had put it on Coronation Day, 'every father sees there his daughter, every infant his mother.'[12] Throughout the Commonwealth, films, newsreels and magazines commented on the monarch's appearance. 'New Zealand and Australian women pride themselves as being among the best dressed in the world,' it was reported during the Royal Tour 'and it was natural that they should want to see what the Queen was wearing.' Films and images of the Queen promoted Commonwealth unity through 'panoply and pageantry' but also bolstered the popularity of British cosmetics and clothing.[13]

The image of the Queen was used to sell millions of plates, tablecloths, powder compacts, goblets and tea towels, alongside cosmetics like Elizabeth Arden's Pink Perfection 'crown jewel lipstick'. Whatever political impact these films had was a consequence of the Queen's appeal to international audiences. Lord Lucas described the tour as 'the greatest piece of selling I have seen in my life.'[14]

Films about the British monarchy were also used by Commonwealth countries to attract international media attention. The Nigerian Film Unit's *Nigeria Greets the Queen* (1956) was made primarily for domestic audi-

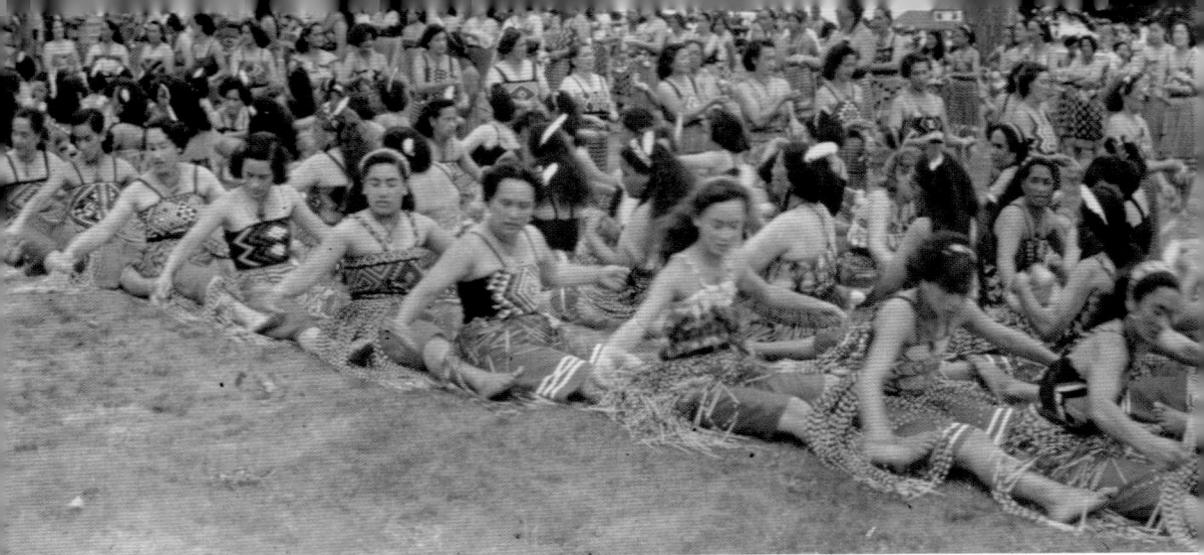

Flight of the White Heron (aka *Royal Tour*, British Movietonews, 1958).

ences, but demand from distributors based in America, Australia, Canada and India made it into a commercial success. *And the Princess Came* (1956), which detailed Princess Margaret's visit to Mauritius, would be used by the post-colonial government to promote international tourism.[15] Conversely, footage during the Coronation of charismatic Commonwealth leaders such as Queen Salote of Tonga bought them a degree of global fame and popular affection.

Over the course of the 20th century, the royal family's ability to generate popular international sentiment beyond the control of the state would become a source of growing anxiety for British politicians. One political effect of the collapse of empire was that the Coronation had decoupled the Queen's domestic status from her new role as Head of the Commonwealth.[16] Officials and elected representatives from across the Commonwealth were now in theory able to offer advice and briefings to the 'British' monarch.

While the postwar British state was setting a course toward centralisation and administrative modernisation, decolonisation would reconstitute the monarchy as the head of an entirely different type of international associa-tion. The Queen now sat at the head of an organisationally amorphous entity, comprised of disparate peoples, living by very different values, scattered over an enormous geographical area. British politicians were often discomforted

as the Queen was pictured alongside 'troublesome' post-colonial leaders. Frustrated by the lack of clear diplomatic boundaries, British politicians and diplomats often quietly encouraged former colonies to become republics.[17]

Over the last 30 years there has been a marked upsurge in the number of films produced about the British monarchy. One argument is that this trend is linked to Britain becoming a service economy. In a globalised world, instead of national industries, Britain has national stories. In this reading, the royal family's pre-eminence reflects its ability to generate an array of captivating characters, stories and myths that can be amplified by the mass media. The monarchy, a bit like the Premier League or Harry Potter, has thus become the perfect vehicle for selling British theatre, holidays and heritage. On the screen it provides the aesthetic backdrop against which a standardised mixture of action, romance and family drama can play out: turning the organisational fabric of the nation into something like a British equivalent of the Marvel Cinematic Universe.

In terms of their ability to project a national image, it feels significant that so many recent films deal with the waning of power: *The Madness of King George* (Nicholas Hytner, 1994), *Mrs Brown* (John Madden, 1997), *The Queen* (Stephen Frears, 2006), *Young Victoria* (Jean-Marc Vallée, 2009), *The King's Speech* (Tom Hooper, 2010), *The Favourite* (Yorgos Lanthimos, 2018). These films don't straightforwardly attack the inequality of political agency, or the idea that social privilege should be determined by birth. What could have been chastening stories about unpredictability, despotism or monarchic irrationality are instead fashioned as more sympathetic stories about isolation, loneliness and vulnerability – explorations of pained responsibility, rather than parables about unaccountable elites or enormous asymmetries of power. Not uncoincidentally, these films also tend to exist in the orbit of the British 'prestige' film: the British monarchy becomes a marionette show of universalised middle-class anxieties. There's a sense that these films reflect the values of the English-speaking bourgeoisie.[18] For British actors, the monarchy has also been a reliable vehicle which they can use to build their profile in America. This is a trend with a long history. Setting a precedent which countless others have followed, *The Loves of Queen Elizabeth* (1912) provided the French actress Sarah Bernhardt with the role that cemented her status as an icon of early cinema.[19]

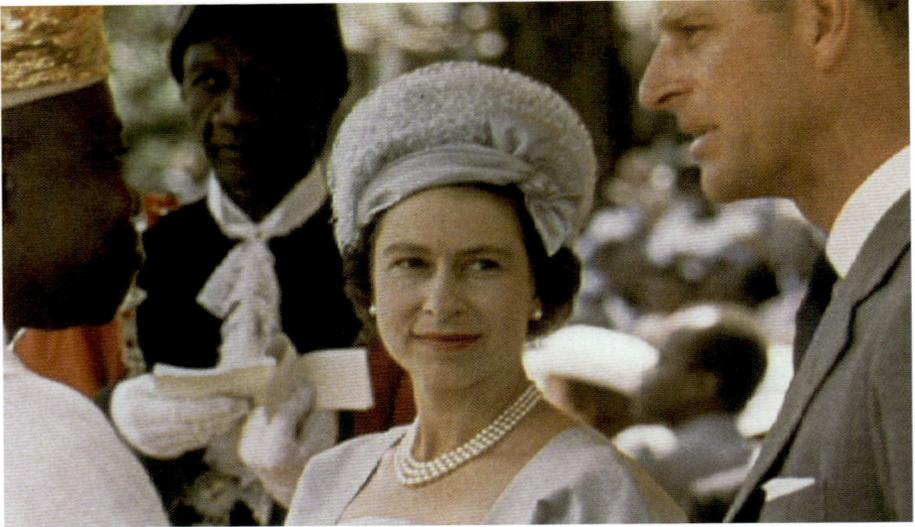

Sierra Leone Greets the Queen (British Pathé / Central Office of Information, 1961).

It was a development that also emphasised that, in an age defined by media technologies, celebrities were the new aristocracy. Since Bernhardt, to play a monarch in a major international film or television production has become a reliable way to be anointed into the upper echelon of the acting profession. By taking the role of monarchs, actors like Colin Firth, Helen Mirren and Olivia Colman have become internationally recognisable symbols of 'Britain'.

This is not a phenomenon that the royal family have themselves been able to capitalise on. This is because positive public identification with the royal family over the past 100 years has rested on the idea that the crown weighs heavily. Free of its exacting demands individual members of the royal family can quickly come to seem grasping, greedy and out of touch. The failure of Prince Edward's production company Ardent Productions is a case in point. While Ardent tried its hand at political soap operas, documentaries about real tennis, disability and the Holocaust, its need to generate overseas sales pushed it to focus increasingly on programmes about royal retainers, royal residences and royal family members.[20] In the process, Prince Edward opened himself up to accusations that he was exploiting his status and

connections.[21] Ardent was eventually wound up after it was discovered that the company was secretly filming Prince William while he was studying at St Andrews University. Farcically, this occurred after the Palace had warned the media about intruding into Prince William's privacy.[22] More recent initiatives, such as Prince Harry and Meghan Markle's deal with Netflix, threaten the political self-abnegation that has been central to the symbolic power of the monarchy. Without this, or a sense of shared suffering or national trauma, the remoteness of the monarchy from everyday experiences quickly becomes apparent. Indeed, greater media intrusion has markedly increased the importance of self-abnegation. The impulse behind films like Vice's *Meghan Markle: Escaping the Crown* (2020) is unlikely to be helpful to the monarchy in this respect.

Instead, perhaps the most notable development over the past 25 years is the strange way that the popular image of Queen Elizabeth II became so closely tied to the work of a single screenwriter. Peter Morgan was cata-

The Queen (Stephen Frears, 2006).

pulted to global fame as the writer of Stephen Frears' *The Queen* (2006), which dealt with the impact of Princess Diana's death on perceptions of the royal family. It was followed by the successful stage play *The Audience* (2013), about the relationship between the Queen and successive British prime ministers, and then the big-budget TV series *The Crown*, which tracks the life and reign of Queen Elizabeth II.[23] After premiering on Netflix in 2016, *The Crown* has grown steadily in popularity. By January 2020 it had been watched by some 73 million households. Across the Americas and Asia the series has created a powerful image of Britain.

While the British state has never been able to exert much control over the meanings of the monarch, Morgan has been able to situate the royal family in a variety of loaded political contexts with a level of discursive freedom unimaginable to a journalist, an elected politician or to the royal family itself.

The Crown is exemplary propaganda in the sense that it generates a variety of internationally popular historical stories about life in modern Britain. Often these stories have been dramatically simplified, at other times they have been entirely fabricated.[24] Attlee valued the monarchy because it kept 'Britishness' at a distance from political and diplomatic controversies, but by the end of Queen Elizabeth II's reign the global entertainment industry had tightly editorialised her life to reflect the fantasies of an educated global elite.

As the reign of Queen Elizabeth II drew to a close, her Coronation was restaged in novels, films and television programmes. In an episode suggestively titled 'Smoke and Mirrors', *The Crown* mixed archive footage of the Coronation with reconstructions starring the actor Claire Foy as Elizabeth II. While the Queen is wary of the presence of television cameras, Prince Philip (played by Matt Smith) argues television will make the Coronation 'less ostentatious, more egalitarian (and) forward-looking'. Reflections on the mediation of the monarch's image were used to encourage a collective reckoning on the meanings of the recent British past.

Images of the royal family punctuate British life: their births, deaths and weddings are committed to public memory and underpin powerful representations of Britain abroad. The Duke and Duchess of Cambridge's wedding in 2011 was watched live by two billion people around the world on a multitude of channels and platforms, including the royal family's own

YouTube channel.[25] It was not a surprise when in 2017 *The Guardian* revealed that every aspect of Queen Elizabeth II's death had already been meticulously planned.[26] Indeed, one consequence of increasing mediatisation is that the kinds of errors, mishaps and behavioural excesses that had marked royal ceremonies of the past have been rehearsed out of existence.[27] While staging the Coronation in 1953 meant setting up stands to accommodate cheering crowds along the Mall, and preparations for Queen Elizabeth II's Golden Jubilee in 2002 entailed erecting giant open-air screens, Queen Elizabeth II's death in 2022 was a multimedia extravaganza. In addition to an estimated 29 million watching the funeral on television in the UK (a number which itself omits people watching communally in pubs, cinemas and care homes), a further 10 million people watched the BBC's coverage on YouTube, with more following events on social media channels such as TikTok.[28] Footage of the Queen lying in state was streamed 25 million times across BBC online.[29]

These numbers illustrated the extent to which, by the end of her life, Queen Elizabeth II had become a particularly powerful media symbol. To an extent this extraordinary popularity can be explained simply by her longevity. Besides the official overseas visits and biennial meetings of the heads of Commonwealth countries, for seven decades the Queen honoured a remorseless schedule, including staple events such as the state opening of Parliament; Remembrance Sunday; the Christmas Day broadcast; the Trooping the Colour; and a series of 4,000-guest garden parties at Buckingham Palace.

In a piece entitled 'Why Queen Elizabeth II was one of the greatest performance artists of all time', Louis Jebb compared the Queen to Marina Abramovic. 'But in the Queen's case,' he wrote, 'answering the need of humans to have contact, to engage with her, lasted not for three months (as in Abramovic's *The Artist is Present* (2010)) but for more than 70 years.'[30]

Film clips of the monarch can be found to illustrate just about every political, cultural and social story about the recent past that will ever be told, from the collapse of the Soviet Union to the end of apartheid and the handover of Hong Kong, to the death of Diana, the War on Terror and Covid-19. Since *The Royal Family* (1969), Richard Cawston's 'behind the scenes' television documentary (unusually broadcast on both BBC1 and ITV), the monarchy became

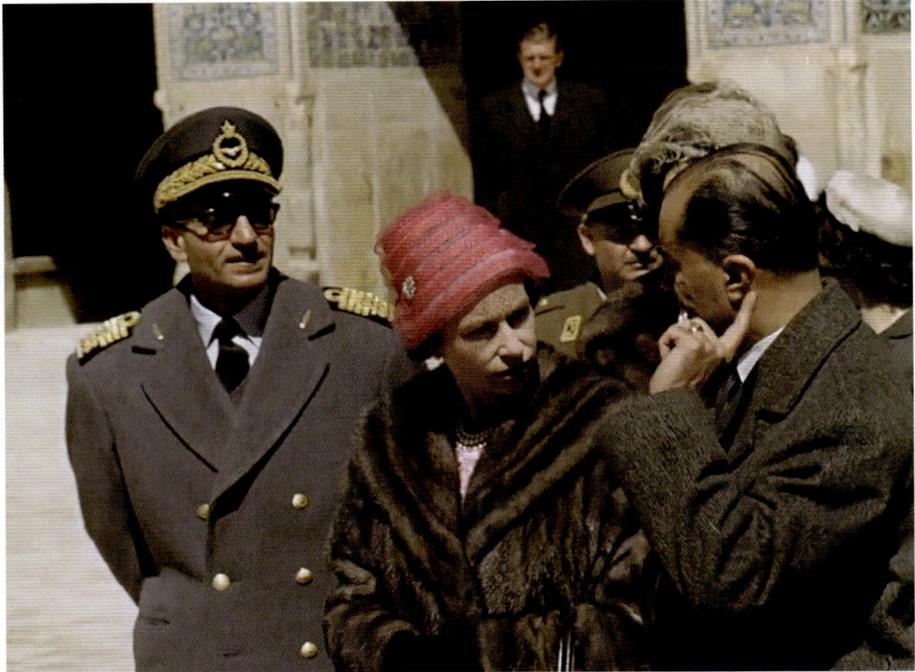

The Queen's State Visit to Iran (Central Office of Information, 1961).

increasingly responsive to the expectation that they should record and share the less formal aspects of their lives. While Cawston's programme was subsequently judged to have intruded too far – and has never been shown since its first airing – the need to manufacture intimacy through the deployment of media technology has grown ever stronger.

In *A Jubilee Tribute to the Queen by the Prince of Wales* (2012), viewers were invited to join the Prince of Wales exploring 'hidden treasures' of the Royals' visual archive. As the future King Charles III talks audiences through a selection of the royal family's home movies, the audience are encouraged to ask 'where were you when?'. The effect is to give emotional continuity to a shared story of Britishness. Some of the footage of Balmoral, horses and Winston Churchill was revealed to have been taken by the Queen herself – a powerful demonstration of the ways in which film can collapse the distance between a national perspective and a very subjective one.[31]

Following the success of John Bridcut's *Jubilee Tribute* (BBC, 2012) came *Diana, Our Mother: Her Life and Legacy* (2017) and *Diana, 7 Days* (2017), which were commissioned by her sons Prince William and Prince Harry to commemorate the 20th anniversary of Princess Diana's death. Similarly, *Prince, Son and Heir: Charles at 70* (2018), was commissioned to celebrate the Prince of Wales' 70th birthday. To celebrate the Platinum Jubilee there was *Elizabeth: The Unseen Queen* (2022), which mixed footage of George V, as well as Princess Anne and the future King Charles III as playful toddlers, to moving and valedictory effect. By the end of Queen Elizabeth II's reign her life was increasingly mediated through digitised archival footage.

Queen Elizabeth II's last memorable film appearance was in a comedy sketch with Paddington Bear, written by Frank Cottrell Boyce. Boyce linked the film's resonance with both her personal situation ('a woman waving a happy goodbye to her grandchildren and great grandchildren, an image of love and a happy death') and a larger national one ('she was a living connection with the postwar consensus'). 'The most emotional moment in that encounter with Paddington is when the bear says: "Thank you, Ma'am. For everything."', he wrote, 'I'm thankful for the way she (the Queen) used the peculiar power of her archaic role to allow us to glimpse, however fleetingly, that we share something good and that we need to defend that.'[32]

These 'personal' tributes reflect both the changing social mores of the 21st century and the power of new media technologies to shape expectations of representation. Queen Elizabeth II's symbolic power partly stemmed from the fact that she allowed people to perceive contemporary Britain within a larger frame of living memory. Because she was not a driving cause of the political and social transformations of the post war period, she also became a potent and incredibly flexible index of them.

At the start of her reign Queen Elizabeth II had rubbed shoulders with substantive figures of 20th-century political history such as Archbishop Makarios, Kwame Nkrumah and Lee Kuan Yew. But by the end of her reign the pattern had been inverted, and considerably less impressive political figures sought out an audience. While Britain's politicians became ever more subservient to the US through the postwar period, American presidents still jostled to get their picture taken with the Queen.

Elizabeth: the Unseen Queen (BBC, 2022).

Indeed, the last decades of the Queen's reign saw a marked increase in deference towards her. Internationally, she was the beneficiary of a growing constitutional conservatism. From Australia to St Vincent and the Grenadines, when presented with a choice, the majority of people were not persuaded by the case to replace her. Domestically, Queen Elizabeth II's personal standing also benefitted from the emergence of a new generation of sharp elbowed politicians. It's been argued that the staged flag-waving crowds that greeted Tony Blair's arrival at Downing Street in 1997 began a trend of highly personalised 'presidential' politics. It's certainly true that 'Tony', 'Dave' and 'Boris' liked to have their picture taken with soldiers and hold press conferences in front of the Union Jack. The idea that politicians are servants of the crown was steadily eroded. This was a generation of politicians who instead encouraged the public to equate 'the nation' with the sectarian pronouncements of their governments, and by doing so inadvertently added to the unifying appeal of a much longer-serving national figurehead.[33] Whether King Charles III possesses the personal charm or the restraint to assume an equivalent role is far from certain. In propaganda terms, the death of Queen Elizabeth II seems more likely to enable even greater state control of the national image.

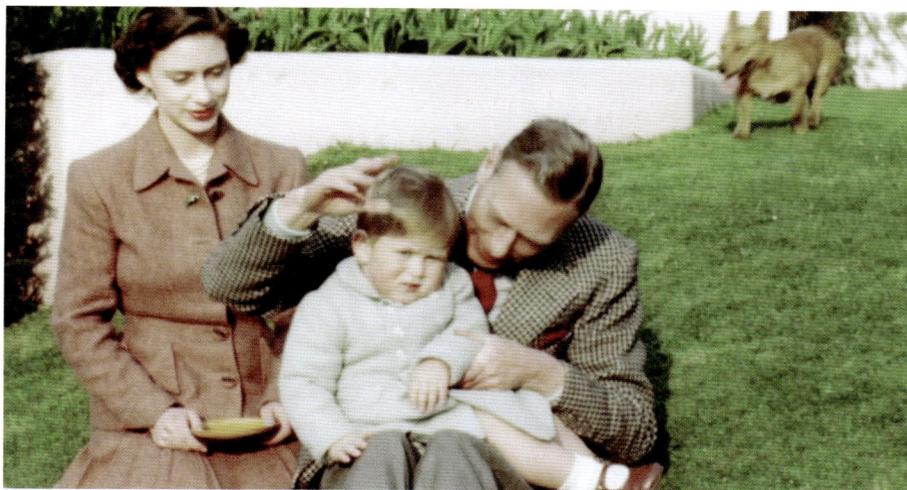

Elizabeth: the Unseen Queen (BBC, 2022).

Indeed, even before her death there was growing criticism of the ways in which an ageing Queen Elizabeth II appeared to be pressured into making public statements on contested issues such as Brexit, climate change and Scottish independence.[34] The argument here is that in the emerging era of 'total' propaganda the place of the monarch will be further diminished and the idea of national loyalty will be increasingly collapsed into obedience to the British state.

Close-up: Education and the Propaganda Film

By the 1970s, British universities were the fastest growing national industry after electronics and natural gas. Accordingly, the education sector played an important role in creating a new iconography of Britain. This included the world's largest radio telescope at Jodrell Bank, the Institute of Theoretical Astronomy at Cambridge and the modernist buildings of Basil Spence.

The growth of mass education was arguably the defining characteristic of the postwar era. Before the Second World War only about 14% of the population progressed to secondary school. While the British Council had made films such as *Oxford* (1940) and *A Farmer's Boy* (1945), promoting Britain's elite universities as well as its vocational education, the second half of the century saw a shift of emphasis. Now, the provision of mass education become a focus of national pride.

While *Comprehensive School* (1962) works something like an organogram – marching viewers through the facilities, aims and pedagogies employed at Holland Park School in West London – it was commissioned from the COI by the Colonial

Comprehensive School (Maxwell Munden, Central Office of Information, 1962).

Office to promote a particular way of life. Educating citizens, and in the process raising living standards, had become one of the key justifications for the expansion of the state.

Propaganda films like *New Universities* (1967) illustrate this even more clearly. Here the COI promoted Britain's higher education sector as a response to the demands of new business methods, computing technologies and advances in the social sciences. *New Universities* also introduces us to the figure of Asa Briggs, an important advisor to the COI who came to feature frequently in their films. After serving as an intelligence officer at Bletchley Park during the war, Professor Briggs became an outstanding social historian, whose commitment to mass education placed him at the centre of a new stratum of postwar professional elite. During the Cold War, the education provided by the British state was often contrasted with Soviet propaganda. Later COI films about education – like *Henry Pluckrose* (*The Pacemakers,* 1971) – illustrate how the promotion of British peda-gogical expertise was tied in with the idea that a rounded education was the best defence against totalitarianism.

Pluckrose, the headmaster of Prior Weston Primary School in the City of London, had become famous for promoting learning in mixed-aged groups and abandoning classrooms for open 'teaching areas'. According to this ethos, the role of education was to instil self-confidence, the courage to question orthodoxy and the ability to resist social pressures to conform.

What made Pluckrose an especially attractive subject for the British over-seas information services was that, as well as a charismatic headmaster, he was a prolific researcher, writer and public speaker. His key book, 'Open School, Open Society' (1975), advanced the idea that schools should be the focal point of their local communities. It was a thesis that saw Pluckrose employed as a consultant in Bulgaria, Canada, France, Germany, Singapore, Hong Kong and the USA.

However, governmental tolerance for the pedagogical expansiveness that had animated Pluckrose was fatally weakened by the collapse of the Soviet Union. While the British educational consultant became a ubiquitous presence overseas in the 21st century, efforts to quantify measurable (and repeatable) benefits to students would pull control of pedagogical innovation away from educators and towards administrative auditors. This transformation of ethos in the educational sector would be mirrored across the entire field of the propaganda film as the 'cultural era' drew to a close.

7. PROPAGANDA FILM AND THE CONTEMPORARY STATE

The scrapping of the Central Office of Information by the Conservative / Liberal Democrat coalition government in 2012 can be seen to mark the end of the 'cultural' approach to propaganda film. The COI's self-image had been fashioned in a climate of relative consensus, but the end of the Cold War in Europe, the development of new digital media, the 'war on terror', mass immigration and the increasing deployment of intrusive surveillance technologies destroyed its foundations. Although announced as a cost-saving measure, the scrapping of the COI led to increases in the scope and reach of government spending on the media. The age of total propaganda was now in full swing.

When the closure of the COI was first announced, rather than alarm at what might replace it, the media reported the news with an amused nostalgia. The assumption was that society had long outgrown public information propaganda. 'The demise brings to an end more than 60 years of information films warning about topics such as the danger of strangers, farm machinery, ponds and reverse parking,' *The Times* sniggered.[1] In retrospect, the radical reshaping of the nation state begun by Margaret Thatcher can be understood as the start of a process that cut the ground from beneath the COI's feet.

In 1986, the COI's 'Tell Sid' adverts played an important role in popularising a controversial new government policy: the privatisation of British Gas. A typical 'Tell Sid' advert begins with a man rushing out of a rural pub. The man barges into a bicycling postman, who then stops to talk to an old lady at a bus stop. The 'Deep England' imagery employed is familiar, perhaps overly

British Gas Shares: Tell Sid (Central Office of Information, 1986).

familiar, but it had a radical purpose: to normalise the selling of national infrastructure. Across a series of adverts, characters urged each other to 'Tell Sid' about the opportunity to buy shares in British Gas at discounted prices.[2] In the COI's campaigns, the policy of privatisation wasn't about tearing up the postwar economic model, it was good news spreading spontaneously through a world that might have been created by the Colonial Film Unit.

But the enormous public take-up of British Gas shares was not a triumph of village gossip; it was the result of a marketing campaign that cost more than £200 million. Aesthetically, 'Tell Sid' is part of the same strain of 'Ye Olde' modernism that inspired Ridley Scott's famous Hovis advert shot against the backdrop of Gold Hill in Dorset. It's part of a cultural moment captured perfectly in Patrick Wright's contemporaneous *On Living in an Old Country*.[3] Initially used to promote the welfare state, the COI was, by the 1980s, commissioning commercial agencies to popularise privatisation. By

directing a self-conscious pastiche of older aesthetics, ideas and sentiments towards bold political ends, 'Tell Sid' might even represent the first post-modern public information campaign.

While the era of 'High Thatcherism' passed relatively quickly, the COI struggled to find a new footing in a world that was increasingly shaped by pan-national commercial, political, and media convergence. Indeed, one of the impacts of Thatcherism was to reconfigure the COI towards the regula-tion, rather than the production of public information. During the John Major government, the COI was tasked with promoting a 'Citizen's Charter' that would enable citizens to monitor public services through 'performance score-cards'.[4] 'Having rolled back the state,' as Robert Hewison put it, 'the government proceeded to fill the vacuum with corporate plans, performance indicators and other forms of measurement.'[5] This was the process of government communication being reconfigured for use as a tool of governance, a pointer to a world where media communications fuse with metrics of organisational performance, as well as a reflection of the way the idea of 'accountability' was evolving in a world newly defined by outsourcing and public-private partner-ships.[6] It is worth saying that the potential larger implications of innovations such as the Citizen's Charter on the future governance of public services do not appear to have been much considered. The primary driver appears to have been defensive: the government simply wanted to create a media mechanism to insulate it from criticisms that they were wasting money.

During the 1990s the COI defaulted to slightly a more decadent version of the approach established earlier in the century by Charles Hill. The Major government appeared completely uninterested in the form and content of the COI's work. For instance, the COI's 'Know the Score' drugs campaign won industry awards but its 'informational' approach to the dangers of illegal recreational drugs in the mid-late 1990s coincided with a large rise in consumption. Commentators noted that the COI appeared to have aban-doned any attempt to seriously tackle the issue. Critics suggested that the government no longer saw the issue as a problem.[7] Reflecting an era of cheap short-haul flights, the COI even produced a series of adverts aimed at hedon-istic young travellers. The Foreign & Commonwealth Office commissioned short films about the myths, as well as the dangers, of football hooliganism. Theo Delaney, the creative responsible for those films, subsequently went

on to make films with Ray Winstone promoting the FAs 'Respect' initiative, as well as a range of 'behind the scenes' football films sponsored by betting companies, and *Finale* (2017), a film with Sir Kenneth Branagh marking Tottenham Hotspur's farewell to the old White Hart Lane.

Budget tightening also saw the COI stumble into the emerging world of 'second-hand advertising'. The brainchild of Henry Whitfield, an advertising manager at Apple, second-hand advertising saw existing promotional films repurposed for international export. Whitfield's firm infamously brokered a deal that saw a film produced for the South Carolina Federal Bank re-edited for use by the Christian Democratic party in Germany.[8] The COI jumped on this trend, offering up its archives just as the pop-cultural fashion for sampling began to explode. In Britain the first wave of rave music begat a trend for sampling children's TV programmes, and The Prodigy's 1991 single 'Charly', using 'Mummy Should Know', one of the COI's *Charly Says* (1973) public information cartoons, became an iconic example of this phenomenon. By the end of the 1990s, the COI was not only being accused of promoting

Charly Says, 'Strangers' (Central Office of Information, 1973).

popular drug culture; to an extent its work had been appropriated by that culture. For the briefest moment, an authentic popular culture was dancing on the grave of the IRD and postwar paternalism.

By the time the Labour Party returned to office in 1997 it had developed an ambivalent relationship with the media industry. During the Thatcher era, Labour liked to draw a contrast between its championing of manufacturing industries and the Conservative Party's subservience to financial services. The failure of this critique to cut through was blamed on media moguls such as Rupert Murdoch, who were accused of obscuring the real causes of Britain's political and economic troubles. The Labour Party felt they had been stitched up, while Britain's media industries had grown fat on the back of privatisation.

New Labour's subsequent assault on the media needs to be understood in the context of nearly 20 years of welled-up anger, impotence and frustration. The exact form this revenge would take would be determined by Alastair Campbell, a former *Daily Mirror* journalist who was appointed Downing Street Director of Communications. Shortly after winning power, Tony Blair's government passed the Civil Service Amendment Order of 1997, which gave political appointees the power to give orders to Civil Servants.[9] Campbell would use this authority to coordinate the machinery of government around the goals of the Prime Minister's Office. The COI's non-ministerial status had been a legacy of the Cold War; relative political independence was secured at the cost of relative political unimportance. Now answerable to the Cabinet Office, the COI was bound into what Campbell determined the communications priorities of the government to be. For the first time since the days of the Ministry of Information, Britain had a *de facto* Minister of Propaganda.

Narrative documentaries featuring 'real people' had been a staple of British film since the days of the GPO Film Unit.[10] Unscripted 'real-life' exchanges subsequently became an established feature of postwar British television. During the New Labour era, this trend of instructional realism was reborn for the age of 'reality TV.' In its most commercial formats, such as the game show *Big Brother* (Channel 4, 2000–10; Channel 5 2011–18), reality TV not only granted viewers intimate access to the lives of the contestants, but it also invited viewers to participate in their world. For a New Labour government frustrated by years in opposition, the idea of embracing these

Beat: Life on the Street (ITV, 2006–08)

popular formats to demonstrate directly the impacts of its policies proved extremely appealing. Accordingly, the COI spent millions subsiding television programmes like *Beat: Life on the Street* (ITV, 2006–08), following the work of Police Community Support Officers, and *UK Border Force* (Sky, 2008–09), about the Border Agency.[11] To the COI, the power and utility of the reality TV format was that it disassociated politicians and officials from the struggle to implement policy initiatives. Instead, by 'going behind the scenes', the day-to-day problems of ordinary workers became the central emotional and imaginative focus of government propaganda.

During the New Labour years, the British propaganda film was also reconstituted for an era shaped by 24-hour news channels. Campbell understood that multi-channel rolling news fragmented audiences and stories. COI campaigns were now infused with both a relentlessness and a directness. Series like *Transatlantic Teleview* had worked through extended interviews; the COI's adverts now simply delivered soundbites. For a COI teacher recruitment programme, celebrities and cultural figures (from the Skunk Anansie singer Skin to footballer David Seaman via Tony Blair) were filmed naming

their favourite schoolteacher. Follow-up adverts bluntly laid out the much-improved financial packages being offered to newly qualified teachers.[12] Slogans and soundbites became the preferred mode of communication because they were both difficult to challenge substantively and, if repeated enough, stood a better chance of surviving a diffuse and indifferent media environment.

The abrasiveness and impatience of such campaigns also reflected longer Labour traditions rooted in religious and ideological commitments. In opposition, the Labour Party had developed a range of intellectual critiques of the advertising industry. They had demanded restrictions on the advertising of credit cards, tobacco products and gambling, while also advocating for greater consumer rights and criticising the industry for its representation of women and ethnic minorities.[13] In power, they would re-target the Thatcherite weapon of regulation away from 'value for money' and towards the advancement of a new cultural agenda. Puritanical and post-68 critiques of media excess fed into COI roadshows on anti-social behaviour, as well as films aimed at reducing teenage pregnancies and tackling drug abuse. There was a new high-handedness in government communications: the COI now occupied a world of short and directive slogans delivered with a martial finality.

This change of approach was also driven by a generational changing of the guard. Until the 1990s, the COI had been led by figures still grounded in its postwar ethos like Keith Belben, John Bolitho and Mike Brodie. While the Thatcher government had recruited private sector expertise to work alongside these career Civil Servants, appointments had usually been from blue chip companies such as British Airways, Mars and Procter & Gamble. Ushered into retirement during the New Labour years, this rather stately managerial mix had been replaced by a younger generation of consultants drawn from the advertising industry. It became the norm for COI leadership to be recruited on short-term contracts from advertising companies like Saatchi & Saatchi. Figures like Carol Fisher and Alan Bishop bought an aggressive campaigning ethos to the COI, which would completely redefine the organisation.[14]

But for all the boasts about 'modernisation', there's also a sense that the COI had become culturally and institutionally exhausted. Perhaps because it had become so entangled with the machinery of central government, and increasingly dealt in idioms imported from the commercial advertising

industry, the majority of propaganda films produced in this period are not very interesting. The 2000s are often regarded as a relatively cultureless decade, driving interest in the internet and on-demand television thereafter, but one overlooked aspect of this is the sheer scale of state and political intervention in popular media culture.

The German philosopher Jürgen Habermas argued that meaningful social communication depended on a careful balance between 'the Lifeworld' and the forces of systemisation.[15] Essentially, he was arguing that a healthy public sphere depends on a balance between organic, independently generated social knowledge and its direction and utilisation by the big battalions of business and government. But the New Labour era saw 'the Lifeworld' completely routed by the system.

Formally, the COI's work had become both ubiquitous and indistinct. This instrumentalism reached a zenith (or nadir) when the government began negotiations with the controversial TV host Jeremy Kyle to host a government-funded reality show that would shame the unemployed into taking any available jobs.[16] 'The cultural imprint of Blairism means that the broadcasting output of the 2000s, perhaps unlike any other era in modern British history,' argued Jason Okundaye, 'can be defined by an open, pro-establishment hostility to marginalised people, in which entertainment and politics were engaged in reciprocal dialogue.'[17] This punitive approach to public information can be compared to the model of 'welfare' visible in works like Ken Loach's *I, Daniel Blake* (2016). The eclipse of the working class first established in COI series like *The Pacemakers* was now complete.

At the same time, the Cabinet Office's yardstick for measuring the success of the COI appeared to have become the re-election of the Labour Party.[18] As the COI's independence was eroded, measured responses to social problems fell out of favour. Instead, the COI tended to demonise the opponents of the Labour Party and pander to the prejudices of the professional middle-classes. The cosy COI of cartoon ginger cats had given way to a propaganda shaped by an aggressive zeal. The postwar Labour government had attempted to use the Festival of Britain to enthuse the public with a hi-tech vision of the future, the New Labour government ran adverts attacking public criticism of the Millennium Dome as the complaints of sheep 'without a mind of their own'.

During the New Labour era the COI had become the biggest advertiser in the UK. In 2009, it was named 'advertiser of the decade' by *Campaign* magazine, an accolade which reflected its swollen budget, which had grown from £47 million in 1993 to around £530 million by 2010.[19] It might be that this relentlessness helped ensure the successive re-elections of the Labour Party but these campaigns also coincided with a dramatic collapse of interest in and enthusiasm for democratic engagement.[20] By the time Labour were removed from office voter turnout had dropped to its lowest level since 1918. The COI's postwar founders had never intended to institutionalise a form of propaganda that promoted weariness, disinterest and apathy.

In 2012 the Conservative-led coalition government abolished the COI as part of its austerity programme. For a government committed to rapidly reducing public expenditure, clawing back the COI's millions appeared a politically painless way to save money.

Nevertheless, there was also a strategic calculation behind the government's decision to abolish the COI. While New Labour prided itself on modernising the COI, the incoming government saw it as fundamentally out-of-synch with the new environment of digital media. This belief apparently reflected the influence of former Saatchi & Saatchi executive Steve Hilton, now political adviser to Prime Minister David Cameron. According to Hilton, the notions of 'messaging' which had held sway during the New Labour era would swiftly become redundant in a world decentred by the spread of new media communication technologies.[21]

Instead, functions once performed by the COI would be partially fulfilled by a new Behavioural Insights Team (BIT), colloquially referred to as the 'nudge unit'.[22] Set up by Hilton and Cabinet Office minister Francis Maude in 2010, the BIT was tasked with applying the insights of behavioural psychology to public policy. This was to be done by using new media technologies to develop 'choice architecture' that integrated state propaganda with the digital administration of public services.[23]

Ultimately, this was a worldview that saw the future of government communications shaped by the fusion of public administration, digital technologies and the real-time monitoring of public sentiment. The aim was not only to 'prompt' citizens to change their behaviour, but to reconfigure the ways in which the public were governed. Scholars of science and technology

have long argued that as the power of technology increases, technology itself comes to provide a legislative structure.[24] A similar insight, along with Hilton's personal and professional ties to Google, seems to have been at the heart of this new vision.

These developments were understood as part of a global phenomenon. By selling BIT's expertise to Australia, Singapore and the USA, the British government would generate hundreds of millions in income and cement its status as a global pioneer in a new field of propaganda.[25] Even newspapers sympathetic to the government's agenda, such as *The Times*, realised that these changes entailed the beginning of an intense 'new era of spin'.[26]

Reflecting the ongoing process of centralisation, bureaucratisation and politicisation, the label 'HM Government' replaced 'COI' as the new badge of all state propaganda activities, while many of the technical functions of the COI were taken over by the Government Communication Service (GCS).[27] Communication is now understood, alongside legislation, regulation and taxation, as one of the four main 'levers' of government. Under Alex Aiken, the Executive Director at time of writing, GCS continues (in its own words) to commission government propaganda films to tackle extremism, attract inward investment and improve public health. Even after New Labour's departure from office, the UK government has remained the commercial media's most important client.

Revealingly, Aiken understands the work of the GCS as part of a story that starts in 1917, when the first Ministry of Information was set up to combat the military threat of Germany, and the ideological threat posed by the Russian Revolution. 'Helping to transform people's behaviour at home while managing Britain's reputation abroad, including countering Russia's dissembling,' according to Aiken, 'has been (government communication's) constant *raison d'être*.'[28] The idea that public information is part of a larger process of cultural mediation popularised by the COI appears to have been displaced by the return of the belief that propaganda is information warfare.

Montage: Economic Propaganda

From the interwar years to the 1980s, workers sat at the heart of the British propaganda film. Patterns of employment centred the national imaginary and were fundamental to political discourse.

CLOCKWISE FROM TOP LEFT:
Workers and Jobs (1935); *Night Shift* (1942); *Good Value* (1942); *The Balance* (1950); *Market Town* (1942); *Miners* (1976); *Ready to Wear* (1962).

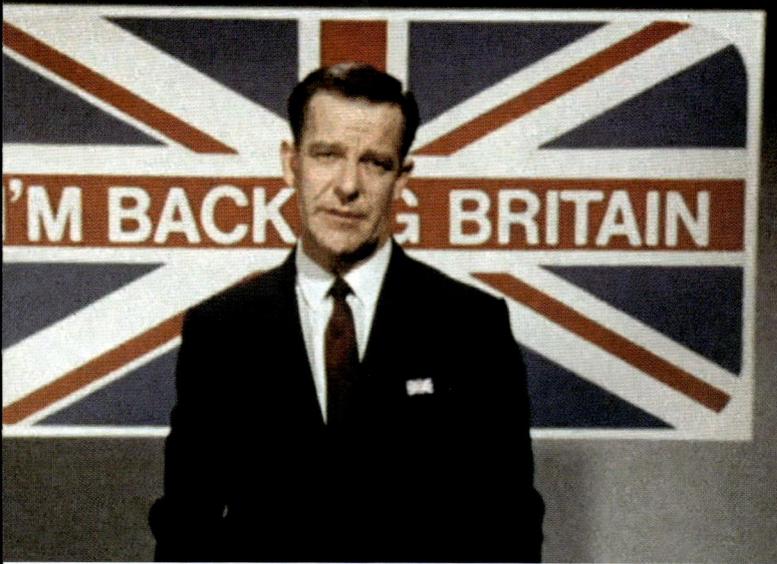

Efforts to promote exports and boost productivity gradually shifted towards the encouragement of consumption. Instead of propriety and tradition came 'openness' and the hard sell. The propaganda film sold 'Britishness' abroad and credit at home.

CLOCKWISE FROM TOP LEFT:
London Line: Colour No. 16 (1968); *London River* (1939); *Ready to Wear* (1962); *Uncommon Market* (1970); *Robinson Charley* (1948); *Bank of England* (1960).

8. BRITISH CINEMA IN THE ERA OF TOTAL PROPAGANDA

In 1999, the filmmaker Alan Parker was appointed the first chairman of the UK Film Council (UKFC). Parker was a sharp-tongued mogul for the 21st century, and his appointment helped spark a renaissance in the British film industry. Every year the UKFC was in existence box office receipts for British films went up, as did the level of inward investment in the British film industry. Yet at the same time, the creation of the UKFC was part of a sustained attempt by New Labour to instrumentalise film for national ends.

While the effectiveness and wisdom of the changes bought in train by the UKFC are debatable, its long-term impact was to entrench a set of tight bureaucratic, managerial and commercial imperatives into the commercial industry. British film was now instrumentalised to boost the national economy or to serve specific political goals, such as ensuring 'equal' visual representation of the UK's nations.[1] The film industry – and the national creative industries – had been reconfigured in terms amenable to strict administrative oversight and control. Unlike Alexander Korda or Michael Balcon, Parker was a mogul of the political bureaucracy, who turned commercial film into a type of propaganda.

In opposition to the pomposity, pretension and avarice that he believed dominated the British film industry, Parker wanted the UKFC to target Hollywood's 'lost middle'. British film productions would attempt to occupy the space that had been vacated by American studios by producing intelligent filmmaking that could be relied on to be interesting rather than edgy.

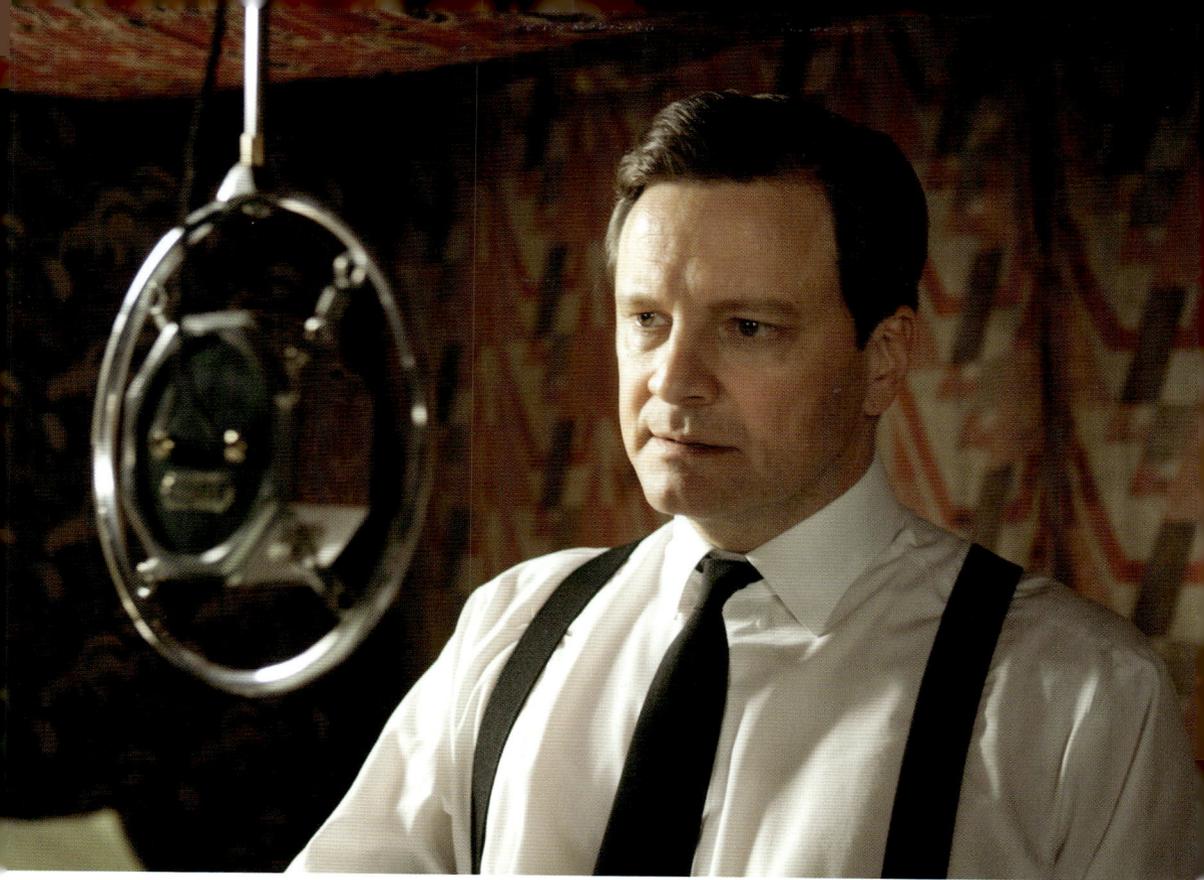

The King's Speech (Tom Hooper, 2011)

The King's Speech (2011) provides the best standalone example of the UKFC's work; Tom Hooper's film won four Oscars and became the most commercially successful independent British film of all time.[2]

Of course, the genesis of Parker's ambitions and the creation of the UKFC need to be situated in a longer story of British fiction film. In 1985, Margaret Thatcher had scrapped the Eady Levy, which for 35 years had redistributed a percentage of box-office receipts back to domestic production. While this move destroyed sizeable parts of the British film industry, the subsequent hardship had bred a generation of determined and commercially entrepreneurial filmmakers. Out of necessity, a Do-It-Yourself ethos emerged that – tinged with a brush of punkish, countercultural attitude – resulted in a wave of distinctive, iconoclastic and unconventional films.[3]

A Turnip Head's Guide to the British Film Industry (Alan Parker, Channel 4, 1986).

Perhaps because he had weathered these hardships, Parker took an acerbic attitude towards the inherited conventions of British film. In 1985, his television documentary *A Turnip Head's Guide to the British Film Industry* (ITV) argued that British film had been undone from within by snobbish intellectuals, emotional frigidity and the trappings of the class system. The criticisms of British modernity first floated by upwardly-mobile 'leftist' professionals like Peter Preston at Expo 67 had now become a mainstream sentiment. What particularly irked Parker was the 'London bus film'. The tacky, fake and somewhat patronising cultural detritus of Swinging London that had been foisted on unsuspecting foreigners by the British film industry.[4]

In contrast, Parker celebrated the achievements of his own generation. Because of their background in advertising, he argued, filmmakers like Hugh Hudson, David Puttnam, Ridley Scott and himself were more attuned to the

importance of building appealing visions of 'the common life'.[5] Parker's vision might also be seen as reflected in his own big-hearted productions like *Bugsy Malone* (1976), *Fame* (US, 1980) and *The Commitments* (US/UK, 1991).[6]

Paradoxically, the film world that matured with the advent of the UKFC and New Labour was often at once explicitly 'Anti-Thatcher' and deeply Thatcherite in many of its assumptions. 'The British film industry never existed, and in the brutal age of global capitalism, it never will,' as Parker put it, 'the era of small British film companies delivering parochial British films is over'.[7]

Here Parker's vision for film was of a piece with New Labour's wider reshaping of the national arts bureaucracies and the new approach to propaganda that they entailed. In his 1998 book *Creative Britain*, Chris Smith (now Lord Smith), who became the first Secretary of State for Culture, Media, and Sport in 1997, argued that government shouldn't discriminate between 'high' and 'low' arts.[8] The rhetoric was guarded, but the impact of this shift proved significant. From the establishment of the National Gallery to the heyday of the COI, politicians and policy-makers had usually shared an implicit belief that the arts were intrinsically 'uplifting'. The partial retreat from this idea kicked away a key pillar of postwar arts policy.[9]

Lacking a language to express why culture might be important, Smith invariably fell back on economic justifications. 'The creative industries are where the growth is, where the jobs are,' he said, 'a new accommodation between those industries and the markets could boost the economy.'[10] Without a governing elite that believed in the intrinsic importance of culture (no matter how poorly-founded this belief might have been), an important rationale of the 20th century cultural propaganda film had been undermined. Instead, the nation's 'culture industries' were to be valued because of their contribution to Britain's post-industrial future.

Accordingly, the UKFC set up a 'Development Fund' to market, test and workshop film ideas into commercially viable projects with global appeal. By intervening as far up the development pipeline as possible, UKFC administrators hoped to 'professionalise' the British film industry. Notable beneficiaries of the scheme included *The Magdalene Sisters* (Peter Mullan, 2002), *Kidulthood* (Menhaj Huda, 2006), and *Under the Skin* (Jonathan Glazer, 2013).

It's difficult to assess the effects of this intervention. No matter how hardheaded the governmental rhetoric, or how intrusive the UKFC's intervention

Caravaggio (Derek Jarman, 1986).

became, the fact remains that most commercial feature films lose money. Around three quarters of the money invested by government in national film production will always be 'wasted'. While *The King's Speech* crowns one version of the UKFC story, the counterpoint was provided by box-office flops such as *Sex Lives of the Potato Men* (Andy Humphries, 2004), *St Trinian's 2: The Legend of Fritton's Gold* (Oliver Parker / Barnaby Thompson, 2009) and *Donkey Punch* (Olly Blackburn, 2009).

Fundamentally, economics couldn't provide New Labour's arts policies with a solid rationale, because the claims made for the financial significance of the cultural industries were so inflated. Once computer software sales (including business software as well as videogames) were stripped out of the figures, any claims about the particular economic importance of the British creative industries quickly fell apart.[11] Equally, by encouraging British film-makers to think of themselves as filling niche roles in a landscape fashioned by American priorities, the UKFC arguably further entrenched the pattern of

British talent departing for America as soon as practically possible. Although it's impossible to know how far their development has been shaped by the imperatives and incentives established by the UKFC, British directors like Edgar Wright might better be classified as 'British-American' filmmakers. There's a direct line from Alan Parker's thinking ('the British film industry never existed') to the kind of sensibility expressed in the work of the generation of filmmakers the UKFC fostered, such as Matthew Vaughn. However we might characterise the type of Britishness propagated by state agencies post UKFC, it feels safe to say that the world of *Mona Lisa* (Neil Jordan, 1986), *Caravaggio* (Derek Jarman, 1986) or *Withnail & I* (Bruce Robinson, 1987) no longer exists. When Paul Rotha began making films at the Empire Marketing Board in the 1930s, the British state had subsidised 'art films' in the name of preserving and promoting a distinct culture, while the 'new wave' cinemas of the 1960s had rooted 'the national' in a wider democratic context of dynamic social self-criticism. In the UKFC era the British film had become a public-private initiative of a reconfigured global Anglosphere.

Investment in post-production facilities did provide the UKFC with significant national successes. Instead of an industry dominated by the opinions of critics and the social affiliations of middle-class activists, Parker demanded greater respect for the craftsmanship to be found at British studios like Elstree. By prioritising training, education and the building of new infrastructure, the UKFC helped cement the UK's reputation in acting, special effects and post-production. Twenty years on and Bond movies, the *Stars Wars* franchises and Disney blockbusters appear to have taken up near-permanent residence in Greater London. Reflecting on the long-term impact of the UKFC, David (now Lord) Puttnam commented, 'the correct thing is to say [that] we've become a film-making nation as opposed to a film-creating nation.'[12]

Nearly every region of Britain now hosts major international film or TV shoots, with HBO in Belfast, Amazon in Cumbernauld, and Wolf Studios in Cardiff among the regional centres of excellence. 'There is a serious money stream coming in,' as Iain Smith, Chairman of the British Film Commission put it, 'British crews and facilities work on content that they would never be able to do within the British context [and] we've benefitted to the tune of billions.'[13] Yet these UKFC's initiatives also ensured that enormous amounts of the 'content' produced in Britain was now owned by American compa-

nies. Perversely, the British government was subsidising a 'national' film industry that created intellectual property for international corporations. Without a belief in 'uplift', or the intrinsic importance of cultural expression, you end up falling back on focus groups. To reformulate Parker's reductive provocation (and it *is* extremely reductive), British film has become 'franchises all the way down.'[14]

During its relatively short existence the UKFC reconfigured the state's approach to national cinema in ways which have continued to shape the culture of British film. Arguably, the UKFC's most significant cinematic legacy is to be found in films it *didn't* fund, such as the *Harry Potter* series (2001–11), literary adaptations like *Great Expectations* (2012), and the *Paddington* franchise (2014-). These are productions that draw on established literary works to promote a vision of Britain to the world that is calculated to be attractive to key target audiences – less dynamic projections of the national scene than an exercise in branding for the tourist industry. Communications, as the GCS

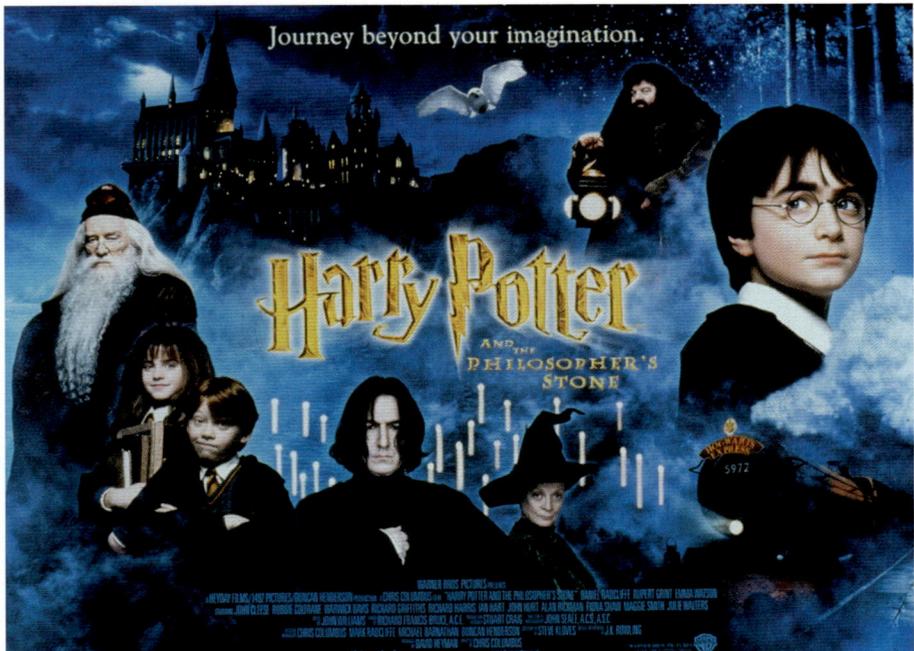

Harry Potter and the Philosopher's Stone (aka *Harry Potter and the Sorcerer's Stone*, Chris Columbus, UK/US, 2001)

insisted, was now one of the four main 'levers' of government. The production, purpose and financing of British film were now aligned to manage a new compact between state, commerce and citizen.

Things didn't have to be this way. Perhaps because South Korea has a strong industrial base, its film industry does not have to be directly tethered to the immediate economic and social priorities of the state. The deep propaganda value of recent films like *Parasite* (2019) illustrate that the value of national cinema needn't depend on self-conscious attempts to sell holidays, heritage or post-production infrastructure. Interestingly, *Parasite* director Bong Joon Ho has named Alfred Hitchcock, Harold Pinter and Joseph Losey among his major influences.[15] The provincial past of British cinema turns out to resonate much more widely than Alan Parker had understood.

Close-up: James Bond and the Secret Intelligence film

According to the American Statistical Association, 20% of the world's population has seen at least one James Bond film,[16] making 007 a formidable weapon of British cultural diplomacy. This importance has increased over time.[17]

The first four films starring the sixth Bond in the franchise, Daniel Craig, starting with *Casino Royale* (Martin Campbell, 2006), took more than $3 billion at the box office while adopting a more serious tone. In *Quantum of Solace* (Marc Forster, 2008), Bond battles corporate plans to privatise Bolivia's water supply, a plotline that mirrored the increasing use of humanitarianism in British military propaganda.

Parties to mark the release of *Spectre* (Sam Mendes, 2015) were used to promote Britain, British filmmaking and British products in embassies and high commissions around the world. Richard Moore, the Head of MI6, has described Bond as an important 'force multiplier'.[18]

But perhaps there's more than box office popularity to Bond's role in British propaganda. The anthropologist and historian David Graeber posited 007 as the ultimate bureaucratic hero: the crime fighter who breaks all the rules but whose entire existence depends on those rules.[19] Bond protects the world from attempts to change it, because any alternative to the international status quo – however corrupt or degraded it might be – would be much worse. For a declining hegemon like Britain this message has a powerful resonance.

Popular films about the intelligence agencies have played an increasing role in the projection of Britain since the Millennium. In particular, Alan Turing and the Bletchley Park codebreakers have emerged as central figures in Britain's victory over Nazi Germany, celebrated in films such as *Enigma* (Michael Apted, 2001) and *The Imitation Game* (US, Morten Tyldum, 2014), and television dramas like *The Bletchley Circle* (BBC, 2012–14). They run alongside initiatives like GCHQ puzzle books, GCHQ coding clubs, and GCHQ competitions run in partnership with children's TV programmes like *Blue Peter* (BBC, 1958–).[20]

The many factors driving the new popularity of Turing's story include the decline of British military hard power and the growth of information technology, as well as

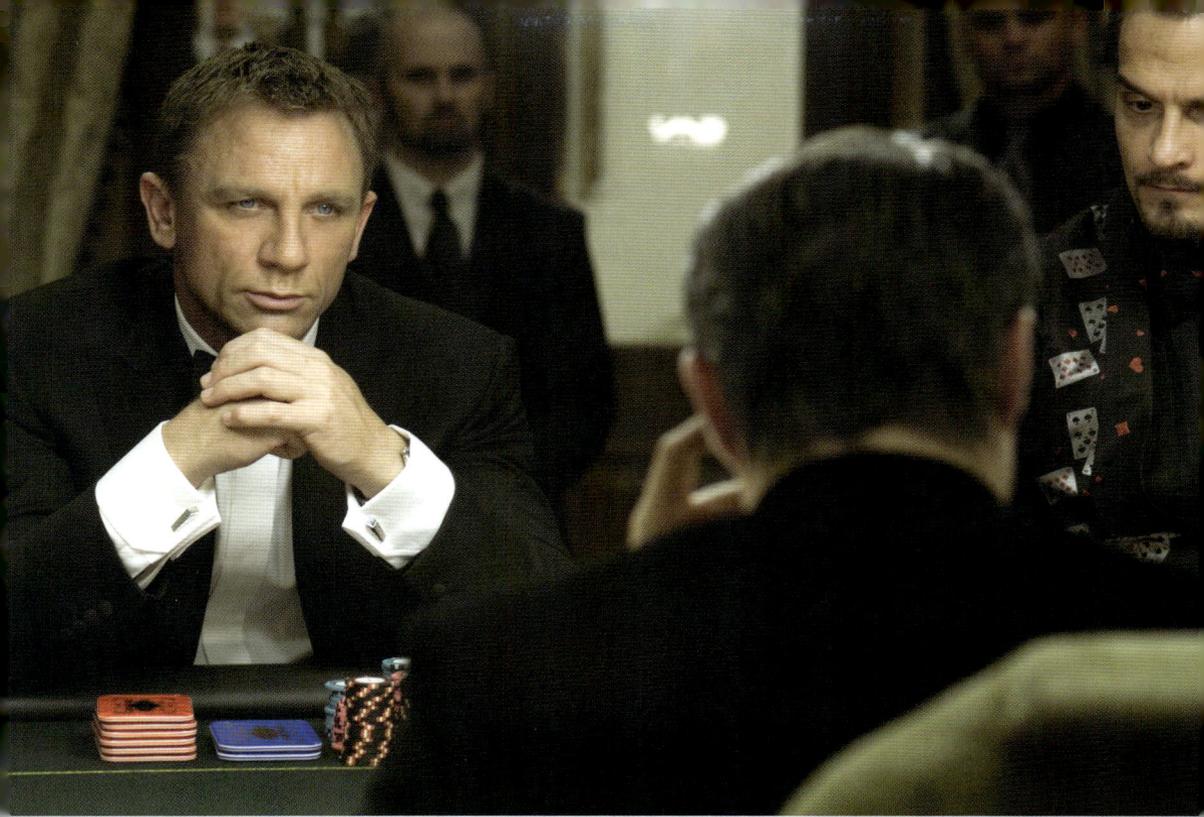

Casino Royale (Martin Campbell, UK/US, 2006).

changes in social norms and values. But equally, GCHQ-endorsed celebrations of Turing, which acknowledge the persecution that led to his suicide, help draw attention from GCHQ's recent activities, including 'false flag activity such as writing blog posts and sending emails under a false identity to incriminate a target,' which, as Rory Cormac has it, proudly 'took '"paranoia" to a whole new level.'[21]

Moreover, the fact that the popular view of the Secret Intelligence Services is dominated by images minted before the 1950s also serves to obscure their recent growth. MI5 has doubled in size since 9/11, while MI6 has grown by a third since 2016.[22] During the post-Soviet period, while the size of Britain's armed services has halved, the cinematic mythology of the Secret Intelligence services has assumed an important psychological role in sustaining the myth of Britain's global power and camouflaging the extent to which their recent expansion was prompted by the 'War on Terror'.

9. THE PROPAGANDA FILM AND HUMANITARIAN WAR

Because no conflict since has been able to match its moral force, the Second World War weighs heavily on the military propagandists of today. In the Anglosphere, and across much of the Western world, it remains the major source of national stories about courage, moral conviction and social co-operation. Attempts to wrestle with any of the conflict's ambiguities head-on, such as *The Guernsey Literary and Potato Peel Pie Society* (Mike Newell, 2018), tend to meet a frosty reception at the box office. Even relatively sophisticated films like *Dunkirk* (Christopher Nolan, 2017) know better than to attack its mythology.

One consequence is that contemporary propagandists often find themselves grappling with how to adapt these pre-existing iconographies to the new realities of warfare.[1] For instance, during the Iraq War of 2003, US Special Forces staged the rescue of Private Jessica Lynch in an abandoned military hospital. Firing blank rounds against the sound of explosions for the benefit of live television, the US military's 'Saving Private Lynch' was a media stunt conducted in self-conscious imitation of Steven Spielberg's World War II film *Saving Private Ryan* (US, 1998).[2] Similarly, language and imagery borrowed from popular films about the Holocaust such as *Schindler's List* (Steven Spielberg, US, 1993) have influenced the way Western military propagandists have framed the 'humanitarian interventions' in Europe, Africa and Asia that followed the end of the Cold War.[3]

The conflict in Syria provides a useful contemporary example of how propagandists have borrowed imagery from the Second World War while

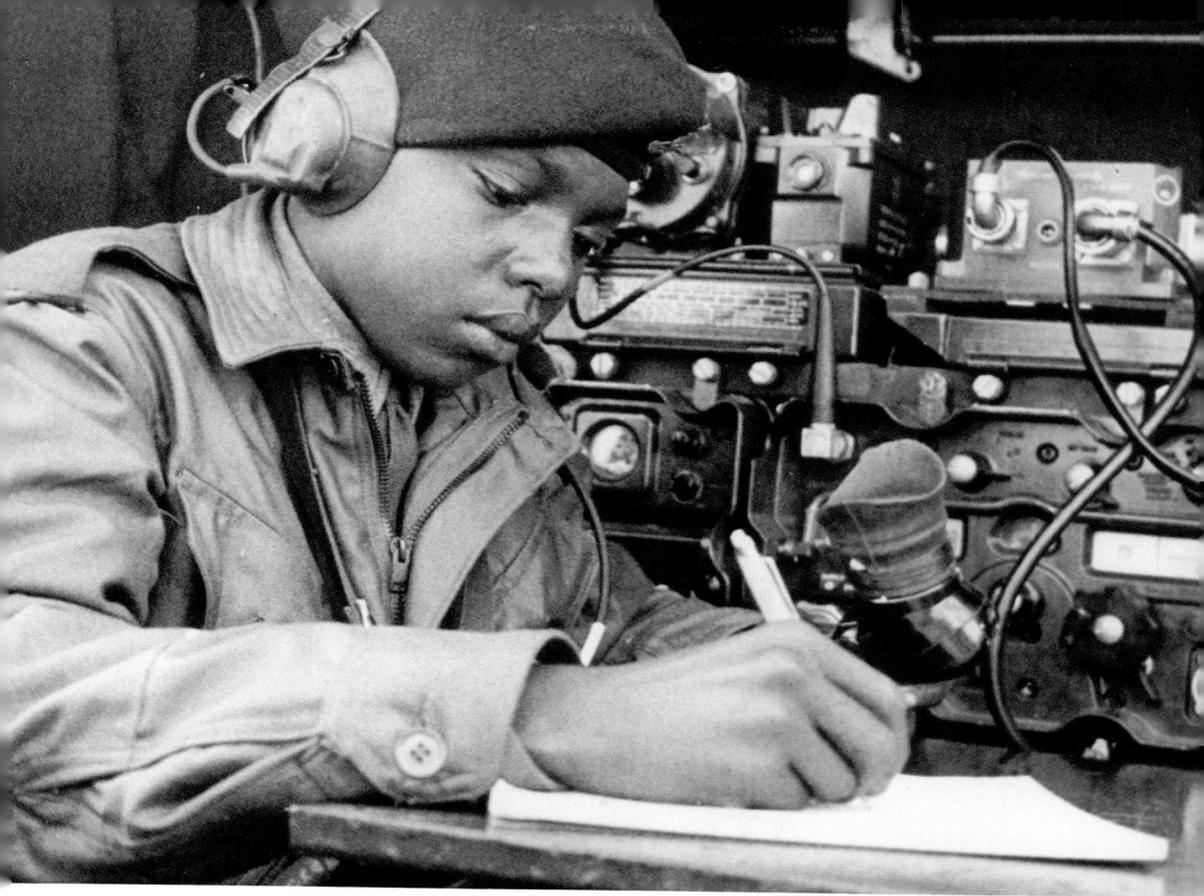

Ten Foot Tall (Joe Mendoza, The Short Films Group / Rank / Central Office of Information, 1964).

reconstituting military objectives into the language of humanitarianism. Despite losing a vote on military intervention in Syria, David Cameron sanctioned the 'deniable' deployment of British special forces, as well as a significant propaganda operation.[4] Primarily, this was an attempt to lay the ground for a 'moderate' successor to Syrian president Bashar al-Assad. However, by encouraging Western audiences to sympathise with the Syrian opposition, a secondary aim was to wear down domestic resistance to the idea of using military force to remove Assad.[5]

During the Civil War, the British government set up front companies in Amman and Istanbul to pay citizen journalists to produce TV footage, radio programmes, social media videos, posters, magazines and even children's

comics opposing Assad's government.[6] Funding seems to have found its way into films like the animated short *Goal to Syria* (Syria, 2015), about a young footballer pulled from the ruins of a bombed building, who scores the winning goal in the 2027 Asia Cup. The film was critically acclaimed at the 2016 Cannes Film Festival for providing 'symbolic, global recognition of the justice of the Syrian revolution.'[7]

The Syrian creatives' producing this content were usually unaware that they had been working for the British government, although when interviewed most seemed unbothered by the revelation.[8] From their point of view, knowing the source of funding didn't affect the justice or integrity of the films they produced. Their political goals could only be achieved with external assistance.

However intentionally, Orlando Von Einsiedel's *The White Helmets* (2016) sat at the filmic forefront of this wave of Western-funded propaganda. Powerful stills from the film, showing a baby being pulled alive from bombed out ruins, turned it into a media sensation. It was awarded the Oscar for Best Documentary (Short Subject) in 2017, and major film industry figures, such as Daniel Craig, Jude Law, Ridley Scott, Chiwetel Ejiofor and Vanessa Redgrave, leant their names to a campaign to nominate the White Helmets for the

Goal to Syria (Amjad Wardeh, Syria, 2015).

HMS Sheffield (Clive Mitchell, BB & H Films / Central Office of Information, 1975).

Nobel Prize.[9] George Clooney and his producing partner Grant Heslov, who a few years earlier had won the best picture Oscar for *Argo* (US, 2012), a film about how the CIA created a fake Sci-Fi movie as a ruse to rescue American diplomats from Iran, were reported to have begun developing a fictional film based on Von Einsiedel's documentary.

Yet watching *The White Helmets* it's difficult to shake the feeling that the film's fame substantially outweighs the level of cinematic achievement. Ostensibly an investigative documentary, the film follows a group of Syria Civil Defence volunteers (White Helmets) as they travel to Turkey for training. While studying techniques for saving lives they learn that a hospital in Syria has been bombed, killing one of the volunteer's brothers. As news of the brother's death filters through, the volunteers' distress is abated when a child they had previously pulled from a bomb site comes to watch them train. Fortified by the child's recovery, they complete their training and return to Syria. As this summary makes plain, while labelled as an investiga-

The White Helmets (Orlando von Einsiedel, 2016).

tive documentary, the film's narrative arc is far from subtle.

In terms of rhetorical lineage, *The White Helmets* has an interesting relationship with Humphrey Jennings' Blitz documentary *Fires Were Started*. Just as in the British propaganda films of World War II, *The White Helmets* shows how war in Syria has brought together a range of social 'types': among the Syrian volunteers are a builder, a tailor and a blacksmith. There's also an older father, a bereaved brother and a young man with a wayward past.

However, while there's also a Jungian dimension to the 'types' in Jennings' film, Von Einsiedel is less interested in tracing the national unconscious than in creating a context for Western viewers to empathise across cultural boundaries. Accordingly, while Islam is shown playing a foundational role in the volunteers' lives, religious belief is ultimately sublimated into their role as fathers, brothers and sons. When one of the volunteers admits to a past as a jihadist, the White Helmets are credited with helping to refocus his anger towards peaceful ends. In an age dominated by fear of the radicalising impact of internet films produced by groups of Islamic fundamentalists, *The White Helmets* provides a narrative of counter-radicalisation.[10]

In interviews Von Einsiedel explained that, rather than exploring the complexities of the conflict, he wanted his film to show 'what's happening

to people every day on the ground with hundreds of bombs being dropped.'[11] This editorial decision perhaps adds to the uncomplicated power of the film's imagery. Aside from passing references to Russian bombing, we're shown a war without fighting. It adds to the film's impact that only women, children and hospital workers appear to be dying. Indeed, the overall impression given by *The White Helmets* is that it is a film reducible to its meme-able parts: it's most effective as a vehicle for disseminating horrifying stills of the conflict. The image of the Syrian baby pulled alive from a bombsite has arguably become one of the dominant images of the war.[12]

It's also noticeable that Von Einsiedel's film is an investigative documentary that tells us nothing about the size, scale and success of the White Helmets' operations, nor about their founding, funding and organisation. In fact, Von Einsiedel wasn't responsible for shooting any of the film's Syrian footage; it was all provided to him by the White Helmets themselves.[13]

We can see *The White Helmets* as an example of a new kind of campaigning cinema, one that reflects the growth of NGOs, (usually) Western-funded organisations whose humanitarian work is often bound up with the advance of particular economic, social and political norms.[14] In the

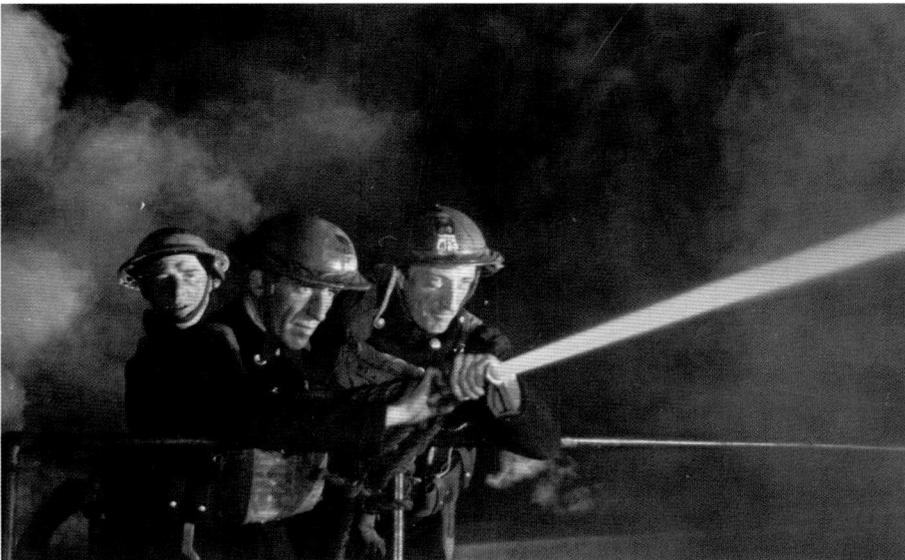

Fires Were Started (Humphrey Jennings, Crown Film Unit, 1943).

21st century the plethora of educational curricula, administrative systems and institutional guidelines (in conjunction with media imagery) created by NGOs have become increasingly important mechanisms of elite-directed change.[15] Interestingly, Von Einsiedel forged his career as a freelance filmmaker through a series of collaborations with NGOs. His films, about skateboarders in Afghanistan and on the work of environmental activists in Congo, provide a 21st-century equivalent of the sort of sponsored filmmaking tradition associated with the Grierson school.

Subsequently, the American investigative journalist Seymour Hersh claimed that the White Helmets worked with radical jihadist groups to stage or recycle footage of the conflict as part of a propaganda war against the Syrian government.[16] Other critics of the White Helmets have pointed out that the group are partly funded by the British Foreign Office and were set up by James Le Mesurier, who at one time seems to have been an MI6 agent.[17]

The extent to which Le Mesurier 'controlled' The White Helmets remains hotly disputed. It's less contentious to say that the British state surreptitiously supports the creation of strategically useful film and media content by organisations which appear to be organic, independent and non-aligned. However, because the extent of the British state's input is purposely concealed, it's difficult to ascertain how grassroots-led many of these initiatives are.[18]

While humanitarian propaganda demanded reconfiguring the image of the soldier, this was a process that had begun long before the end of the Cold War. No longer able to call upon a reserve of troops from either India or Africa, COI recruit campaigns were forced to rethink the image of the British soldier for the post-colonial era. The phasing out of National Service in 1957, added urgency to the task of selling life as a soldier to the British public.[19] There were three main ways the COI approached the task. Until the explosion of unrest in Northern Ireland in the 1970s, none of them involved actual combat.

'We drive, ski, float, fly, jump. And sometimes we even march,' ran the tagline of a typical recruitment advert. For much of the latter half of the 20th century, the British Army was sold as an organisation that offered young men opportunities for travel, sport and self-development. (It was only from the mid-1990s that frontline roles began opening up to women.) Opportunities to learn about new technologies were particularly empha-

sised. As one promo ran, the army equipped 'today's communicators for tomorrow's world.'[20]

This changing world is well represented by *They Stand Ready*, a DVD compilation of COI films commissioned by the British military released by the BFI in 2010. Temporally, the compilation guides us from the victory parades at the end of the Second World War to the later years of the Cold War. Especially striking is the trajectory of the films' iconography. Put simply, the collection starts off with films celebrating the bravery and sacrifice of soldiers, and ends up promoting Tornado jet fighters.

The changes chronicled in *They Stand Ready* illustrate the dawning of what Edward Luttwak has described as the era of 'post-heroic warfare'.[21] According to Luttwak, this is a process by which remote controlled and long-range weapons have become the dominant mode of combat. For propagandists, post-heroic warfare poses a significant challenge of representation. New technologies have expanded the battlefield, displacing the centrality of face-to-face fighting. This separation of combatants has made it difficult to narrate what is happening. Jean Baudrillard was widely mocked when he asserted that 'the Gulf War did not take place', but his argument was not that the War didn't happen, but that the reality of the conflict had become decoupled from its mediation.[22]

In addition to this crisis of representation, post-heroic warfare creates new types of reputational risk for propagandists. By reducing the human costs of military intervention, post-heroic warfare necessitates the creation of a compelling rationale for military action. Without a strong moral rationale, it doesn't take much for slick celebrations of technology to be perceived as the glorification of consequence-free slaughter – especially as, while the size of Britain's armed forces has shrunk to inconsequentiality, it remains a significant manufacturer of hi-tech weapons.

While for most sectors of the British economy the liberalisation of global trade has led to the hollowing out of industries nationalised after the Second World War, the arms industry has for the most part been excluded from international treaties prohibiting state aid and government subsidy.[23] Under the New Labour government, not only was the arms trade defended as a hub of national manufacturing expertise, but it was also championed as a potential tool supporting the government's 'ethical foreign policy.' During

the Second World War, prop makers at Shepperton film studios built fake ships, tanks and aeroplanes that were designed to mislead German reconnaissance. By contrast, when the New Labour government was accused of selling weapons in breach of a UN embargo, it was claimed that they were being used as props in *Black Hawk Down* (US/UK, Ridley Scott, 2001).[24]

Whether ethical or not, the Labour Party and the British state were clearly also responding to the balance of financial power. In an era of globalisation, securing supplies and resources has become increasingly important: the historic strengths of the British arms industry had been mutually constituted with the growth of powerful extractive oil and mining companies like BP and Rio Tinto, and it has become received wisdom that it is politically and materially risky to challenge them.[25]

Equally, in an increasingly financialised economy, the brokering of arms deals with countries like Indonesia and the Gulf States was also important to the profits of British banks like Barclays and HSBC.[26] Indeed, over the past 30 years a web of relationships has grown between the arms industry, political parties and the armed services. Although it's a provocation usually made by anti-war protesters, in contemporary YouTube videos such as *Case White: The Delivery of the Eurofighter Typhoon in RAF Operational Service* (2018), the accusation that the British armed forces have become part of BAE systems sales force can appear close to the mark.[27] If nothing else, the BAE Typhoon films reveal the extent to which Tony Scott's *Top Gun* (US, 1986) has become the dominant model for propagandists seeking to sell British military equipment abroad.

In *The Utility of Force*, General Rupert Smith, one of the leading contemporary theorists of war, argued that the era of interstate war has been superseded by a new era of 'war amongst the peoples.'[28] Specifically, Smith was drawing on his experiences as a British soldier in Bosnia, Kosovo and Northern Ireland, where the use of lethal force proved less important than the ability to control a range of social, cultural and administrative factors. According to Smith, it's now impossible to 'win a war' without constructing a shared narrative framework.

One story used to illustrate this point is that when the Soviets withdrew from Afghanistan in 1989 they believed their intervention had been successful, while in the 21st century the British Army arrived in Helmand accompanied

Routine Adventure (Peter Broderick, Wyvern Films / Central Office of Information, 1965).

by an institutional memory of victory in the Afghan Wars. By contrast, Afghan villagers not only believed they had previously defeated both sets of invaders, but that the British Gurkhas were fighting for the Soviet Union.[29] It is for this reason that, at least since the Yugoslavian Wars, the creation of new media infrastructures has become an essential part of post-conflict nation building. The subsequent formation of the 77th Brigade, a unit of the British army tasked with developing narratives, storyboards and social media videos, was a further response to this development.[30] As the military propagandists' work comes to focus on peacekeeping, reprogramming the human sensorium has become a military objective.

Underpinning the rise of 'humanitarian' propaganda and the era of post-heroic warfare has been the rapid growth of digital media. In the pre-modern agricultural world, wars tended to be seasonal, while after the industrial revolution manufacturing capability became key to success in modern warfare. But in the 21st century, 'war' has expanded in tandem with

This is Woke (2019, social media campaign).

the growth of a global communications infrastructure. 'World War III will be a guerrilla information war,' as McLuhan had predicted in 1970, 'with no division between military and civilian participation.'[31]

We can chart the effects of this shift through initiatives like the creation of the Research, Information and Communications Unit (RICU), founded in 2007 as part of the Office for Security and Counter Terrorism (OSCT). Just like its Cold War predecessor the IRD, RICU aimed to 'effect attitudinal and behavioural change' through feeding stories to news agencies and conducting surreptitious media campaigns. Richard Chalk was recruited from the PR firm Bell Pottinger, where he had been working on campaigns in Iraq for the Pentagon, to lead RICU's production of 'innovative counter ideological messages'.[32] To do this RICU employed anthropologists, linguists, psychologists and digital marketing specialists.

When it became evident that British Muslims were travelling to Syria to wage jihad, RICU sponsored the Breakthrough Media Network to coordinate a group called Help for Syria. Targeting Muslim men between 15 and 39 years old, their campaign disseminated adverts on social media, leafleted 760,000

households, broadcast films on YouTube and visited numerous university campuses. Help for Syria later claimed to have no knowledge of the UK government's involvement.[33]

This Is Woke, launched in 2019, provides a further illustrative example of how RICU's initiatives simultaneously targeted domestic and international audiences.[34] Through Instagram, Twitter and Facebook, a fake media company was used to push mostly innocuous social media videos about vegetarianism, climate change and the importance of mental health to British Muslims. Very much in the vein of the COI's *Teleview* series, *This Is Woke* made heavy use of personal profiles, for instance about the female American basketball player Bilqis Abdul-Qaadir. It also produced stories echoing the plots of popular feature films. For example, a short video telling the story of a dancer who escaped persecution in Syria to train at the Dutch National Ballet was clearly inspired by *Billy Elliott* (Stephen Daldry, 2000).[35]

Over the past 15 years RICU has sold its propaganda expertise around the world. The international division of RICU has won contracts in Algeria, Bangladesh, Belgium, Finland, France, Kenya, Kosovo, the Netherlands, Indonesia, Jordan and Pakistan. It has worked with the EU and the British Council to sponsor teacher training, as well as programming Arabic-language children's television to promote tolerance. Thirty million Muslims watched *My 2012 Dream* (2012), a film following athletes from Afghanistan and Pakistan as they trained to compete at the London Olympics, which had been secretly funded by RICU to challenge the idea that the Games were unIslamic.[36]

'Ala Khatrek Tounsi' (Because You Are Tunisian), a social media-driven initiative celebrating Tunisian identity that ran over several years in the 2010s, provides a good example of this work.[37] 'Ala Khatrek Tounsi', like other RICU initiatives, recycled many of the standard templates of postwar cultural propaganda: popular music, youth cultures, filmmaking and sports stars. The British Council commissioned graffiti artists to paint the campaign slogan on walls that were discreetly protected by the Tunisian police. Rappers like Djappa Man were dropped into the space once occupied by Pink Floyd.

RICU was established in the aftermath of the 7/7 attack on London. Faced with the challenge of Islamic fundamentalism, and apparently

inspired by Frances Stonor Saunders' book about Cold War propaganda, Gordon Brown demanded 'a programme of cultural warfare' targeted at the British population.[38] Its creation reflected a new political formulation: that in a networked age, the old concept of 'national security' would be superseded by 'human security'.[39]

As the *This is Woke* campaign illustrates, the issue with these new doctrines of warfare is that they imply the need for a continual stream of state intervention.[40] In a world without clearly defined boundaries, everywhere becomes a potential battlefield. Although justified as anticipatory self-defence, it's an ideology that risks dramatically narrowing the space for any kind of democratic deliberation (let alone disagreement) as civilians are pulled into an information war.[41] During the multifaceted Covid crisis that began in 2020, the deployment of the 77th Brigade to counter domestic misinformation was just one of a number of state propaganda initiatives that drew accusations from scientists, MPs, journalists and others that the British government had adopted totalitarian practices of 'perception management'.[42]

Unlike in 1945, when victory over Nazi Germany prompted the restructuring of the MOI into the considerably less assertive COI, post 7/7 we have seen the adoption of doctrines that emphasise the continuous threat of 'war among the peoples'. A world where there is no prospect of a definitive victory is also a world which demands the constant production of propaganda at home and overseas. The assumption is that Britain is under continuous low-level attack.[43]

Equally, while the main televisual media formats of the postwar period were associated with spaces of private leisure, thanks to the ubiquity of the smart phone the new world of digital media potentially augments and overlaps every waking moment. Cheap to produce and easy to share, with its provenance difficult to establish, propaganda film has become both barely noticeable and endemic. 'It is like breathing oxygen,' as Philip Taylor put it, 'one knows it is there, but it is difficult to see it for what it is.'[44] This is a world of total propaganda.

CONCLUSION

O ver the course of this story we have, in the words of Srdjan Vucetic, shifted from a 19th-century world of British exceptionalism to a 21st-century world of British exemplarism.[1]

From *Fires Were Started* to *The White Helmets* via the Drogheda Report, we've seen how the practices of British propaganda film have invariably been driven by the need for military, diplomatic and political recalibration. It's also become apparent that the British propaganda film has generally defined itself against the image of the United States. While this positioning allows only limited claims for British greatness in specific areas such as intelligence, education and culture, it's also provided a comfortable niche from which Britain has been able to sell itself as a bridge (or a hub) between Europe and the US.

Importantly, this relationship with America has not only structured the tone and content of much of the British state's propaganda, but it has also dominated the structure and outlook of Britain's film and media industries. 21st-century British film self-consciously isn't about 'a badly attended puppet theatre that puts on verse dramas about the decline of the wool industry in Derby,' as Armando Iannucci put it, it's about 'winning rallying cries from the likes of Clint Eastwood and Steven Spielberg's DreamWorks Studios'.[2]

Yet at the same time, the story of British propaganda film is not only about international diplomacy. This is also a story about the transformation of the British state. Over the course of this book we have shifted from propaganda film produced by a manufacturing nation with full employment, to propaganda film produced by an 'open' economy dominated by finance and the provision of specialised services.

The director and producer Sam Napier-Bell began his career working on government films like England's *Wealth from Wool* (1948), but little more than ten years later found himself collaborating with Terence Conran on Swinging London promos like *Sixty Years of Fashion* (1960).[3] During the postwar period, films about the wool industry first morphed into films about synthetic fabrics and then into promotional films promoting high-end fashions.

Perhaps the most important function of the propaganda film has been keeping Britain's outward-facing propaganda in sympathy with the self-image of its citizens: maintaining a balance between the image of the country projected overseas and the lived experience of its people.

Here we can see that the propaganda film has played a crucial role in regulating national identity through the processes of decolonisation and mass immigration. Series such as *This Week in Britain*, *London Line* and *Roundabout* were designed to manage relations with Australia, Canada and New Zealand, as well as Hong Kong, South Asia and West Africa. From the COI to RICU this has often also meant creating imaginative templates to help manage community relations. We are all now at Home with Mr English.

We can also see the growth of 'cultural propaganda' in the early postwar period as part of a larger attempt to usher democratic societies away from the ideological extremes that ravaged Europe through the early 20th century. One of the roles of propaganda in postwar Britain was to position people as the ends not the means of the national political culture. 'Let us now have enough sense to accept the position of a small country and try to show the world how to preserve some elements of civilisation and decency that the large ones are rapidly stamping out,' as the academic Joan Robinson put it.[4] In filmic representations, Britain (especially its monarchs) has the courage to stand alone.

But alongside these broad historical stories, this book has also proposed a categorisation of propaganda film – heroic, cultural and total – that mirrors Hobsbawm's taxonomy of the 'short twentieth century'.[5] Alongside the challenges of postwar diplomacy and the expansion of the British state, this categorisation also plots the story of the propaganda film against the development of new audiovisual technologies. Over the course of the book the story of the propaganda film has become the story of propaganda media.

Not only did the First World War establish Hollywood's technological and commercial dominance of the global film industry, but at a more abstract level it also entrenched a particular type of viewing. Early cinema was presentational. The 'cinema of attractions' was analogous to the vaudeville show; there remained a clear separation between the audience and what was shown on screen.[6] But the Hollywood system that matured after 1918 placed audiences psychologically 'inside' the action. Film could now envelop its audiences in entirely fake worlds. Through skilful use of editing and montage a series of entirely unrelated cinematic fragments could be experienced as contiguous space and time. While Hollywood filmmakers seized on the new aesthetic possibilities of editing and montage, propagandists from the 'heroic' era such as Sergei Eisenstein and Dziga Vertov realised that these techniques also enabled filmmakers to create representations of political and social realities that had never actually existed. For Eisenstein, montage cinema promised to close the substantive gap that existed in Russia between Marxist theory and an illiterate agrarian populace. Vertov's experiments combining old and unrelated newsreel footage (for example) helped establish (and the study of his work arguably continues to buttress) the reputation of Soviet high culture.[7]

During the 'cultural' era of propaganda film, however, the rise of techniques such as rear projection worked to fragment the unity of the cinematic image. On the studio sets of the COI telemagazines we might leap from a bustling shopping street to complex scientific experiments. British pop singers perform in front of animated backdrops, while cross dissolves are used to link miscellaneous stories. From the perspective of the propagandist, aside from the particular political imperatives of the Cold War, the rise of televisual technologies encouraged a mode of visual communication that emphasised disjuncture, critical distance and a recognition of the complex and multifactoral genesis of new ideas. By contrast, it is no coincidence the era of 'total propaganda' has developed in tandem with rapid advances in technology. This is a world where digital compositing allows for the re-integration of live action elements into dynamically rendered computer generated worlds. New media landscapes have expanded to fill the space which visitors to *Labyrinth* in Montreal and 'The Crystal' in Brisbane still had to walk around. The audiovisual culture theorised by Marshall McLuhan has becomes an audiovisual-spatial culture.

Inspired by the outpouring of grief that greeted the death of Princess Diana in 1997, and the messages of support for the footballer Fabrice Muamba after he collapsed in a televised FA Cup match in 2012, RICU created a propaganda model of 'controlled spontaneity'.[8] The goal was to deescalate intercommunal tension by sponsoring community groups, commissioning fly posters and creating social media films that could be released during national crises. When employed in the aftermath of the 2017 Jihadist attacks in London, the manifestations of the RICU's 'controlled spontaneity' included the photo of a woman in a Union Jack hijab adorning the front page of *The Sun* newspaper and the transportation of around 100 imams to London Bridge to lead a vigil for the dead.

What is interesting here is that propaganda tools first developed to fight the threat of Islamic fundamentalism have over time been repurposed to serve an increasingly broad range of issues including public health campaigns.[9] In war, propaganda is essential to training and socialisation. It allows soldiers to foresee, simulate and memorise their response to stressful situations. The contemporary propaganda film attempts to utilise the digital media environment to mould civilians in the same way. RICU's attempts at 'controlled spontaneity' are attempts to manage unpredictable surges in social sentiments in a world where public interjection is no longer seen as a precondition of persuasion. This is a type of propaganda that attempts to police, train and condition the behaviour of civilian subjects.

During the Covid-19 pandemic, the self-reinforcing power of this imaginative policing was exemplified by the resurgence of media interest in the film *Contagion* (Steven Soderbergh, US, 2011). Originally inspired by interviews with the 'virus-hunter' Dr Ian Lipkin, *Contagion*'s plot dramatised the concerns of the public health establishment. In the film a novel virus emerges that only high-level medical technocrats are able to understand and which can only be stopped by the rapid development of a vaccine, in short the film's plot reflected the growing assertiveness of a new generation of public health experts whose norms were shaped by the SARS outbreak of 2003.

Yet these new protocols had encountered resistance after the 'fake' swine flu pandemic of 2009, when the Council of Europe accused the World Health Organization, national governments and EU agencies of vastly exaggerating a health scare for financial benefit. In the light of this scandal, public health

officials were keen to promote *Contagion* to help counter the resistance which their new policies faced. It was no coincidence that the film positioned sceptical journalists and alternative media as dangers to public health.

During the Covid crisis this propaganda of the health bureaucracy seeped into the political sphere. For example, then Minister for Health Matt Hancock claimed to be inspired by the film, a startling illustration of the ways in which pre-emptive, elaborate, and exhaustive plans for managing an anticipated disaster can become a self-fulfilling prophecy.

Western governments (not just Britain's) have justified these expansive practices of propaganda by pointing to the changed nature of the digital landscape. In an age of information abundance, this thinking goes, the mass public are liable to become overwhelmed. With the population no longer trusted to deliberate, Western governments fear that vaguely defined 'bad actors' (or familiar geopolitical rivals such as Russia) can use emotional triggers to manipulate and undermine the social order. In the interests of public safety we are told that governments must intervene to shore up a shared vision of reality.[10]

The widespread collapse of belief in the transformative potential of culture among political, cultural and military elites, has compounded this lack of faith in public educability. A belief in the transformative power of the arts was part of the postwar consensus, its collapse has pushed the British state back towards its 19th-century position of either valuing culture in utilitarian terms or attempting to harness it to the cause of social regulation. The museums and libraries that sprang up in the industrial revolution acted as storehouses of commercial knowledge, while promising to keep workers out of the pubs. There is a tinge of the moral capitalist in the films of the total propaganda era; the improving layout of the Quaker village has transmuted into the emotional architecture of the digital propaganda film.

Ultimately then, the story of the British propaganda film has become enmeshed in a story about the British state's responses to the totalising implications of digital technology. Asked to radically expand their regulatory activities, at the same time as the new media technologies they are supposed to control undermine their authority to do so, even the most liberal British governments have been dragged by the digital media world into uncomfortable places.

Unlike the era of heroic propaganda, which sought to spread revolutionary ideas, the age of total propaganda has been mainly concerned with either fragmenting, eliminating or closing-off challenges to the dominant models of organising society. The drives to develop individual self-esteem and build self-respect that were at the heart of Cold War propaganda have given way to practices where people are once again understood as ends as much as means.[11]

The last sections of this book take place in the aftermath of 9/11, when digital technologies that matured in the fighting of counter-insurgencies in the Middle East, have also become foundational to the spread of global popular media cultures. The world of total propaganda is one where the smart phone has become the key to accessing all culture, from libraries and art galleries to film, television and videogames. This is a world where adults in the West spend around four hours a day online and half their waking time viewing screens.[12] Where it has become unimaginable, perhaps even impossible, to play a full role in a developed society without engaging with digital technology platforms that are designed to be highly addictive. Beginning with computers in every home, moving on to smart-phones in every pocket, the tech giants' business models now depend on popularising 'wearables' (a source of biodata) and encouraging the development of 'smart homes' equipped with networked appliances.[13]

The neuroscientist Susan Greenfield has warned that the totalising forces of new media innovations are leading to an asocial dystopia.[14] Bathed in artificial images, colours and sounds, individuals spend increasing amounts of time in ever more sealed environments. Subjectively, there appears to be infinite freedom to choose, mediate and customise, but objectively the world becomes more conformist, predictable and tightly controlled than ever before. Even worse, because the suppression of privacy lies at the heart of the digital business model, there is an incentive to overstate risks to our personal health and security because a level of imminent threat is necessary to justify both state and corporate stockpiling of private personal data.[15]

More bleakly still, it's been argued that we're headed to a future where demands for 'security' keep millions of people in a constant state of tension, frustration and anxiety. The direction is towards the 'Israelisation' of life: a

world of tighter borders, with more restrictions on political expression and the employment of intrusive ID systems to control access to both civic and economic life.[16]

The anxieties expressed by Greenfield and others are familiar ones. From long before Stephen Tallents published *The Projection of England* film theorists had assumed there was a connection between the world made visible on screen and interior psychological reality.[17] The world of secular filmic propaganda grew out of the bureaucratic conviction that if the internal life of the nation could be made visible it would build trust between 'the masses' and Britain's cultural elites: intervention in the private sphere could be justified in order to build a virtuous public sphere.

Accordingly, during the Second World War, film played a vital role in constructing a shared imaginative world which could be widely disseminated, discussed and contested. Films like *Target for Tonight* had an important role to play in linking together a wide range of often contradictory ideas and emotions. During the Cultural Cold War, British propaganda film more usually encouraged its audiences to identify with outstanding individual accomplishments, scientific developments, or intellectual, cultural and consumer fashions.

The world that has emerged since the 'War on Terror', however, has shifted the propagandists' subject of focus away from the external image and on to interior psychological processes. Instead of persuading people, the digital propaganda films of our age are procedural. They attempt to construct rituals: they work through the imposition of systems, process and rules. Hyperlinks, highlighted sentences and scrolling screens, encourage an approach to filmic propaganda that prompts the viewer to follow preprogrammed trails. Instead of being encouraged to identify with the story of a famous opera singer, we are being asked to follow paths laid out by a digital media designer.[18] Theoretically, in a world of total propaganda, idiosyncratic personal associations, memories and ideas can be engineered out of existence.

Here you would be forgiven for thinking that the story of the propaganda film culminates in something close to the dystopian world envisioned by Jacques Ellul, where technological progress has eroded not just individual autonomy, but our capacity to comprehend the world. The excitement generated by the rush of new digital technologies – and the speed and

Phone Story (2011, videogame).

intensity of communication they allow – has obscured the way that the processes of digital convergence enable (and perhaps even demand) ever greater management of public thought and behaviour.

However, while we may live in an era of total propaganda, there are many reasons to resist accepting all of the heightened claims made for it. In 1944, George Orwell mocked 'the automatic way in which people go on repeating certain phrases (such as) "the abolition of distance" and the "disappearance of frontiers" at a time when states were re-erecting frontiers, weaponising radio to broadcast propaganda and controlling travel and migration as never before.'[19] It's a welcome reminder that the defence of democratic autonomy has always depended on a healthy scepticism about grand claims on the future: especially as many aspects of Greenfield's technological determinism are far from novel.

Even if it is true that digital media calls for a shift of rhetorical emphasis, there is no reason why its procedural rhetorics of persuasion – the hyperlinks, highlighted sentences and scrolling screens – must destroy individual deliberation.[20]

One of the key postwar roles of British propaganda, as I argued in Chapter 1, was to 'film [a] new political consensus into existence'. To this end, during the interwar years, Tallents and Grierson refashioned the industrial process film to promote a new type of political economy. Recent satirical videogames like *Phone Story*, in which players have to build an iPhone by playing sub games that involve them utilising child labour, exploiting Chinese workers and managing environmental loopholes, work in very similar ways.[21]

Procedural rhetoric may not open up space for discussion, but because it shifts attention on to the social rules which structure thought and action, it does allow for pointed critique. As *Phone Story* illustrates, there can be a Brechtian bluntness about this. Similarly, while there is a sinister aspect to the establishment of new army divisions such as the 77th Brigade, compared to the 'heroic' propaganda that sought to fashion entirely new civilisational forms, their social media storyboards pale into insignificance. In both their aesthetic accomplishment and their temporal ambition, we are a long way from the radically disruptive worlds of Sergei Eisenstein and Leni Riefenstahl. Instead, the world of total propaganda is a world where swarms of content are used to temporarily distract audiences from the immediate here and now.[22]

Throughout this book we have also seen how propagandists are often those most impacted by propaganda. From William Sellers to James Le Mesurier, propaganda initiatives have been bound up with attempts to mould new elite in-groups. 'I look on cinema as a pulpit,' said John Grierson, 'and use it as a propagandist.' Grierson's much quoted quip is a good reminder that propagandists have often been profoundly indifferent to their congregation.[23] In the era of total propaganda, when digital technologies increase the appearance and illusion of control, the scope for misalignment between propagandists and their audiences hinted at by Grierson has never been larger. Successful propaganda has instead generally depended on skilful intermediaries able to tap into wellsprings of emotion that exist outside of the state. This is Habermas 101. In the fight against Nazism, the popular influence of Powell and Pressburger's films was directly related to the Ministry of Information's inability to control them. It was the double-edged ambivalence of *Animal Farm* that made it such an effective weapon for Cold War propagandists. By contrast, RICU has not recruited artists, writers or

intellectuals of a similar calibre. There is no Christopher Mayhew working to ensure propaganda is anchored by genuine cultural achievement.

On top of this, as Ellul argued, ignorance, indifference and the pressures of everyday life have the effect of inoculating ordinary people from the excesses of propaganda. By contrast, intellectuals, writers and filmmakers are not only the professions most actively employed in the psychological, technological and sociological reshaping of the world, but they are also the ones most exposed to – and susceptible to – its claims.[24] In a postindustrial society like 21st-century Britain, this has important implications. One of the reasons that the story of the propaganda film is so culturally impactful in Britain is because it reflects the values and worldview of Britain's oversized media industries.

The Story of British Propaganda Film has revealed that when existing norms of governance have been challenged (the Second World War, decolonisation, the War on Terror) the British state has responded by increasing the production of propaganda film. But it is worth keeping in mind that no matter how much control has ever been exerted over the media, the propaganda film has never been able to save unpopular policies or protect unpopular governments.

This is because at the heart of the propaganda film are problems of political guidance and public knowledge, and the digital technologies of total propaganda can just as easily add to these problems as solve them. The coordination necessary to manage large data sets may well create larger and less sophisticated bureaucracies that generate ever greater resentment.[25] Indeed, the analyst Martin Gurri has argued that awareness of greater state intervention leads to 'a paralysis by distrust' that makes it impossible for established elites to ever fully regain control of the public sphere.[26]

So, while we can be wary of a moment where totalising political and cultural appetites are both resurgent and cloaked in the garb of technological inevitability, the enormous ambitions of the age stand in stark contrast with a reality where that is much less innovative and impressive than it purports to be.

The era of total propaganda could well turn out to be a display of overwhelming force that only barely conceals fundamental weakness.

RECOMMENDED READING

HISTORIES AND CONCEPTS

Jonathan Auerbach and Russ Castronovo (Eds.) *The Oxford Handbook of Propaganda Studies* (Oxford: Oxford University Press, 2013)

Ian Aitken, *Film and Reform: John Grierson and the Documentary Film Movement* (London: Routledge, 2013)

Scott Anthony & James Mansell (Eds) *The Projection of Britain: A History of the GPO Film Unit* (London: BFI, 2011)

Sir Fife Clark, *The Central Office of Information* (London: Allen & Unwin, 1970)

James Chapman, *The British at War: Cinema, State and Propaganda, 1939–1945* (London: I B Tauris, 1998)

Nicholas J. Cull, David Culbert, David Welch (Eds.) *Propaganda and Mass Persuasion: A Historical Encyclopaedia, 1500 to the Present* (Oxford: ABC Clio, 2003)

Hugo García, 'Reluctant liars? Public Debates on Propaganda and Democracy in Twentieth-Century Britain (*c.* 1914–1950)' in *Contemporary British History*, 4, 2019

Lee Grieveson & Colin MacCabe, *Empire and Film* (London: BFI, 2011)

Linda Kaye & Emily Crosby (eds), *Projecting Britain: The Guide to British Cinemagazines* (London: British Universities Film & Video Council, 2008)

Nicholas Reeves, *The Power of Film Propaganda: Myth or Reality?* (London: Continuum, 2004)

Tom Rice, *Film for the Colonies: Cinema and the Preservation of the British Empire* (Oakland, California: University of California Press, 2019)

Caroline Ritter, *Imperial Encore: The Cultural Project of the Late British Empire* (Oakland: University of California Press, 2021)

Tony Shaw, *British Cinema and the Cold War: The State, Propaganda and Consensus* (London: I B Tauris, 2011)

Philip M. Taylor, *British Propaganda in the Twentieth Century: Selling Propaganda* (Edinburgh: Edinburgh University Press, 1999)

Claire Wardle & Hossein Derakshan, 'Thinking about 'information disorder': formats of misinformation, disinformation, and mal-information' in *Journalism, Fake News and Disinformation* (Paris: UNESCO, 2018), pp.44–56

David Welch, *Protecting the People: the Central Office of Information and the Reshaping of Postwar Britain, 1946–2011* (London: British Library Publishing, 2019)

THEORIES & CONTEXTS

Emerson T. Brooking & P.W. Singer, *LikeWar: The Weaponization of Social Media* (New York; Houghton Mifflin Harcourt, 2018)

Rory Cormac, *Disrupt and Deny: Spies, Special Forces, and the Secret Pursuit of British Foreign Policy* (Oxford: Oxford University Press, 2018)

François du Cluzel (ed) *Cognitive Warfare: The Future of Cognitive Dominance* (NATO Collaboration Support Office, 2020)

Derrick De Kerckhove, *The Skin of Culture: Investigating the New Electronic Reality* (London: Kogan Page, 1997)

Jacques Ellul, *Propaganda: The Formation of Men's Attitudes* (New York: Random House, 1973)

Martin Gurri, *The Revolt of the Public and the Crisis of Authority in the New Millennium* (San Francisco: Stripe Press, 2018)

Richard S Lambert, *Propaganda* (London: T. Nelson & Sons, 1938)

Marshall McLuhan, *The Global Village: Transformations in World Life and Media in the 21st Century* (Oxford: Oxford University Press, 1989)

Vance Packard, *The Hidden Persuaders* (London: Longmans, Green & Co, 1957)

Daniel Pick, *Brainwashed: A New History of Thought Control* (London: Profile, 2022)

Peter Pomerantsev, *Nothing Is True and Everything Is Possible: The Surreal Heart of the New Russia* (London: Faber & Faber, 2017)

Emile Simpson, *War from the Ground Up: Twenty-First Century Combat as Politics* (London: Hurst, 2012)

Frances Stonor Saunders, *Who Paid the Piper?: The CIA and the Cultural Cold War* (London: Granta, 1999)

Mark Wollaeger, *Modernism, Media, and Propaganda* (Princeton, NJ; Princeton, 2006)

Shoshana Zuboff, *The Age of Surveillance Capitalism* (London: Profile Books, 2019)

A PROPAGANDA PLAYLIST

This list is offered not as a canon of propaganda film, but as a list of films that both illustrate the arguments of this book and are easily accessible. In addition to BFI Player (player.bfi.org.uk) and BFI DVDs, many of the films can also be found on the websites of the British Council (film.britishcouncil.org/resources/film-archive), the Colonial Film database (colonialfilm.org.uk), the National Archives, and the Imperial War Museum. Others can be found elsewhere online, though not necessarily legitimately.

Key: * official version online, † DVD/Blu Ray

War Office Official Topical Budget and Pictorial News 341–1 (1918) *
The Battle of the Somme (1916) †
Drifters (John Grierson, 1929) †
Industrial Britain (Robert Flaherty, 1931) †
The Private Life of Henry VIII (Alexander Korda, 1933) †
Housing Problems (Arthur Elton & Edgar Anstey, 1935) †
Night Mail (Harry Watt & Basil Wright, 1936) †
Spare Time (Humphrey Jennings, 1939) * †
Swinging the Lambeth Walk (Len Lye, 1939) *
London Can Take It (Harry Watt & Humphrey Jennings, 1940) †
Mr English at Home (Gordon Hales, 1940) *
The Lady Hamilton (aka *That Hamilton Woman*) (Alexander Korda, 1941)
Target for Tonight (Harry Watt, 1941) †
Mrs Miniver (William Wyler, 1942) †
Fires Were Started (Humphrey Jennings, 1943) †
The Life and Death of Colonel Blimp (Michael Powell & Emeric Pressburger, 1943) * †
Desert Victory (Roy Boulting, 1943) †

Workers' Weekend (Ralph Elton, 1943) †

A Diary for Timothy (Humphrey Jennings, 1945) †

What a Life! (Michael Law, 1948) †

Daybreak in Udi (Terry Bishop, 1949) *

Now is the Time (To Put on Your Glasses) (Norman McLaren, 1951)

The Waking Point (Crown Film Unit, 1951) *

The Boy Kumasenu (Sean Graham, 1952) *

A Queen is Crowned (Castleton Knight, 1953) †

Animal Farm (John Halas & Joy Batchelor, 1954) *

Atomic Achievement (John Reeve, 1956) * †

Seawards the Great Ships (Hilary Harris, 1960) * †

Return to Life (John Krish, 1960) * †

British Sporting Personalities: Peter May (COI, 1962) *

Comprehensive School (Maxwell Munden, 1962) *

People, Productivity and Change (Peter Bradford, 1963) †

Moslems in Britain – People (COI, 1964) *

London Line No.112 (COI, 1966) *

Opus (Don Levy, 1967) †

The Pacemakers: Henry Pluckrose (COI, 1971) *

North Kensington Law Centre (COI, 1973) *

London Line: African Student Families (COI, 1975) *

Insight: Zandra Rhodes (COI, 1981) * †

Tornado (COI, 1985) †

AIDS – Monolith (COI, 1987) *

Stinx (Public Health Scotland, 2000) *

Black Hawk Down (Ridley Scott, 2001) †

UK Border Force (Sky, 2008–09) †

The King's Speech (Tom Hooper, 2010) †

Contagion (Steven Soderbergh, 2011) †

Goal to Syria (Amjad Wardeh, 2016) *

The White Helmets (Orlando von Einsiedel, 2016) *

Ahmad Joudeh – Syrian Ballet Dancer (This is Woke, 2017) *

Elizabeth: The Unseen Queen (Simon Finch, 2022) *

NOTES

INTRODUCTION

1. George Orwell, 'Charles Dickens' (1940), p.138 in G. Packer (ed.) *All Art is Propaganda: Critical Essays by George Orwell* (Boston & New York: Mariner Books/Houghton Mifflin Harcourt, 2009)

2. *Topical Budget* was established as a commercial newsreel in 1911, but in May 1917 the company came to an agreement with the War Office, gaining privileged access to footage shot by official cameraman on the war fronts and renaming itself the *War Office Official Topical Budget*. The arrangement was difficult, and in November 1917 the War Office formally acquired the newsreel, directing it to more dedicated propaganda use. Control subsequently passed to the Ministry of Information, and the newsreel operated as *Pictorial News (Official)* until 1919, when it was sold to the *Daily Sketch* newspaper and reverted to its original name. See Luke McKernan, *Topical Budget: The Great British News Film*. (London: BFI, 1992)

3. For illustrative examples, see Sara Carter, 'Orwell's *1984* is Prophetic: How the Leftists Are Trying to Change and Erase President Trump and History', *The Sara Carter Show*, 21 November 2020; Simon Black, 'A Message to Anyone Who Feels Like "Winston" in Orwell's *1984*', *Sovereign Man*, 13 January 2021; Kevin Duffy, 'The Dystopian Bubble: George Orwell Meets Charles Mackay', *The Mises Institute*, 9 February 2021

4. Indeed, the UK's Central Office of Information (COI) made money by advising, consulting and training post-colonial governments to make propaganda films See Fife Clark, *The Central Office of Information* (London: Allen & Unwin, 1970)

5. Eric Hobsbawm, *The Age of Extremes: The Short Twentieth Century, 1914–1991* (London: Michael Joseph, 1994)

6. Jacques Ellul, *The Technological Society* (New York: Alfred A. Knopf, 1964) and *Propaganda: The Formation of Men's Attitudes* (New York: Random House, 1973)

7. See Jacob Van Vleet and Jacob Marques Rollinson (Eds.) *Jacques Ellul: A Companion to His Major Works* (Eugene: Cascade Books, 2020)

8. Scott Anthony, *Public Relations and the Making of Modern Britain: Stephen Tallents and the Birth of a Progressive Media Profession* (Manchester: Manchester University Press, 2012)

9. Notably with the fashionable embrace of 'nudge theory' and behavioural economics.

10. See, for example, Ian Cobain, Alice Ross, Ross Evans and Mona Mahmood, 'Inside Ricu, the Shadowy Propaganda Unit Inspired by the Cold War,' *The Guardian*, 2 May 2016. https://www.theguardian.com/politics/2016/may/02/inside-ricu-the-shadowy-propaganda-unit-inspired-by-the-cold-war' (accessed: 23 August 2023)

11. Intriguingly, these initiatives often seem to echo the religious origins of propaganda as part of the Catholic Church's wider suite of coercive measures aimed at Protestants during the counter-reformation. See Maria Teresa Prendergast and Thomas A. Prendergast, 'The Invention of Propaganda: a Critical Commentary on and Translation of *Inscrutabili Divinae Providentiae Arcano*' in Jonathan Auerbach and Russ Castronovo (eds.) *The Oxford Handbook of Propaganda Studies* (Oxford: Oxford University Press, 2013)

12. Rupert Smith, *The Utility of Force: The Art of War in the Modern World* (London: Allen Lane, 2005)

13. Murtaza Hussain, 'New ISIS Propaganda Film Features Canadian-Sounding Fighter', *The Intercept*, 19 September 2014. https://theintercept.com/2014/09/19/isis-new-propaganda-film-features-american-accented-fighter/' (accessed: 2 December 2023)

14. See Emile Simpson, *War From the Ground Up: Twenty-First Century Combat as Politics* (London: Hurst, 2012)

15. See, for example, Bruce Lannes Smith, Harold D. Lasswell, and Ralph D. Casey, *Propaganda, Communication, and Public Opinion; A Comprehensive Reference Guide* (Princeton, New Jersey: Princeton University Press, 1946)

16. Simon Hooper, 'REVEALED: How UK counter-terror unit uses rap, graffiti to target Middle Eastern youth', *Middle East Eye*, 23 November 2018. https://www.middleeasteye.net/news/revealed-how-uk-counter-terror-unit-uses-rap-graffiti-target-middle-eastern-youth' (accessed: 13 September 2023)

17. Claire Wardle & Hossein Derakshan, 'Thinking about "Information Disorder": Formats of Misinformation, Disinformation, and Mal-Information' in Cherilyn Ireton & ulie. Posetti (eds.) *Journalism, 'Fake News' & Disinformation* (UNESCO), pp.43–54

CHAPTER 1

1. See Gary S. Messinger, *British Propaganda and the State in the First World War* (Manchester and New York: Manchester University Press, 1992)

2. See Nicholas Reeves, *Official British Film Propaganda During the First World War* (London: Croom Helm, 1986)

3. See Paul Swann, *The British Documentary Film Movement, 1926–1946* (Cambridge: Cambridge University Press, 1989)

4. See Paul Virilio, *War and Cinema*, trans. Patrick Camiller (London and New York: Verso, 1989)

5. Harold Lasswell. *Propaganda technique in the world war* (London: Kegan Paul, 1927)

6. Ian Christie, 'Where Is National Cinema Today (and Do We Still Need It)?' *Film History*, Vol. 25, No. 1–2, (2013), pp.19–30

7. Scott Anthony, *Public Relations and the Making of Modern Britain*

8. See. Ian Aitken, *Film and Reform: John Grierson and the Documentary Film Movement* (London; Routledge, 1990)

9. Forsyth Hardy (Ed.) *Grierson on Documentary* (London: Faber, 1966)

10. For more on Grierson's vision of a global propaganda network see John Grierson, 'The Voice of the State', John Grierson Archive, University of Stirling, G5/8/10, p.49

11. See M. Wollaeger, *Modernism, Media and Propaganda: British Narrative from 1900 to 1945* (Princeton & Oxford; Princeton University Press, 2006)

12. For an interesting discussion on the connections between Grierson's thought and the emergence of cybernetics see James Purdon, *Modernist Informatics: Literature, Information, and the State* (Oxford; Oxford University Press, 2016)

13. Paul Rotha, *The Film Till Now: A Survey of the Cinema* (Jonathan Cape; London, 1930)

14. See Andrew Higson, *Waving the flag: Constructing a National Cinema in Britain* (Oxford; Oxford University Press, 1995)

15. Stephen Tallents, *The Projection of England* (London: Faber, 1932)

16. See Scott Anthony & James G. Mansell (Eds.) *The Projection of Britain: A History of the GPO Film Unit* (London: British Film Institute, 2011)

17. See Arthur Marwick, 'Middle Opinion in the Thirties: Planning, Progress and Political "Agreement"', *The English Historical Review*, Vol. LXXIX, April 1964, pp.285–298

CHAPTER 2

1. See K. Gladstone 'British Interception of German Export Newsreels and the Development of British Combat Filming, 1939–1942', *Imperial War Museum Review*, No.2 (1987)

2. See Caroline Moorehead, *Sidney Bernstein: A Biography* (London; Jonathan Cape, 1984) & R. Artmonsky, *Jack Beddington: The Footnote Man* (London, Artmonsky Arts, 2006)

3. See Phillip M. Taylor, *British Propaganda in the Twentieth Century* (Edinburgh; Edinburgh University Press, 1999)

4. See J. Baker White, *The Big Lie* (London; Evans Brothers, 1955)

5. Nicholas Reeves, *The Power of Film Propaganda: Myth or Reality?* (London: Continuum, 1999); for a discussion of these so-called 'fake' films, see Bryony Dixon, *The Story of Victorian Film* (London: Bloomsbury/BFI, 2023),

6. See Kay Gladstone, 'The APFU: The origins of British combat filming during the Second World War', *Film History*, Vol. 14, No. 3/4 (2002), pp.316–331

7. James Chapman and Nicholas J. Cull, *Projecting Empire: Imperialism and Popular Cinema* (London and New York: I. B. Tauris, 2009)

8. Anthony Aldgate, 'Creative tensions: *Desert Victory*, the Army Film Unit and Anglo-American rivalry, 1943–5' in Philip Taylor (ed.), *Britain and the Cinema in the Second World War* (Basingstoke: Palgrave, 1988), pp.144–167

9. Frederic Krome, '*The True Glory* and the Failure of Anglo-American Film Propaganda in the Second World War', *Journal of Contemporary History*, Vol. 33, No. 1 (1998), pp.21–34

10. Ian Grant, *Cameramen at War* (Cambridge: Patrick Stephens, 1980)

11. See Michael Newton, 'The Boulting Brothers: Holy Fools', *The Guardian*, 26 July 2013, https://www.theguardian.com/film/2013/jul/26/boulting-brothers-holy-fools' (accessed: 21 September 2023); and Geoffrey Macnab, 'The Boulting Brothers: Double Visionaries of British Cinema,' *The Independent*, 8 August 2013, https://www.independent.co.uk/arts-entertainment/films/features/the-boulting-brothers-double-visionaries-of-british-cinema-8752793.html' (accessed: 10 October 2023)

12. For an overview see Taylor (ed.) *Britain and the Cinema in the Second World War*

13. For illustrative example, Paul Addison, *The Road to 1945: British Politics and the Second World War* (London: Pimlico, 1994) & Correlli Barnett, *The Audit of War: The Illusion & Reality of Britain as a Great Nation* (London: Macmillan, 1986)

14. See Iain McLaine, *Ministry of Morale: Home Front Morale and the Ministry of Information in World War II* (London: Allen and Unwin, 1979)

15. Charles Barr, "Much Pleasure and Relaxation in These Hard Times': Churchill and Cinema in The Second World War', *Historical Journal of Film, Radio and Television* (2011) 31:4, pp. 561–586

16. Churchill's obsession with film also proved prescient. Propaganda film has arguably played an important role in establishing 'his reputation as the great political leader of 20th-century Britain. The iconographic legacy of wartime propaganda remains so potent that Gary Oldman was able to win an Academy Award for playing Churchill more than 70 years later. It's impossible to imagine anyone winning an Oscar for playing Clement Attlee. See, for instance, Giles Milton, 'One Important Difference Between Gary Oldman's Winston Churchill in Darkest Hour and the Real Prime Minister', *Time*, 2 March 2018

17. Greg Walker, 'The roots of Alexander Korda: Myths of identity and the international film', *Patterns of prejudice*, 37:1 (2003), pp.3–25

18. For a wider context on Korda's films see James Chapman, 'Cinema, propaganda and national identity: British film and the Second World War' in Justine Ashby & Andrew Higson (Eds.) *British Cinema, Past and Present* (London: Routledge, 2000)

19. Charles Drazin, *Korda: Britain's Only Movie Mogul* (London: Sidgwick & Jackson, 2002)

20. Nicholas J. Cull, *Selling War: The British Campaign Against American 'Neutrality' in World War II* (Oxford: OUP, 1995)

21. Michael Korda, *Charmed Lives: The Fabulous World of the Korda Brothers* (London: Allen Lane, 1980)

22. Barr, "Much Pleasure and Relaxation in These Hard Times", p. 562

23. See Ian Jack, 'Churchill and the Film-Maker: Sadly, Their Dream of England Persists', *The Guardian*, 5 January 2019. https://www.theguardian.com/commentisfree/2019/jan/05/churchill-film-maker-dream-england-alexander-korda' (accessed: 12 August 2023)

24. Fiona Macdonald, 'Mrs Miniver: the Film that Goebbels Feared', *BBC*, 9 February 2015 https://www.bbc.com/culture/article/20150209-the-film-that-goebbels-feared (accessed: 5 May 2020)

25. Mark Duguid & Katy McGahan, 'From Tinsel to Realism and Back Again: Balcon, Ealing and Documentary' in Mark Duguid, Lee Freeman, Keith Johnston & Melanie Williams (eds.) *Ealing Revisited* (London: BFI, 2012)

26. See Robert Murphy, *Realism and Tinsel: Cinema and Society in Britain 1939–1949* (Routledge; London, 1989)

27. National Archives, FO371/22839, 'Memorandum by Lord Halifax', 21 October 1939

28. See Mark Glancy, *When Hollywood Loved Britain: The Hollywood British Film, 1939–1945* (Manchester; Manchester University Press, 1999)

29. *Documentary News Letter*, vol. 3, no. 5, May 1942, p 6

30. Michael Powell, *A Life in Movies: An autobiography* (London; Faber, 1986)

31. James Chapman, 'The Life and Death of Colonel Blimp Reconsidered', *Historical Journal of Film, Radio and Television*, Vol. 15, No. 1 (1995), pp.19–54 and A. L. Kennedy, *The Life and Death of Colonel Blimp* (London; BFI, 1997)

32. Joe Queenan, 'Good Fellows: Martin Scorsese and Colonel Blimp', *The Guardian*, 28 October 2012. https://www.theguardian.com/film/2012/oct/28/good-fellows-martin-scorsese-blimp' (accessed: 20 July 2022)

33. Quoted in Derek Malcolm, 'Humphrey Jennings: Fires Were Started', *The Guardian*, 25 February 1999. https://www.theguardian.com/film/1999/feb/25/derekmalcolmscenturyoffilm.derekmalcolm?view=desktop' (accessed: 07 September 2023

34. Quoted in Alan James Harding (2017) 'Evaluating the Importance of the Crown Film Unit, 1940– 952', Unpublished doctoral dissertation, Nottingham Trent University, UK, p.172

35. Harding, 'Evaluating the Importance', pp.148–189

36. My argument here rests heavily on the work of James Chapman (1995) 'Official British Film Propaganda during the Second World War', unpublished doctoral dissertation, Lancaster University, UK, pp.410–450

37. Harry Watt, *Don't Look at the Camera* (London: Paul Elek, 1974), p.152

38. Quoted in Barr, '"Much Pleasure and Relaxation"', p.564

39. *The Times*, 15 October 1942, p.6

40. Paul Rotha, 'The British Case', *Rotha on Film: A Selection of Writings on World Cinema* (London, Faber & Faber, 1958), p.241

41. Bill Desowitz, '*Dunkirk*': How Christopher Nolan's Visual Effects Team Pulled off Realistic Dogfights and More Gritty Action', *IndieWire*, 5 January 2018

42. Dominic Selwood, 'Dresden Was a Civilian Town with No Military Significance. Why Did We Burn its People?', *The Telegraph*, 10 August 2020. https://www.indiewire.com/awards/industry/dunkirk-christopher-nolans-visual-effects-oscar-1201913630/ (accessed: 19 July 2023)

43. Jennifer Renee Brown (2010) 'Alfred Hitchcock Presents; 'Propaganda': A Rhetorical Study of Alfred Hitchcock's World War II Propaganda Films', unpublished Masters dissertation, Liberty University, USA

44. José Harris, *William Beveridge: A Biography* (Oxford: Clarendon Press, 1977)

45. Although the story is more complex than this: see Martin Stollery, 'Only Context: Canonising Humphrey Jennings / Conceptualising British Documentary Film History', *Journal of British Cinema and Television*, 10.3 (2013), p.395–414

46. Philip C. Logan, *Humphrey Jennings and the British Documentary: A Reassessment* (London: Ashgate, 2011)

47. Harding, 'Evaluating the Importance', pp.209–218

48. See Toby Luckhurst, 'Dresden: The World War Two Bombing 75 Years on', https://www.bbc.co.uk/news/world-europe-51448486 13 February 2020 (accessed: 5 May 2023)

49. See David Edgerton, *Warfare State: Britain 1920–1970* (Cambridge: Cambridge University Press, 2006)

CHAPTER 3

1. Tom Rice, *Films for the Colonies: Cinema and the Preservation of the British Empire* (Oakland: University of California Press, 2019)

2. British Film Institute, *The Film in Colonial Development: A Report of a Conference* (London: BFI, 1948), p.46

3. National Archives, CO875/10/11, 'Colonial Film Unit: Distribution and Technical Questions: Replies to Questionnaire on Films Shown', John Wilson to Director of Education, Accra, 28 May 1942

4. It is possible that the 'African' girl was born in Britain. Prompted by a query from a BBC researcher, a commentator on the BFI YouTube channel provided plausible biographical information that may help contextualise the film. See https://www.youtube.com/watch?v=6QbHhm4620I (accessed: 12 August 2023)

5. Vanessa Thorpe, 'Propaganda Coup of England's First Black May Queen', *The Observer*, 21 June 2009. https://www.theguardian.com/world/2009/jun/21/black-may-queen-youtube (accessed: 1 December 2023)

6. Marc Matera, *Black London: The Imperial Metropolis and Decolonization in the Twentieth Century* (Oakland: University of California Press, 2015), p.305

7. Rice, *Films for the Colonies*

8. Elizabeth Lebas, *Forgotten Futures: British Municipal Cinema 1920–1980* (London; Black Dog Press, 2011)

9. Montagu Slater, 'Cinema in the Bush,' *The Listener*, 23 September 1948, pp.441–42

10. Rice, *Films for the Colonies*, p.126

11. National Archives, INF 12/282, 'Progress Report, June 20–July 17, 1946, Monthly Meetings with Colonial Office, 1946–1949', Hyde to Grierson, 23 March 1949

12. 'Sean Graham, Writer – Obituary', *The Telegraph*, 18 October 2015. https://www.telegraph.co.uk/news/obituaries/culture-obituaries/11938996/Sean-Graham-writer-obituary.html (accessed: 10 August 2023)

13. Although Nkrumah's government was overthrown by a US-backed military coup in 1966, the sophisticated propaganda apparatus his government constructed have helped ensure that his inspirational political vision has had a rich afterlife (a cultural memory that also obscures some of the less attractive authoritarianism of Nkrumah's leadership). See, for example, Richard Rathbone, *Nkrumah and the Chiefs; The Politics of Chieftaincy in Ghana, 1951–60* (Athens; Ohio University Press, 1999)

14. British Film Institute, *The Film in Colonial Development*, p.26

15. See, for example, Glenn Reynolds, *Colonial Cinema in Africa: Origins, Images, Audiences* (Jefferson; McFarland, 2015)

16. See, for instance, I.Q. Hunter & Laraine Porter (eds.) *British Comedy Cinema* (Abingdon; Routledge, 2012)

17. Rice, *Films for the Colonies*, p.100

18. Mary Field, *Good Company: The Story of the Children's Entertainment Film Movement in Great Britain 1943–1950* (London; Longmans Green, 1952), Henri Storck, *The Entertainment Film for Juvenile Audiences* (Paris: UNESCO, 1950)

CHAPTER 4

1. Quoted in David Welch, *Protecting the People: The Central Office of Information and the Reshaping of Postwar Britain, 1946–2011* (London; British Library, 2019), p.15

2. Martin Moore, *The Origins of Modern Spin: Democratic Government and the Media in Britain, 1945–51* (Basingstoke; Palgrave, 2006)

3. Both *Housing Problems* and *The Londoners* were sponsored by the British Commercial Gas Association, with the involvement of LCC.

4. Quoted in Welch, *Protecting the People*, p.16

5. While *Daybreak in Udi* was made by committed left-wingers, and the historian Femi Shaka has remarked on the realism of key scenes, more recently the film has been described as 'deeply politically incorrect', if not straightforwardly racist. Femi Okiremuete Shaka, *Modernity and the African Cinema: A Study in Colonialist Discourse, Post-coloniality and Modern African Identities* (Trenton, N.J.: Africa World Press, 2004)

6. Press quotes from Richard Pease, 'The story of "Britain's Sputnik"', *http://news.bbc.co.uk/1/hi/sci/tech/7190813.stm*, 15 January 2008 (accessed: 15 May 2023)

7. Sir Fife Clark, *The Central Office of Information* (London: Allen & Unwin, 1970)

8. David Thomson, *A Biographical Dictionary of Film* (London: Deutsch, 1994) [page?]

9. See 'The Duke of St Albans', *The Times*, 11 October 1988 & 'Duke of St Albans', *The Telegraph*, 11 October 1988

10. Clark, *The Central Office of Information*; Welch, *Protecting the People*

11. See, for example, 'Lord Drogheda', *Financial Times*, 28 December 1989

12. While Drogheda's published report made no mention of the Information Research Department, it seems a safe assumption that a restricted section 'unpublishable because of its confidential nature' outlined more of the relationship between Britain's 'official' and 'unofficial' propaganda operations. See Robert Marett, *Through the Back Door: An Inside View of Britain's Overseas Information Services* (Oxford: Pergamon Press, 1968), p.153

13. Frances Donaldson, *The British Council: The First Fifty Years* (London: Jonathan Cape, 1984), p.193

14. See Clark, *The Central Office of Information* and Emily Crosby & Linda Kaye (eds.) *Projecting Britain: The Guide to British Cinemagazines* (London: BUFVC, 2008)

15. Quoted in Lyn Smith, 'Covert British Propaganda, The Information Research Department: 1947–77', *Millennium: Journal of International Studies*, Vol 9., No.1 (1980), p.68

16. Daniel Loeb, *Orwell Subverted: The CIA and the Filming of Animal Farm* (Pennsylvania: Pennsylvania State University Press, 2007)

17. See J. Stewart, *The story of British animation* (London: BFI/Bloomsbury, 2021)

18. Ian Aitken, 'British governmental institutions, the Regional Office in Singapore and the use of Official Film in Malaya and Singapore, 1948–61', *Historical Journal of Film, Radio and Television*, Vol. 35, No. 1. (2015), pp.27–52

19. Keith Middlemass, *Politics in Industrial Society: the Experience of the British System Since 1911: Politics in Industrial Society* (London: Andre Deutsch, 1979)

20. Robin Ramsay, 'The Clandestine Caucus', *Lobster Magazine*, 1 June 1996

21. John Hall, personal communication, 7 October 2019

22. Quoted in Crosby and Kaye (eds.) *Projecting Britain*, p.73

23. Quoted in Crosby and Kaye (eds.) *Projecting Britain*, p.87

24. Tom Sutcliffe, 'Rita Hunter', *The Guardian*, 2 May 2001. https://www.theguardian.com/news/2001/may/02/guardianobituaries (accessed: 9 September 2023)

25. Charles Hill, *Both Sides of the Hill* (London : Heinemann, 1964), p.190

26. This is an approach that Hill would develop further in his subsequent career as Chairman of the Independent Television Authority, where he worked alongside Robert Fraser, the first Director General of the COI.

27. See Patrick Russell and James P. Taylor (eds.) *Shadows of Progress: Documentary Film in Postwar Britain* (London: BFI, 2010), which includes extensive summaries of Rayant and other key production companies and clients in this postwar media space.

28. Hannah Neale, interview with the author, 9 June 2020

29. Scott Anthony, '"I thought I was more important than I actually was": John Bankole Jones, London Line and the cultural propaganda film' in Beatriz Lopez, James Smith, & Guy Woodward (eds.) *British Writing, Propaganda and Cultural Diplomacy in the Second World War and Beyond* (London: Bloomsbury Academic, 2024)

30. Gordon Johnston & Emma Robertson, *BBC World Service: Overseas Broadcasting, 1932–2018* (Basingstoke: Palgrave, 2019)

CHAPTER 5

1. Jackson, *Humphrey Jennings*, pp.350–1

2. Barry Turner, *Beacon for Change: How the 1951 Festival of Britain Shaped the Modern Age* (London; Aurum Press, 2011)

3. Quoted in Logan, *Humphrey Jennings and the British Documentary*, p.333

4. Lindsay Anderson, 'Only Connect: Some Aspects of the Work of Humphrey Jennings', *Sight and Sound*, April-June (1954), pp.181–6.

5. Quoted in Welch, *Protecting the People*, p.112

6. Quoted in Janine Marchessault, *Ecstatic Worlds: Media, Utopias, Ecologies* (Cambridge, Mass.: MIT Press, 2017), p.115

7. Jez Stewart, 'Truly, Madly, Deepie: Britain's First Fling with 3D', *BFI*, 23 May 2023

8. Quoted in Welch, *Protecting the People*, p.111

9. Quoted in Marchessault, *Ecstatic Worlds*, p.119

10. In 1964, the Experimental Film Fund was replaced by the BFI Production Board, which continued until 2000.

11. Marshall McLuhan, *Understanding Media: The Extensions of Man* (London: Routledge, 1964)

12. Marshall McLuhan & Quentin Fiore, *War and Peace in the Global Village* (New York: Simon & Schuster, 1968), p.183

13. Marshall McLuhan & Quentin Fiore, *The Medium is the Massage* (Harmondsworth: Penguin, 1967)

14. Marchessault, *Ecstatic Worlds*, pp.127–158

15. 'Is U.K. Trade Image Good Enough?', *The Times*, 16 May 1966, p.19

16. John Hall, personal communication, 7 October 2019

17. 'Freedom for What?', *The Times*, 2 November 1967, p.viii & Edgar Anstey, 'Towards a National School for Films and TV', *The Times*, 2 November 1967, p.v

18. 'Interview', *Sunday Times*, 28 April 1968, p.55

19. Levy followed *Opus* with the BFI-funded experimental feature *Herostratus*. Although influential on directors like Stanley Kubrick, Nicolas Roeg and Michael Winner, the film was not a success and the director subsequently moved to the US, where he taught at the California Institute of Arts.

20. This was because many of McLuhan's ideas about the media – like those of Humphrey Jennings – developed out of the teachings of I. A. Richards, under whom he had studied at Cambridge. In books like *The Meaning of Meaning*, Richards had helped transform the teaching of English by insisting on the importance of contextual readings. In part, McLuhan's theories profitably extended Richards' methods into the larger realms of global electronic communication.

21. 'The most impressive dome I know is St Sophia's in Istanbul, built by Justinian in the sixth century,' replied a wounded Spence on the BBC, 'having recently been in Baghdad, I saw an exhibition of some very beautiful Bedouin tents which could be models of the German pavilion.' Basil Spence, 'Expo '67', *The Times*, 2 May 1967, p.11

22. Peter Preston, 'Selling Britain Abroad', *Punch*, 30 July 1969, p.169

23. See, for instance, Robert S. Simpson's *Videowalls: The Book of the Big Electronic Image* (Oxford; Focal Press, 1997) and *Electrosonic: 50 Years on the Audio-Visual Front Line* (Burbank, CA, 2014)

24. Tymn Lintell, interview with the author, 16 August 2020

25. There is an interesting related political story here, too. For instance, the architect of the Dome, Lord Peter Mandelson, was the grandson of Herbert Morrison, who oversaw the Festival of Britain.

26. McLuhan & Fiore, *War and Peace in the Global Village*, p.136

CHAPTER 6

1. Quoted in Jeffrey Richards, 'The Coronation of Queen Elizabeth II and Film', *The Court Historian*, 9:1 (2004), p.74

2. Edward Owens, *The Family Firm: Monarchy, Mass Media and the British Public, 1932–53* (London: University of London Press, 2019)

3. For an illustrative example, see Irene Morra and Rob Gossedge (Eds.) *The New Elizabethan Age: Culture, Society and National Identity After World War II* (London: I.B. Tauris, 2016)

4. Quoted in Laura Clancy, '"Queen's Day – TV's Day": the British monarchy and the media industries', *Contemporary British History*, 33:3 (2019), p.431

5. Ibid, p.435

6. Ibid, p.434

7. 'Coronation Films', *The Times*, 6 June 1953, p.8

8. Stuart Hall, *Representation: Cultural Representations and Signifying Practices* (London: SAGE, 1997)

9. Quoted in Richards, 'The Coronation of Queen Elizabeth II and Film', p.76

10. Michael Billington, 'Christopher Fry', *The Guardian*, 4 July 2005. https://www.theguardian.com/news/2005/jun/29/guardianobituaries.artsobituaries (accessed: 7 October 2023)

11. Quoted in P. Murphy, *Monarchy and the End of Empire: The House of Windsor, the British Government, and the Postwar Commonwealth* (Oxford: Oxford University Press, 2013), p.3

12. Quoted in Ruth P. Feingold, 'Marketing the Modern Empire: Elizabeth II and the 1953–54 World Tour', *Antipodes*, 23:2 (2009), p.152

13. See Feingold, pp.147–154

14. 'The World Was Waiting', *The Listener*, Vol. 53, No. 1350, 13 January 1955, p. 48

15. See Rice, p.252

16. Philip Murphy, *The Empire's New Clothes: The Myth of the Commonwealth* (London: Hurst, 2018)

17. Philip Murphy, *Monarchy and the End of Empire* (Oxford: Oxford University Press, 2013)

18. Andrew Higson, 'From Political Power to the Power of the Image: Contemporary 'British' Cinema and the Nation's Monarchs' in M. Merck (Ed.) *The British Monarchy on Screen* (Manchester: Manchester University Press, 2016)

19. See Victoria Duckett, 'Her Majesty Moves: Sarah Bernhardt, Queen Elizabeth and the Development of Motion Pictures' in Mandy Merck (ed), *The British Monarchy on Screen* (Manchester: University of Manchester Press, 2016)

20. Andy Beckett, 'It's a Royal Cock-up', *The Guardian*, 5 March 2002. https://www.theguardian.com/media/2002/mar/05/themonarchy.broadcasting (accessed: 10 Septmeber 2023)

21. See, for example, 'My Work is Rather Subversive', *The Daily Telegraph*, 25 October 1999, p.13

22. 'Earl Apologises over his TV Firm "Stalking" William', *The Independent*, 28 September 2001, p.13

23. See Mandy Merck, 'Melodrama, Celebrity, *The Queen*' in Merck (ed.) *The British Monarchy on Screen*; 'How the Man behind "The Crown" Made the Monarchy Relevant Again', *New York Times*, 6 November 2019, https://www.nytimes.com/2019/11/06/magazine/the-crown-peter-morgan.html' (accessed: 21 November 2023); '"The Crown" Showrunner on Bringing the "Most Glorious and Most Sour Fairy Tale of the 20th Century" to Screen', *The Hollywood Reporter*, 17 August 2021, https://www.hollywoodreporter.com/tv/tv-news/the-crown-showrunner-peter-morgan-season-four-1234996463/ (accessed: 20 November 2023)

24. For example, in an episode about a presidential visit to Buckingham Palace in 1961, disparaging comments by Jackie Kennedy prompt the Queen to fly to Ghana to persuade President Nkrumah to stay in the Commonwealth. This simply never happened. See, for example, Sonia Sodha, 'It May Be Good Fun, but It's Not Always Good History', *The Guardian*, 31 December 2017, https://www.theguardian.com/commentisfree/2017/dec/31/it-may-be-good-fun-but-its-not-always-good-history-the-crown (accessed: 23 September 2023)

25. Rory Cellan-Jones, 'Digital Royal Wedding: Or #Rw2011', 19 April 2011, https://www.bbc.co.uk/blogs/thereporters/rorycellanjones/2011/04/digital_wedding_or_rw2011.html (accessed: 24 May 2023)

26. S. Knight, '"London Bridge is Down": the Secret Plan for the Days after the Queen's Death', *The Guardian*, 17 March 2017. https://www.theguardian.com/uk-news/2017/mar/16/what-happens-when-queen-elizabeth-dies-london-bridge (accessed 21 September 2023)

27. For reflection on this see, for instance, 'A Coronation for the Twenty-First Century', *The Court Historian*, 9:1 (2004), pp.81–84

28. The BBC said a total of 32.5 million people tuned in to watch the event across its channels and live iPlayer feed.

29. Alex Finnis, 'How Many People Watched the Queen's funeral? The Viewing Figures for Elizabeth II's State Funeral Explained,' *The Independent*, 21 September 2022

30. Louis Jebb, 'Why Queen Elizabeth II Was One of the Greatest Performance Artists of All Time', *The Art Newspaper*, 8 September 2022. https://www.theartnewspaper.com/2022/09/08/is-queen-elizabeth-ii-the-ultimate-performance-artist (accessed: 9 May 2023)

31. Christina Jordan, 'From Private to Public: Royal Family Memory as Prospective Collective Memory in *A Jubilee Tribute to The Queen by The Prince of Wales* (2012)', *Journal of Aesthetics & Culture*, 11:1 (2019), pp.48–55

32. Frank Cottrell-Boyce, 'When We Asked the Queen to Tea with Paddington, Something Magic Happened – the Most Lovely Goodbye,' *The Guardian*, 11 September 2022. https://www.theguardian.com/commentisfree/2022/sep/11/when-we-asked-queen-to-tea-with-paddington-something-magic-happened-most-lovely-goodbye (accessed: 21 June 2023)

33. Imagining the Queen's 100th birthday, the historian Andrew Roberts conjured up a world where the head of an unelected Tony Blair appeared on British stamps while the Queen's position depended on the votes of an enthusiastic mass public. Andrew Roberts, 'What Will it All Be Like When the Queen is 100?', *The Sunday Telegraph*, 6 August 2000, p.32

34. For instance, Peter Hitchens, 'Our Green Queen Has Just Made a Terrible Mistake by Taking a Side in Politics', *The Mail on Sunday*, 6 November 2021. https://www.dailymail.co.uk/debate/article-10172943/PETER-HITCHENS-Green-Queen-just-terrible-mistake-taking-politics.html (accessed: 19 October 2023)

CHAPTER 7

1. 'Spending Cuts Drive Deep and Charley Says it No More', *Times*, 24 June 2011, p.47

2. If you'd bought 100 shares in British Gas for £135 in 1986 and held on to them, you would, own part of at least three companies worth, at the time of writing, more than 12 times what you had paid for them.

3. Patrick Wright, *On Living in an Old Country: The National Past in Contemporary Britain* (London: Verso, 1985)

4. Nicholas Deakin, 'Citizens, Charters and Concordats: how the Major Government confronted the challenge of engagement with civil society in public sector reform', *Observatoire de la société britannique* (7) 2009, pp.49–61

5. Quoted in Adrian Ellis, *Valuing Culture* (London; Demos, 2003)

6. Michael Power, *The Audit Society: Rituals of Verification* (Oxford; OUP, 1999)

7. Matthew Cowen, 'Agencies Feel Highs and Lows of COI Health Tasks,' *Campaign*, 25 February 2000, p.10

8. 'For Sale Second-Hand Commercials,' *Campaign*, 29 November 1991, pp. 26.

9. A phenomenon closely observed by Peter Hitchens: see, for illustrative example, 'I'm Glad Alastair Campbell Got the Chop – He's Much more Dangerous than Corbyn,' *The Mail on Sunday*, 2 June 2019. https://www.dailymail.co.uk/debate/article-7095023/PETER-HITCHENS-Im-glad-Alistair-Campbell-got-chop-hes-dangerous-Corbyn.html (accessed: 27 November 2023)

10. Scott Anthony, *The Guardian*, 13 March 2009. https://www.theguardian.com/film/2009/mar/13/the-saving-of-bill-blewitt (accessed: 12 October 2023)

11. 'Close-Up: Live Issue – Should the State be Funding TV Shows?' *Campaign*, 19 September 2008, p.11

12. Claire Cozens, 'This Client Brief Will Self-Destruct in Five Seconds...', *Campaign*, 21 July 2000, p.25

13. Andrew Grice, 'Party Lines on Advertising' *Campaign*, 3 April 1992, pp. 26.

14. Andrew Grice, 'Ex-adman Retires after Safeguarding COI's Future' *Campaign*, 29 October 1993, p.19

15. Jürgen Habermas, *The Theory of Communicative Action, Vol. 1, Reason and the Rationalization of Society* (Cambridge; Polity, 1984) and *The Theory of Communicative Action, Vol. 2, Lifeworld and system: a critique of functionalist reason* (London; Polity, 2006)

16. 'Close-Up: Live Issue – Should the State be Funding TV Shows?' *Campaign*, 19 September 2008, p.11

17. Jason Okundaye, 'The Blair Show', *Tribune*, 29 June 2020

18. 'Government Adspend Policy Shows History Repeating Itself,' *Campaign*, 3 August 2001, p.19

19. 'Advertising 2000–2009: Advertiser of the Decade – COI,' *Campaign*, 11 December 2009, p.18

20. Progressively fewer people turned out to vote between 1997 and 2005 before a modest uptick in 2010.

21. James Pamment, *British Public Diplomacy and Soft Power: Diplomatic Influence and the Digital Revolution* (Basingstoke; Palgrave, 2016); Matthew D'Ancona, *In It Together: The Inside Story of the Coalition Government* (Harmondsworth; Penguin, 2014)

22. Julian Glover, 'What is the Government's "Nudge Unit"?', *The Guardian*, 19 September 2011. 'https://www.theguardian.com/commentisfree/2011/sep/19/government-nudge-unit-behavioural-insights-team (accessed: 28 October 2023)

23. See Richard H. Thaler & Cass R Sunstein, *Nudge: Improving Decisions about Health, Wealth, and Happiness* (New Haven & London: Yale University Press, 2008) &; David Halpern, *Inside the Nudge Unit: How Small Changes Make a Big Difference* (London: WH Allen, 2015)

24. Jack Stilgoe, *Who's Driving Innovation? New Technologies and the Collaborative State* (Cham, Switzerland; Palgrave Macmillan, 2019)

25. Ben Quinn, 'The "Nudge Unit": The Experts that Became a Prime UK Export,' *The Observer,* 10 November 2018. https://www.theguardian.com/politics/2018/nov/10/nudge-unit-pushed-way-private-sector-behavioural-insights-team (accessed: 12 May 2023)

26. Jill Sherman, 'Whitehall Fears New Era of Spin under Cameron's Media Chief,' *The Times*, 23 March 2011, p.13

27. 'Close-Up: Should the Government be a Brand?', *Campaign*, 21 September 2012, p.19

28. '100 Years of Keeping Calm and Carrying On', *Campaign*, 24 February 2017, p.32

CHAPTER 8

1. If *The King's Speech* promoted Britain abroad, the UKFC's New Cinema Fund was given a domestic role to play, managing social cohesion, representing diversity and attempting to direct the cultural redistribution of esteem. It funded films such as *Bloody Sunday* (Paul Greengrass, 2002), *A Way of Life* (Amma Assante, 2004) and *Red Road* (Andrea Arnold, 2006).

2. Andrew Pulver and Xan Brooks, 'How *The King's Speech* has revived the British film industry', *The Guardian*, 11 February 2011. https://www.theguardian.com/film/2011/feb/11/the-kings-speech-british-film (accessed: 30 July 2023)

3. From *Prick up Your Ears* (Stephen Frears, 1987) to *Naked* (Mike Leigh, 1993), via *Distant Voices, Still Lives* (Terence Davies, 1988) and *The Cook, the Thief, His Wife and Her Lover* (Peter Greenaway, 1989) to *The Crying Game* (Neil Jordan, 1992). After 1994, the ambitions of this independent-led renaissance would be further lifted by an infusion of funds from the newly-established National Lottery. See Lester D. Friedman (Ed.) *Fires Were Started: British Cinema and Thatcherism* (London; Wallflower Press, 2006)

4. On this see Alexander Walker, *Hollywood, England: the British Film Industry in the Sixties* (London; Harrap, 1986)

5. New Labour's approach to the culture industries appears to reflect the disproportionate influence of a network of high-profile supporters particularly, the film producer David Puttnam, the architect Richard Rogers, the fashion designer Paul Smith, and the publishing executive Gail Rebuck, many of whom had donated significant amounts of money to the Labour Party at a time when its fortunes were at a low ebb. Following Tony Blair's landslide victory, Puttnam was ennobled and appointed founding Chair of the National Endowment for Science Technology and the Arts (NESTA), a public body designed to promote creativity, talent and innovation. See Robert Hewison, *Cultural Capital: The Rise and Fall of Creative Britain* (London; Verso, 2014)

6. Ronald Bergan, 'Sir Alan Parker Obituary', *The Guardian*, 31 July 2020. https://www.theguardian.com/film/2020/jul/31/alan-parker-obituary (accessed: 15 December 2023)

7. Quoted in Gillian Doyle, Philip Schlesinger, Raymond Boyle & Lisa Kelly, *The Rise and Fall of the UK Film Council* (Edinburgh; Edinburgh University Press, 2015), p.83

8. Chris Smith, *Creative Britain* (London; Faber, 1998)

9. Quoted in J. Carey, *What Good are the Arts?* (London; Faber, 2006), p.98

10. Peter Koenig, 'Creative Industries: The Cool Economy; Is Chris Smith More Vital than Gordon Brown?', *The Independent*, 15 February 1998. https://www.independent.co.uk/news/business/creative-industries-the-cool-economy-is-chris-smith-more-vital-than-gordon-brown-1144798.html (accessed: 1 December 2023)

11. Hewison, *Cultural Capital*

12. Geoffrey Macnab, 'Britain's Film Renaissance: Made in UK, Owned in USA?', *The Financial Times*, 30 April 2018. https://www.ft.com/content/90908690-373d-11e8-b161-65936015ebc3 (accessed: 30 November 2023)

13. Macnab, 'Britain's Film Renaissance'

14. For examples of alternative films sponsored by UKFC see *The Arbor* (2010), *I Am Slave* (2010) and *Tyrannosaur* (2011).

15. See, for example, 'Bong Joon Ho Reveals to *The Playlist* Five Films That Influenced His Masterpiece Parasite', *The Playlist*, 11 October 2019, 'Bong Joon Ho on Making the Movie of the Year', *Rolling Stone*, 16 December 2019 & 'From Mansfield Park to Mojo: why Harold Pinter's Acting Deserves to Be Celebrated', *The Guardian*, 6 September 2021. https://www.theguardian.com/film/2021/sep/06/from-mansfield-park-to-mojo-why-harold-pinters-acting-deserves-to-be-celebrated#:~:text=There%20is%20a%20special%20thrill,Canadian%20writer%2Ddirector%20Patricia%20Rozema (accessed: 5 May 2023)

16. James Chapman, *Licence to Thrill: A Cultural History of the James Bond Films* (London: I.B. Tauris, 2009)

17. Huw D Jones & Andrew Higson, 'Bond Rebooted: The Transnational Appeal of the Daniel Craig Bond Films' in Jaap Verheul (ed.) *The Cultural Life of James Bond: Specters of 007* (Amsterdam: Amsterdam University Press, 2020)

18. Quoted in Helen Warrell, 'The Spies who Struggle to Love James Bond', *The Financial Times*, 20 December 2021. https://www.ft.com/content/18ded85b-557e-4380-8d5f-4d50fa3f5881 (accessed: 10 September 2023)

19. David Graeber, *The Utopia of Rules: On Technology, Stupidity, and the Secret Joys of Bureaucracy* (New York: Melville House, 2015)

20. Matt Kennard, 'The UK's largest intelligence agency is infiltrating British schools', *Declassified UK*, 2 June 2020. https://www.declassifieduk.org/revealed-the-uks-largest-intelligence-agency-is-infiltrating-british-schools/ (accessed: August 30 2023)

21. Rory Cormac, *Disrupt and Deny: Spies, Special Forces, and the Secret Pursuit of British Foreign Policy* (Oxford: OUP. 2018) p.274

22. Richard Norton-Taylor, *The State of Secrecy: Spies and the Media in Britain* (London: I B Tauris, 2018)

CHAPTER 9

1. Interestingly, anti-war activists have responded in kind. The torture of Iraqi prisoners at Abu Ghraib by British soldiers revealed by the 'Accidental Electrocution' photograph published by the *Daily Mirror* in 2004 was itself a nod towards the 'Accidental Napalm' photograph of a badly burned young girl from the Vietnam War. This trend has been heightened by the dissemination of digital media tools, which enables pastiches of everything from the flag raising at Iwo Jima to 'Tank Man' at Tiananmen Square via the killing of Che Guevara. See Nathan Philip Roger (2010), *Image Warfare in the War on Terror: Image Munitions and the Continuation of War and Politics by Other Means* (unpublished thesis, Swansea University, 2010)

2. David Campbell, 'Cultural Governance and Pictorial Resistance: Reflections on the Imaging of War', *Review of International Studies*, 29 (2003) pp. 62–4; Alistair Finlan, *Special Forces, Strategy and the War on Terror: Warfare by Other Means* (London: Routledge, 2008), pp. 146–7; and Naomi Klein, 'The Year of the Fake', *The Nation*, 8 Jan 2004, https://www.thenation.com/article/archive/year-fake/ (accessed: 20 December 2021)

3. Philip. M. Taylor, *Munitions of the Mind: A History of Propaganda from the Ancient World to the Present Era* (Manchester: Manchester University Press, 2003)

4. See Cormac, *Disrupt and Deny*

5. It was a propaganda campaign that also self-consciously reflected (if not restaged) the battles of the cultural Cold War. The lack of intervention in Syria, for instance, was periodically contrasted with George Orwell's enlistment in the Spanish Civil War. An analogy frequently repeated in 'left-leaning' journals where resistance to British intervention has been highest. See for example, George Monbiot, 'Orwell Was Hailed a Hero for Fighting in Spain. Today He'd Be Guilty of Terrorism,' *The Guardian*, 10 February 2014. https://www.theguardian.com/commentisfree/2014/feb/10/orwell-hero-terrorism-syria-british-fighters-damned (accessed: 30 November 2023)

6. Ian Cobain & Alice Ross, 'British Propaganda Efforts in Syria May Have Broken UK Law', *Middle East Eye*, 11 May 2020. https://www.middleeasteye.net/news/exclusive-british-propaganda-syria-war-opposition-illegal-internal-review (accessed: 30 November 2023)

7. Ian Cobain, Mustafa Abu Sneineh & Harun al-Aswad, 'Syrian Activist Killed by Islamic State Was Working on British-Backed Comic', *Middle East Eye*, 12 May 2020. https://www.middleeasteye.net/news/syria-activist-killed-islamic-state-british-propaganda-comic (accessed: 30 November 2023)

8. Ian Cobain & Alice Ross, 'The British Government's Covert Propaganda Campaign in Syria', *Middle East Eye*, 19 February 2020. https://www.middleeasteye.net/news/revealed-british-government-covert-propaganda-campaign-syria (accessed: 30 November 2023)

9. Liam Stack, 'After Years of War, Celebrities Find a Syrian Group to Back', *New York Times*, 14 September 2016. https://www.nytimes.com/2016/09/15/world/middleeast/white-helmets-nobel.html (accessed: 30 November 2023)

10. For more on this see Cornelia Bjola and James Pamment (eds.) *Countering Online Propaganda and Extremism: The Dark Side of Digital Diplomacy* (London & New York: Routledge, 2019)

11. Joshua Keating, 'The White Helmets: A New Netflix Documentary Shows in Gripping Detail what the War in Aleppo Looks Like from the City's Streets', *Slate*, 19 September 2016. https://slate.com/culture/2016/09/an-interview-with-orlando-von-einsiedel-and-joanna-natasegara-about-netflixs-the-white-helmets-a-documentary-on-the-war-in-syria.html (accessed: 10 September 2023)

12. See, for example, Ishaan Tharoor, 'A Picture of a Syrian Boy Goes Viral, but the War Goes on', *The Washington Post*, 19 August 2016. https://www.washingtonpost.com/news/worldviews/wp/2016/08/19/a-picture-of-a-syrian-boy-goes-viral-but-the-war-goes-on/ (29 November 2023)

13. Dominique Sisley, 'Talking Trump, Syria and Humanity with Orlando Von Einsiedel', *Dazed*, 31 January 2017. https://www.dazeddigital.com/tag/syria (accessed: 29 November 2023)

14. Renee Hobbs, 'The Blurring of Art, Journalism, and Advocacy: Confronting 21st Century Propaganda in a World of Online Journalism', *I/S: A Journal of Law and Policy for the Information Society*, Vol. 8, no. 3 (2013), pp.625–637.

15. See, for example, Mary Harrington, 'The Manufacturing of Consensus', *Unherd*, 7 January 2022. https://unherd.com/thepost/the-manufacturing-of-consensus/ (accessed: 11 October 2023)

16. '"Propaganda organization": White Helmets "engage in anti-Assad activities"' – author Sy Hersh to *RT*, 30 June 2018. https://www.rt.com/news/431379-white-helmets-propaganda-syria/ (accessed: 20 May 2023)

17. According to his obituary, Le Mesurier's formative experiences were in Kosovo, where he worked with the Kosovo Liberation Army, before being employed on training projects in Indonesia, Israel, Iraq, Sri Lanka and the UAE. These experiences led him to stress the importance of community-led activism over 'big-budget' governmental interventions. Michael Chulov, 'James Le Mesurier obituary', *The Guardian*, 13 November 2019. https://www.theguardian.com/world/2019/nov/13/james-le-mesurier-obituary (accessed: 29 November 2023).

18. Ben Norton, 'Leaked Docs Expose Massive Syria Propaganda Operation Waged by Western Govt Contractors and Media,' *The Grayzone*, 23 September 2020. https://www.thegrayzone.com/2020/09/23/syria-leaks-uk-contractors-opposition-media (accessed: 27 November 2023). The fact that members of the White Helmets were granted asylum in the UK as they fled the advancing Syrian military in 2018 might suggest the group had a closer relationship with the British state than usually assumed: see Patrick Wintour, 'UK Agrees to Take in Some White Helmets Evacuated from Syria by Israel', *The Guardian*, 22 July 2018 https://www.guardian.com/world/2018/jul/22/israel-evacuates-800-white-helmets-in-face-of-syria-advance (accessed: 28 November 2023). The death of Le Mesurier, who reportedly fell from a balcony in Istanbul in 2019, means we are unlikely to find out the truth any time soon. The BBC's *Mayday: Intrigue* podcast series represents a thorough, if programmatically sympathetic, attempt to probe the many complexities of the story. See https://www.bbc.co.uk/programmes/mooop6fd (accessed: 9 June 2023).

19. Richard Vinen, *National Service: A Generation in Uniform 1945–1963* (London: Penguin, 2015)

20. Peter Johnston, '"Men of Action": Printed Propaganda in the Recruitment of the Regular British Armed Forces, 1960–85' in Mark Connelly, Jo Fox, Stefan Goebel, and Ulf Schmidt (eds.) *Propaganda and Conflict: War, Media and Shaping the Twentieth Century* (London & New York: Bloomsbury, 2019), pp.285–302

21. Edward N. Luttwak, 'Towards Post-Heroic Warfare', *Foreign Affairs*, 74, No. 3 (1995), pp. 109–22

22. Jean Baudrillard, *The Gulf War Did Not Take Place* (Sydney: Power Publications, 1995)

23. See Emma Ann Rose Mayhew, 'A Dead Giveaway: The Government-Arms Industry Links Behind New Labour's Support for Arms Exports' (2004), unpublished thesis, Bristol University, UK.

24. *ibid*, p.59

25. Neil Cooper, 'Arms Exports, New Labour and the Pariah Agenda', *Contemporary Security Policy*, 21 (3) (2000), pp.54–77. The dominant view remains that Britain's arms industry has a strategic (as well as economic) importance. See Ministry of Defence, *Industry for Defence and a Prosperous Britain: Refreshing Defence Industrial Policy* (2017)

26. See *Gunrunners Gold: How the Public's Money Finances Arms Development Movement* (World Development Movement, 1995)

27. See, for instance, https://www.youtube.com/c/BAESystemsplc/videos

28. Rupert Smith, *The Utility of Force: The Art of War in the Modern World* (London: Allan Lane, 2005)

29. See, also, Emile Simpson, *War from the Ground up: Twenty-First Century Combat as Politics* (London: Hurst, 2012)

30. The 77th Brigade takes its name – 'the Chindits' – from guerrilla forces deployed behind enemy lines during the Second World War in Burma to create confusion among the occupying Japanese army. While we should be wary about over interpreting this, there is a troubling suggestion here that parts of the state imagine that Britain is an occupied country. See Carl Miller, 'Inside the British Army's Secret Information Warfare Machine', *Wired*, 14 November 2018. https://www.wired.co.uk/article/inside-the-77th-brigade-britains-information-warfare-military (accessed: 9 September 2023)

31. Marshall McLuhan, *Culture is Our Business* (New York; McGraw-Hill, 1970), p.66

32. See Ian Cobain, Alice Ross, Rob Evans & Mona Mahmood, 'Inside RICU, the Shadowy Propaganda Unit Inspired by the Cold War', *The Guardian*, 2 May 2016. https://www.theguardian.com/politics/2016/may/02/inside-ricu-the-shadowy-propaganda-unit-inspired-by-the-cold-war (accessed: 29 November 2023)

33. Ian Cobain, Alice Ross, Rob Evans & Mona Mahmood, 'Help for Syria: the "aid campaign" secretly run by the UK government, *The Guardian*, 3 May 2016. https://www.theguardian.com/world/2016/may/03/help-for-syria-aid-campaign-secretly-run-by-uk-government (accessed: 20 November 2023)

34. Ian Cobain, 'This Is Woke': The Media Outfit That's Actually a UK Counter-Terror Programme', *Middle East Eye*, 15 August 2019. https://www.middleeasteye.net/news/revealed-woke-media-outfit-thats-actually-uk-counterterror-programme (accessed: 27 November 2023)

35. The film *Dancing to Freedom* can be watched here: https://www.facebook.com/182132308897000/videos/703090966801129/

36. Ian Cobain, Alice Ross, Rob Evans & Mona Mahmood, 'Government hid fact it paid for 2012 Olympics film aimed at Muslims', *The Guardian*, 3 May 2016. https://www.theguardian.com/uk-news/2016/may/03/government-hid-fact-it-paid-for-2012-olympics-film-aimed-at-muslims (accessed: 30 November 2023)

37. S. Hooper, 'How UK Counter-Terror Unit Uses Rap, Graffiti to Target Middle Eastern Youth', *Middle East Eye*, 23 November 2018. https://www.middleeasteye.net/news/revealed-how-uk-counter-terror-unit-uses-rap-graffiti-target-middle-eastern-youth (accessed: 29 November 2023)

38. Francis Stonor Saunders, *The Cultural Cold War: The CIA and the World of Arts and Letters* (New York and London: The New Press, 2013), p.xiii

39. See Dominique Moïsi, *The Geopolitics of Emotion: How Cultures of Fear, Humiliation and Hope are Reshaping the World* (London: Bodley Head, 2009), p.281

40. See, for instance, Philip Cunliffe, *Cosmopolitan Dystopia: International Intervention and the Failure of the West* (Manchester: Manchester University Press, 2020)

41. Previously, Information leaked by Edward Snowden revealed that Britain's 'Joint Threat Research Intelligence Group' spams phones, impersonates Facebook posts, and alters social media photos. G. Greenwald, 'How Covert Agents Infiltrate the Internet to Manipulate, Deceive, and Destroy Reputations', *The Intercept*, 25 February 2014

42. It was widely reported that public health scientists who disagreed with government policy during the pandemic believed that they had been subject to co-ordinated media attacks. See, for example, 'Scientists accuse the government and media of "smear campaign"', *PR Week*, 6 August 2021. In 2023, RICU's domestic propaganda activities during the pandemic were featured in an investigation by the civil liberties group Big Brother Watch. Its *Ministry of Truth* report (https://bigbrotherwatch.org.uk/wp-content/uploads/2023/01/Ministry-of-Truth-Big-Brother-Watch-290123.pdf [accessed: 2 February 2023]) showed how both Labour and Conservative MPs, as well as major journalists and high-profile academics from the University of Oxford and University College London, had comments critical of the government analysed by anti-misinformation units during the pandemic.

43. According to its proponents, Hybrid warfare is a military strategy which stretches far beyond conventional warfare to employ political warfare, irregular warfare and cyberwarfare, along with other influencing methods, such as fake news, lawfare and electoral intervention. See, for example, *MCDC Counter Hybrid Warfare: Understanding Hybrid Warfare* (January 2017). https://assets.publishing.service. gov.uk/media/5c8141e2e5274a2a51ac0b34/concepts_mcdc_countering_hybrid_ warfare.pdf (accessed: 10 December 2023)

44. Taylor, *Munitions of the Mind*, p.300

CONCLUSION

1. Srdjan Vucetic, *Greatness and Decline: National Identity and British Foreign Policy* (Montreal & Kingston: McGill-Queen's University Press, 2021)

2. Armando Iannucci, 'It's folly to sweep aside 10 years of success at UK Film Council', *The Observer*, 15 August 2010. https://www.theguardian.com/film/2010/aug/15/ folly-to-axe-film-council-iannucci (accessed: 10 October 2023)

3. As recorded in his unpublished memoir 'Sam's Autobiography.' Sam Napier Bell, personal communication, 23 October 2020

4. Quoted in F. O'Toole, *Heroic failure: Brexit and the Politics of Pain* (London: Head of Zeus, 2019), p.8

5. Eric Hobsbawm, *The Age of Extremes: The Short Twentieth Century, 1914–1991* (London: Michael Joseph, 1994)

6. Tom Gunning, 'The Cinema of Attractions: Early Cinema, Its Spectator, and the Avant-Garde,' *Wide Angle*, 8 (1986), pp.3–4.

7. Lev Manovich, *The Language of New Media* (Cambridge, MA: MIT Press, 2002) p.140

8. Ian Cobain, '"Controlled spontaneity": The Secret UK Government Blueprints Shaping Post-Terror Planning', *Middle East Eye*, 22 May 2019. https://www. middleeasteye.net/news/mind-control-secret-british-government-blueprints- shaping-post-terror-planning (accessed: 27 Novmeber 2023)

9. For instance, the British government are accused of doing this during the COVID-19 crisis. See Laura Dodsworth, *A State of Fear: How the UK Government Weaponised Fear During the Covid-19 Pandemic* (London: Pinter & Martin, 2021)

10. See, for instance, François du Cluzel, *Cognitive Warfare* (NATO Allied Command Transformation, 2020)

11. Richard Sennett, *Respect: The Formation of Character in an Age of Inequality* (London: Penguin, 2003)

12. Ofcom, *Online Nation 2022* (London: Ofcom, 2022)

13. Shoshana Zuboff, *The Age of Surveillance Capitalism* (London: Profile Books, 2019)

14. Susan Greenfield, *Tomorrow's People: How 21st Century Technology is Changing the Way We Think and Feel* (London: Allen Lane, 2003)

15. Nick Srnicek, *Platform Capitalism* (Cambridge: Polity Press, 2017)

16. See, Moisi, *The Geopolitics of Emotion*, p.254

17. For example, Hugo Münsterberg's classic *The Film: A Psychological Study – The Silent Photoplay*, first published in 1916.

18. An argument strongly made by Lev Manovich in *The Language of New Media*

19. George Orwell, 'As I Please,' *Tribune*, May 12, 1944

20. For an excellent discussion of this see Ian Bogost, *Persuasive Games: The Expressive Power of Videogames* (Cambridge & London: MIT Press, 2007)

21. See Stuart Dredge, 'Apple Bans Satirical iPhone Game Phone Story from its App Store', *The Guardian*, 14 September 2011. https://www.theguardian.com/technology/appsblog/2011/sep/14/apple-phone-story-rejection (accessed 15 December 2023)

22. See, for instance, Jeff Giesa, 'It's Time to Embrace Memetic Warfare', *Defence Strategic Communications: The Official Journal of the NATO Strategic Communications Centre of Excellence*, Vol. 1, No. 1 (Winter 2015), pp.67–75

23. Quoted in Erik Barnouw, *Documentary: A History of the Non-Fiction Film* (New York, NY: Oxford University Press, 1983), p.85

24. David Graeber famously argued that the growth of post-industrial 'bullshit jobs' had the effect of encouraging people to identify with the perspectives and sensibilities of administrators, managers and officials. It may be that this is also an important political consequence of Britain's over-sized propaganda and public relations industry. See David Graeber, *Bullshit Jobs: A Theory* (London: Allen Lane, 2018)

25. For a much broader discussion on this see Geoffrey C. Bowker, *Memory Practices in the Sciences* (Cambridge & London: MIT Press, 2005)

26. Martin Gurri, *The Revolt of the Public and the Crisis of Authority in the New Millennium* (San Francisco: Stripe Press, 2018), p.65

INDEX

Index entries in **bold** indicate illustrations.

ILLUSTRATION CREDITS

While considerable effort has been made to correctly identify copyright holders, this has not been possible in all cases. Where no rights holder is listed, the image is understood to be out of copyright. Any omissions or corrections brought to our attention will be remedied in any future editions. The majority of images are sourced from digitised films from the BFI National Archive.